This book is dedicated to photographers in the world's newest democracies and to those photographers who risked their lives covering the Chinese massacre.

Pictures of the Year

Photojournalism/15

An annual based on the 47th
Pictures of the Year
competition sponsored by the
National Press Photographers
Association and the University
of Missouri School
of Journalism, supported by
grants to the university from
Canon U.S.A., Inc. and
Eastman Kodak Co.

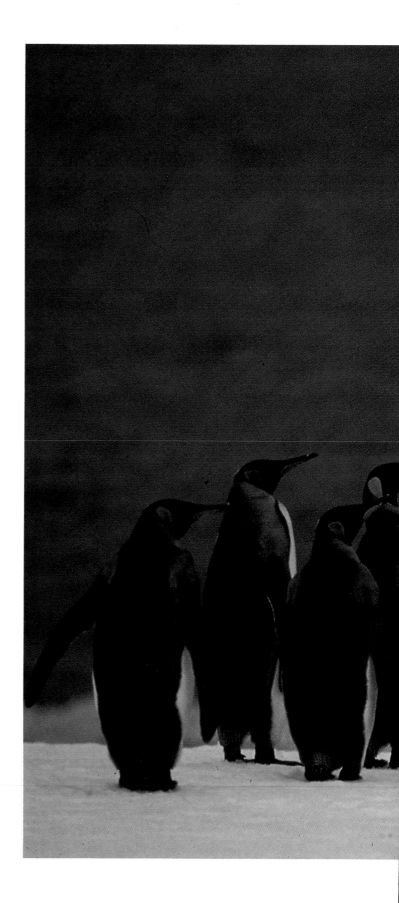

A tourist catches the interest of the natives on South Georgia Island.
FRANS LANTING, NATIONAL GEOGRAPHIC

A message from NPPA's President

1989 was an extraordinary year, a year of startling change and monumental happenings, a year almost unrivaled in its constant barrage of important events.

Photojournalists were swept along by the firestorms of change, recording reality as it unfolded before them. The results of their work are in this book.

This truly is a documentation of one of the most interesting years of our lives. From the Berlin Wall to Tiananmen Square, we saw the world change fundamentally. Hugo devastated the South, and we were there to witness it. Oil devastated the pristine North, and we went there. San Francisco shook, and we were there to witness the destruction. We witnessed the Spirit of Freedom tear down the Wall and also be suppressed by a government that denied killing people even as they died before our eyes. More than ever before, the camera was the prime reporter of world events. 1989 truly was a visual year.

It also was a year of compassion. Look at the stories by the Photographers of the Year, the Kodak Crystal Eagle Award winner and the Canon Photo Essayist; share in the power and passion of their work as they witness for us the human side of AIDS, child abuse and drug abuse. Passion for their work and compassion for their subjects mark the work of our winners, as those characteristics mark the work of all great photojournalists.

It is with pride that NPPA offers *The Best of Photojournalism/15*. Read it, remember the events and learn from them. This is the power of our profession.

— John Long

NPPA President

ISBN: 0-89471-874-6
ISSN: 0161-4762

Front cover photo by Liu Heung Shing.
Back cover photo by James L. Stanfield.

Printed and bound in the United States of America by Jostens Printing and Publishing Division, Topeka, KS 66609. The editor wishes to thank Dave Klene for his cooperation during this project.

Canadian representatives: General Publishing Co., Ltd., Don Mills, Ontario M3B 2T6.

International representatives: Worldwide Media Services, Inc., 115 East Twenty-third Street, New York, NY 10010.

This book may be ordered by mail. Please include $16.95 plus $2.50 for postage and handling. *But try your bookstore first!* Running Press Book Publishers, 125 South Twenty-second Street, Philadelphia, PA 19103.

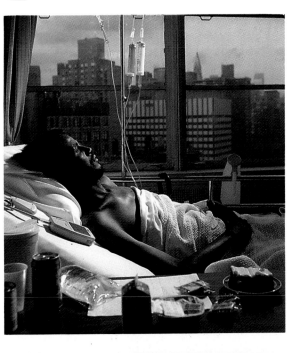

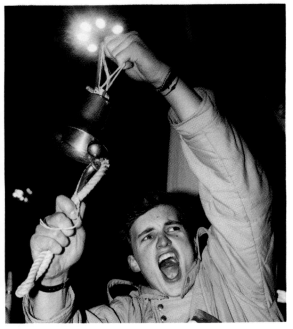

The PJ15 crew are staff members of The Arizona Republic and Phoenix Newspapers Inc. who gave of their own time to make this project successful.

Table of Contents

The POY 15 Staff

Editor, designer	Howard I. Finberg
Associate editor, photo editor	Joe Coleman
Associate editor, photo coordinator	Judy Tell
Associate editor, designer	Phil Hennessy
Associate editor, designer	Diana Shantic
Associate editor, designer	Michael Spector
Associate editor, designer	Pete Watters
Text editor	Patricia Biggs Henley
Assistant text editor	Leslie Zeigler
Cover design, typography	Carolyn Rickerd
Cover art work	Kee Rash
Lab assistant	Dave Seal
Computer coordinator	Don Foley

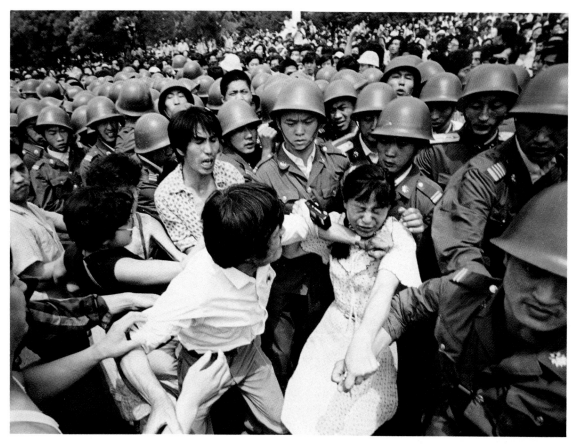

A demonstrator is caught between other protesters and Chinese soldiers in Beijing.
JEFF WIDENER, THE ASSOCIATED PRESS

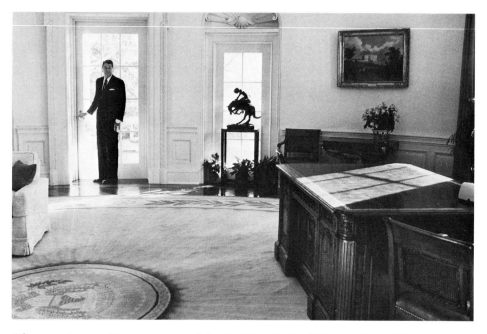

After serving eight years as president of the United States, Ronald Reagan leaves the Oval Office for the last time.
JOSE R. LOPEZ, THE NEW YORK TIMES

1989
The Year in Pictures

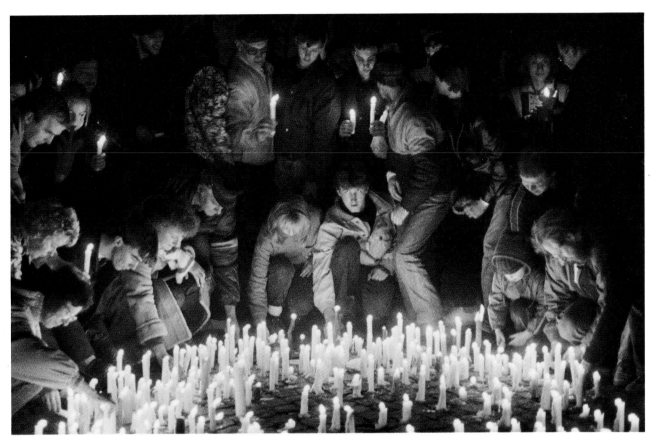

Peaceful demonstrators in Leipzig, East Germany, hold a protest at the headquarters of the secret police.
MICHAEL A. SCHWARZ, THE ATLANTA JOURNAL-CONSTITUTION

It was a wondrous year for photography and photojournalists, as once again, the power of the still image from halfway around the world was evident.

Think of the massacre in Beijing: The image of a single man standing in front of a row of tanks comes to mind. Think of the end of the Berlin Wall: Images of Berliners on top of the structure recall those joyous days.

Television covered those events in 1989, but it was the still photograph that etched a single image upon the collective minds of readers around the world. Television could (and often did) play its film and videotape over and over, but being able to study the photographs of such historic moments brings us closer to the events.

This year the power of photography was at its height, as photographers jumped from one world hot spot to another:

From Panama to China.

From China to Eastern Europe.

From Eastern Europe to Panama again.

"Once in a lifetime" images were captured on film; photographers who went to far corners of the world returned with prize-winning pictures. And some homebound photographers seemed to despair that all of the "good images" were beyond their reach.

However, while we celebrate the internationalism of many of this book's winners, it is crucial to note that two important winners recorded small slices of America's day-to-day existence:

• Alon Reininger began shooting his story about AIDS (see page 213) in 1982 when the disease was barely known outside medical and gay circles. His work captured a hidden slice of American life and brought it to the front of our conscience. Reininger is the second winner of the Kodak Crystal Eagle Award.

Continued on the next page

A U.S. soldier orders one more soda and one more Snickers to go during a break from duty in Panama City.
JIM VIRGA, FORT LAUDERDALE (FLA.) SUN-SENTINEL

The Year in Pictures/1989

Continued from previous page

• Stormi Greener confronted us with an even more frightening disease — child abuse (see page 15). There is no medical test to identify potential abusers, no virus to contend with. Yet, the abuse of our children destroys not only the child and our future but the parent as well. It is a disease of silent suffering and loud cries; photojournalists do not need to travel the world to find its victims. Greener's work on the subject won the Canon Photo Essay.

Such is the dual nature of prize-winning photographs: Some are stories that happen around the corner (or maybe next door); some are stories from distant places that we may never see personally.

But we have eyes in both places. The eyes of the

thousands of photographers who strive to capture slices of our lives, moments of history.

Photography affects our lives like no other invention in modern time, although some would argue that television is a more powerful force. I leave that judgment to the historians.

The problem with television's images is this: They are fleeting moments that do not sear the mind. When we think of key events in our world, we review our own mental "snapshots" of those people and places, the ones that speak to our souls. Television is a cold, flickering medium.

Because of the still photograph's lasting power, journalists must guard its virtue jealousy. At one point,

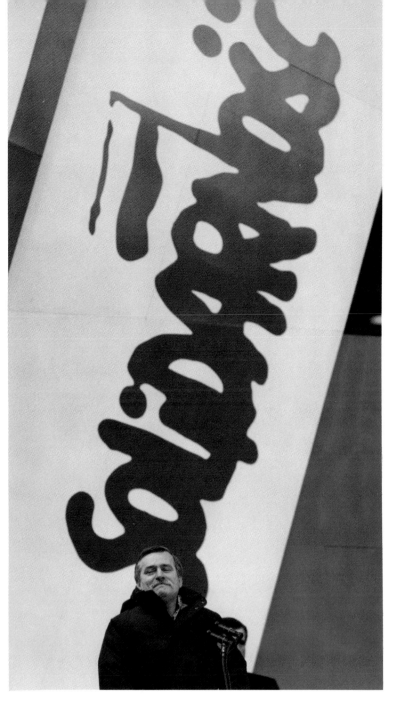

Polish Solidarity leader Lech Walesa smiles with pride while an interpreter relays his message at a Chicago rally.
RICHARD A. CHAPMAN, CHICAGO DAILY HERALD

A wood duck in a pristine pond in Walla Walla, Wash.
JEFF HORNER, WALLA WALLA UNION-BULLETIN

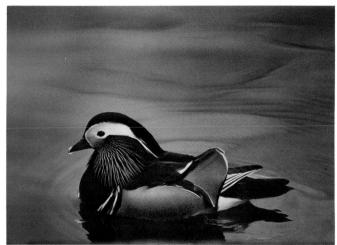

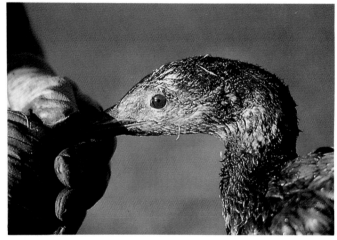

A cormorant in Prince William Sound, Alaska.
ROBERT HALLINEN, ANCHORAGE DAILY NEWS

it seemed that the greatest threat to the integrity of a negative came from large and expensive color digitizing equipment. This equipment changed the way many advertising photographs were published and threatened to take away the truthfulness of journalism's photographs.

However, today it is not the powerful and costly systems that make many anxious, but the ubiquitous Macintosh and its ability to alter photographs. The user-friendly Mac and its mouse-driven software terrorize the truthfulness of the images captured on film.

To be aware of the problem, to speak out against the dangers is not enough. Journalists and readers must unite to demand veracity in the photographs they look at. We should demand honesty because the times demand honesty; we need to know that the images we see are images of real events and not a hideous form of propaganda.

We need to know that what we see is what was there. Truth — from around the corner or around the world.

— Howard I. Finberg
Editor

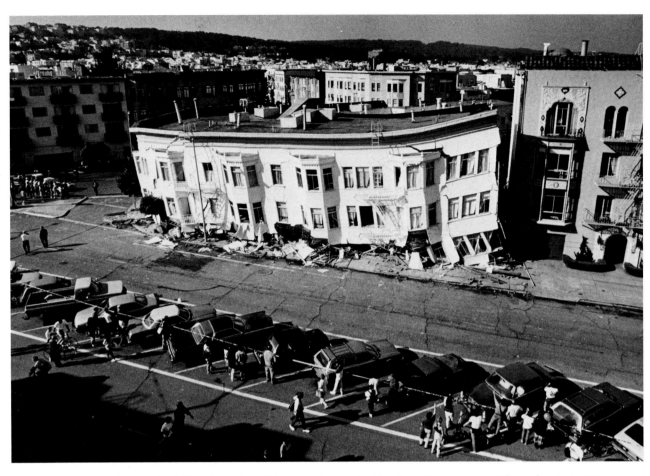

A three-story apartment building is reduced to two stories in the San Francisco earthquake Oct. 17.
BRANT WARD, SAN FRANCISCO CHRONICLE

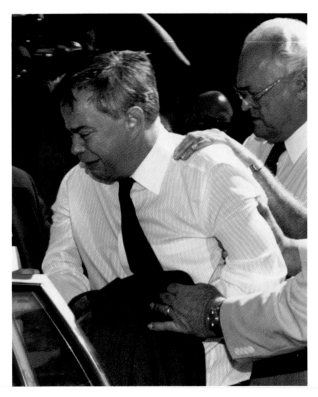

Former T.V. evangelist Jim Bakker is taken into custody after an emotional collapse. His psychiatrist, Dr. Basil Jackson, assists him.
MARK B. SLUDER, PICTURE GROUP

Ken Brokaw peeks through the ceiling to talk to Ray Corey as the men install a light fixture in a bank.
KIT C. KING, SPOKANE (WASH.) SPOKESMAN-REVIEW

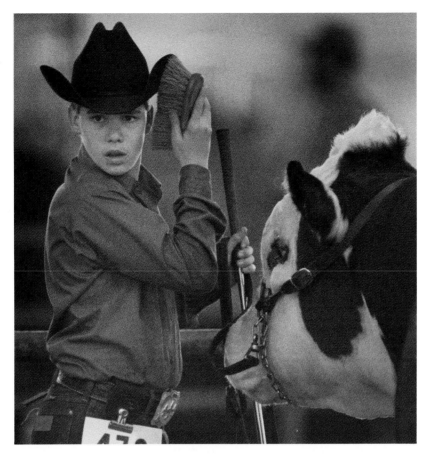
Remmy Forbes, 12, and Skeeter get ready to win grand champion.
STEPHAN SAVOIA, BATON ROUGE (LA.) STATE-TIMES

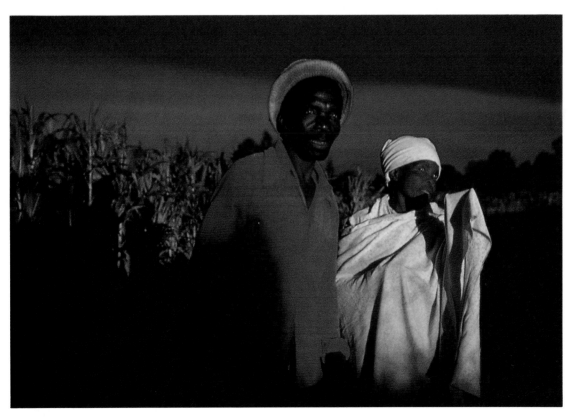
A Malawi couple walks home along the border road of Malawi and Mozambique.
ELI REED, MAGNUM

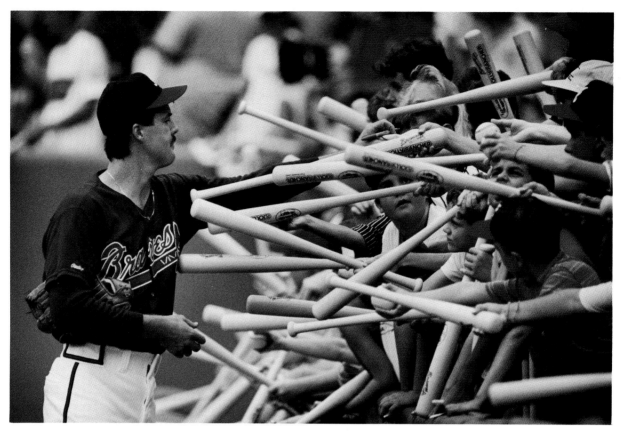

Relief pitcher Mark Eichhorn of the Atlanta Braves autographs baseball bats for fans.
FRANK NIEMEIR, THE ATLANTA JOURNAL-CONSTITUTION

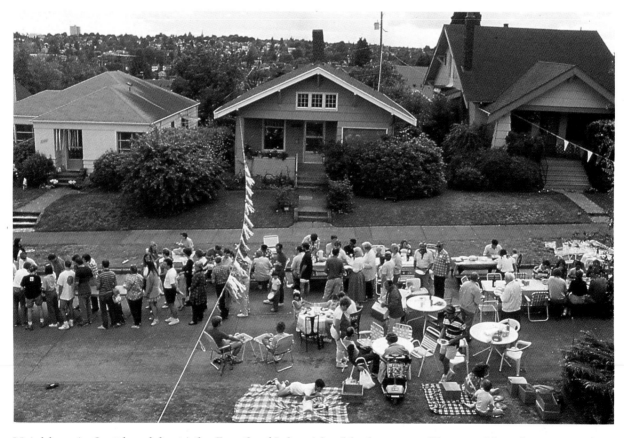

Neighbors in Seattle celebrate the Fourth of July with a block party, a 30-year-old tradition.
BETTY UDESEN, THE SEATTLE TIMES

After finally qualifying for subsidized housing, Christy Dray moved into her "dream house" only to have her landlord sell it and evict her. She stayed, changing the locks and sleeping on the floor.
RANDY OLSON, THE PITTSBURGH PRESS

Police rescue a man who had threatened to jump from a sign high above a freeway.
CHRIS YOUNG, OMAHA (NEB.) WORLD-HERALD

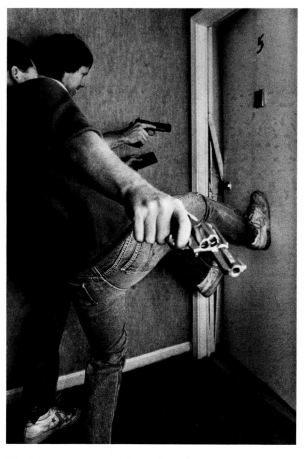

Undercover cops make a drug bust in Louisville.
PAT MCDONOGH,
THE LOUISVILLE (KY) COURIER-JOURNAL

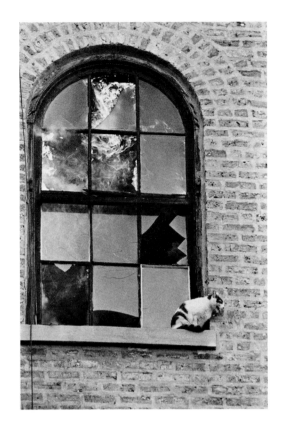
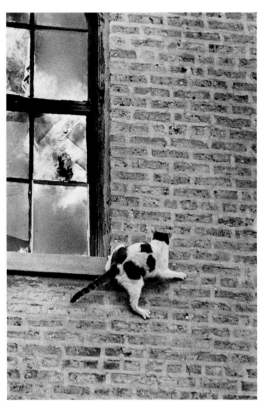
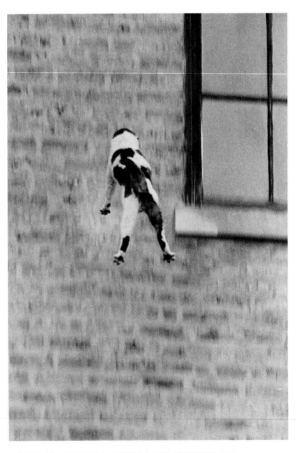
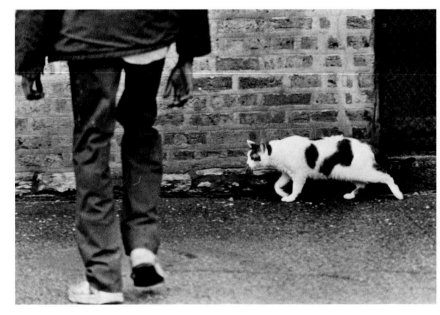

1 down, 8 lives to go

A cat makes its getaway from the fifth floor of a burning building in Chicago. As the heat shatters the window, the cat tries to leap to another ledge, but instead falls to the ground. Unruffled, it walks away from the scene. A few minutes later, it was adopted by a passerby who named it Fireball. The building did not fare as well: The blaze destroyed eight art galleries, causing $50 million in damage.

JOHN H. WHITE, CHICAGO SUN-TIMES

Stormi Greener, Minneapolis Star-Tribune

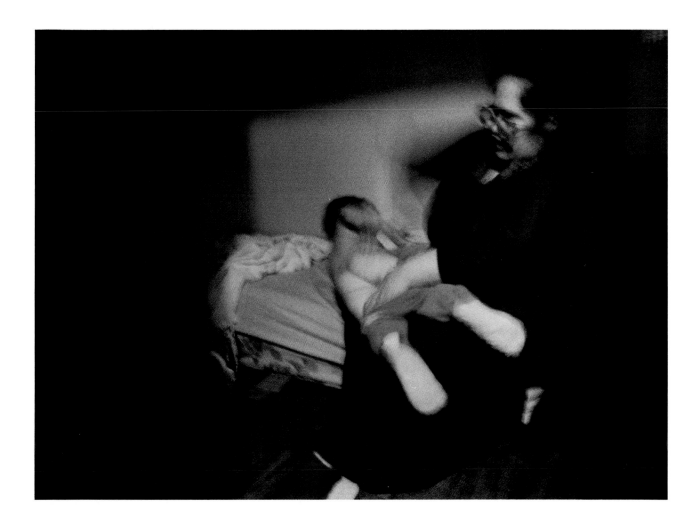

Struggling to break the cycle of abuse

Pat Ward knew she was on the verge of falling into a pattern of abuse. At 31, she was frustrated with the problems of too little money, too little self-esteem and too little patience for the antics of her 3-year-old son, James.

"Sometimes I can see it coming — the abuse," she said in 1989. "Sometimes I can't. I forget the line between discipline and hitting. I'm very shady on that." Taped to her walls were signs to remind her of that line: "Kids need encouragement like plants need water," and "Attack the problem, not the child."

"My job skills are limited," she said. "I don't spell well, I have dyslexia and that causes problems. I don't have any office skills. The most I can hope for is being a stock clerk at Target or a cashier."

Her father hit her regularly until she was an adult, she said, and the cycle threatened to continue. "I was slapped and a belt was used on me. I don't want to become that kind of parent. But I am."

She considered giving up James and his baby sister, Eowyn, for adoption or placing them in a foster home. She said that sometimes when she felt herself losing the struggle, she considered suicide because it would have meant she had some control over her life.

In March, after reading about child abuse in the *Star-Tribune* in Minneapolis, Pat called the paper to say she had abused her son and wanted to stop. She agreed to allow a reporter and photographer to visit her home, hoping that telling her story would "help other parents who love their children, but who abuse them." Stormi Greener and *Tribune* reporter Paul McEnroe chronicled her life.

Greener visited the family on an almost daily basis for four months. "During my time with her I was able to understand her frustrations in mothering a very active boy, along with her frustrations of being poor. I did not witness any brutality or any lack of true love and concern for her children," Greener says.

On a brighter note: Since the story ran, Steve began working full time, and they moved into a house owned by Pat's father to catch up on their bills. Pat took parenting classes and the family received counseling. Looking back, Pat says she can't imagine living the way she did, because now things are going so well.

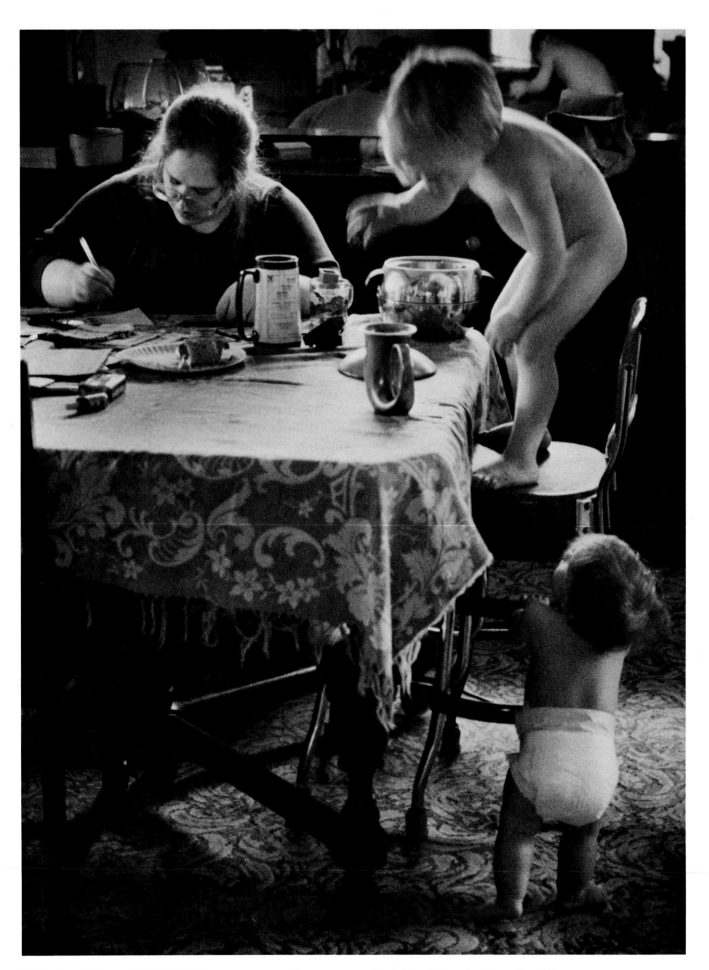

It is a hectic household. Pat clips coupons as James runs naked, his sister chasing after him.

CANON PHOTO ESSAY / *STORMI GREENER*, "CYCLE OF ABUSE"

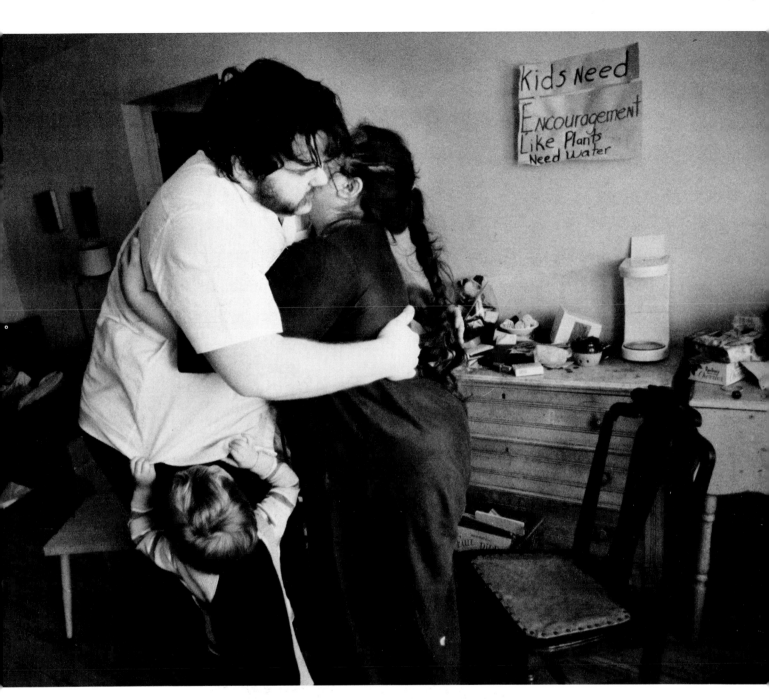

James tries to be included as Steve hugs his wife before leaving for work.

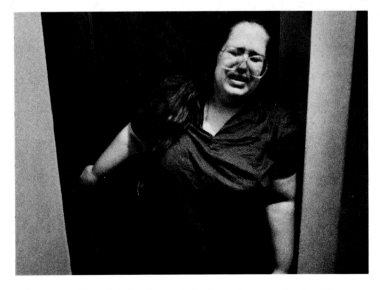

Whenever Pat thinks she might beat James, she holds a
door shut between them until she regains control.

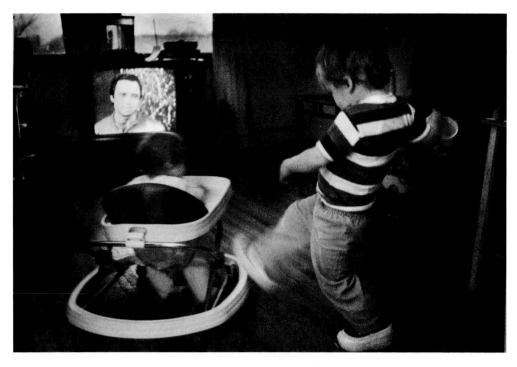

James is often in trouble for hitting or kicking his sister. "If I don't teach him different, is he going to grow up to be a rapist, a murderer?" asks his mother.

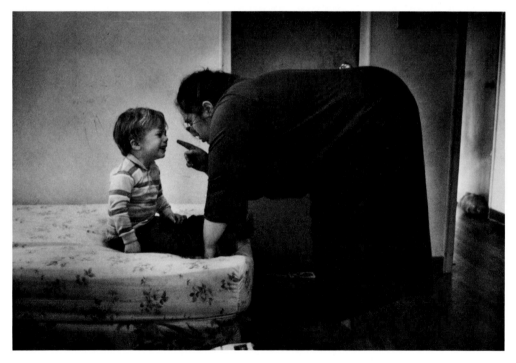

Pat scolds James for leaving his bedroom and kicking his door in frustration. "Now he actually tells me not to yell at him; it's a game," she says.

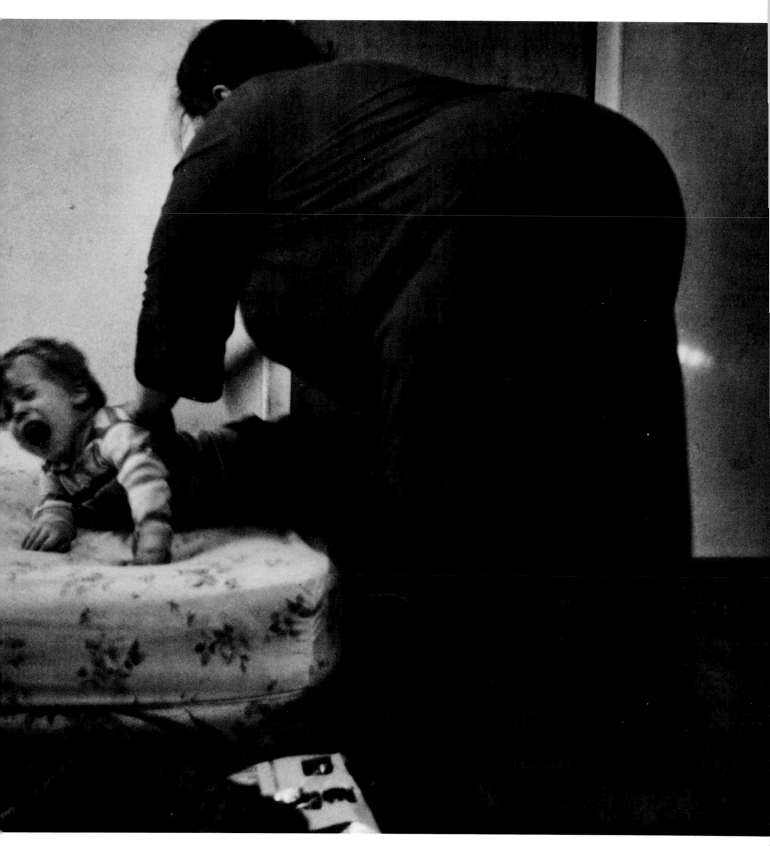

The scolding becomes a spanking. "I don't know how to get his attention unless it's into pain," she says.

Steve, just home from a night shift, carries baby Eowyn to a bath.

CANON PHOTO ESSAY / *STORMI GREENER,* "CYCLE OF ABUSE"

With overwhelming monthly bills, sometimes there isn't money for a trip to the laundromat.

Pat, still in her bathrobe in the afternoon, seems weary of the children.

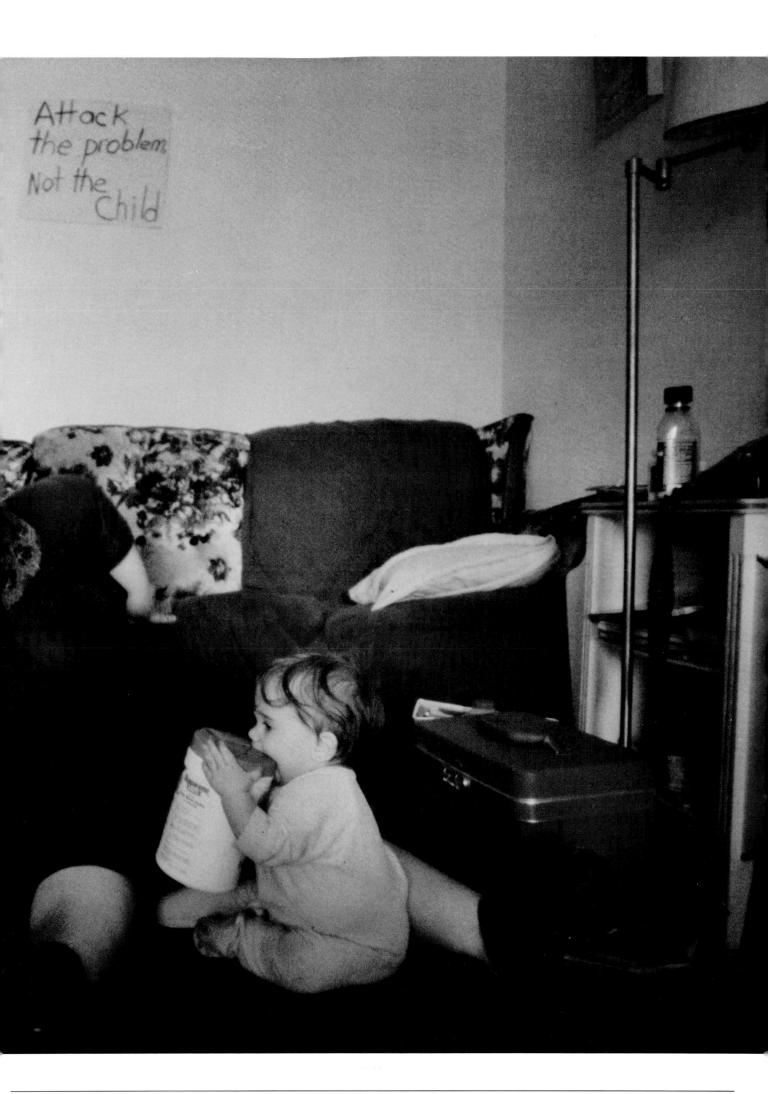

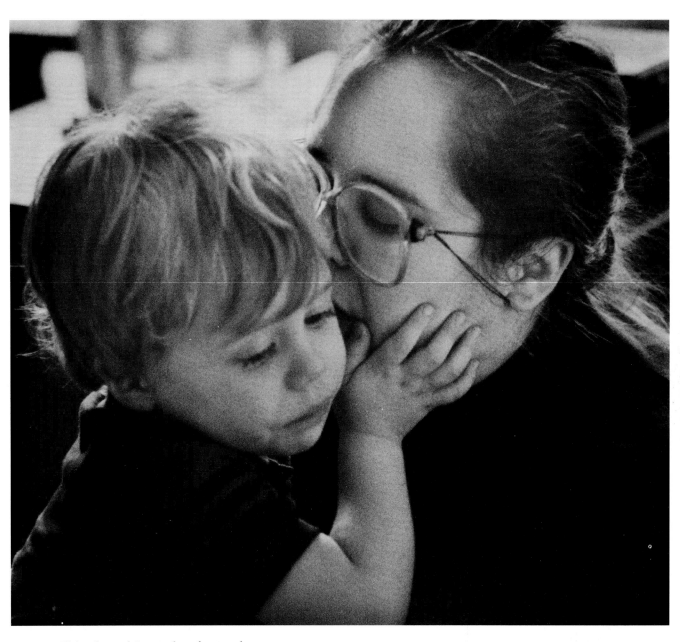

James still looks to his mother for tenderness.

CANON PHOTO ESSAY / *STORMI GREENER*, "CYCLE OF ABUSE"

Carol Guzy, The Washington Post

A worker in Prague, Czechoslovakia, shows his solidarity from inside a factory during a nationwide strike in November.

Luncheon conversation at the Capital Hilton brings together Maryland Daughters of the American Revolution (from left) Mrs. Charles A. Bloedorn, Mrs. David S. Hawkins and Mrs. Roger W. Carroll.

A Chinese student in Washington, D.C., screams during a rally protesting events in Tiananmen Square, Beijing, in June 1989.

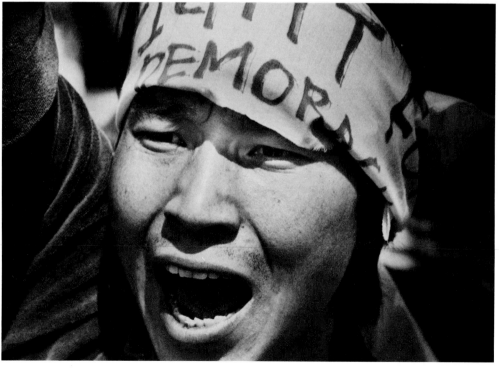

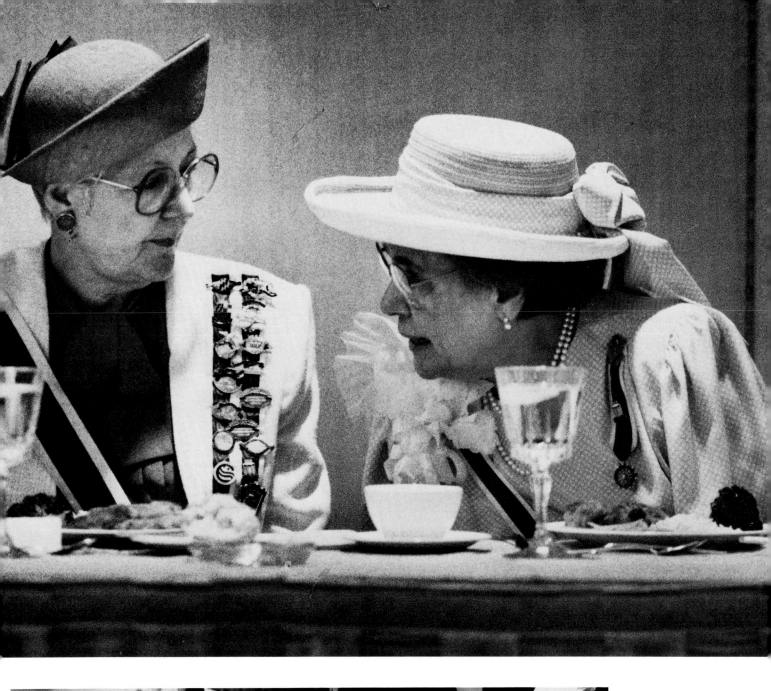

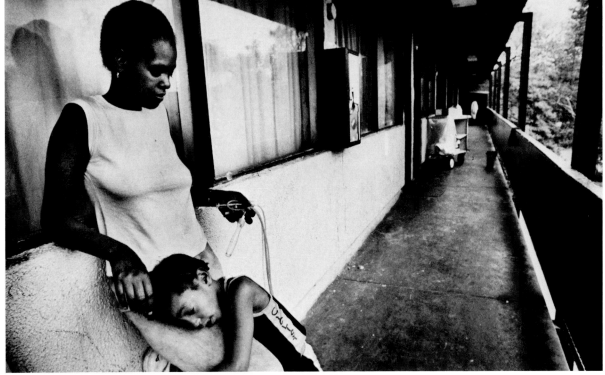

A woman is embraced by her child at Capitol Inn, a homeless shelter in Washington, D.C.

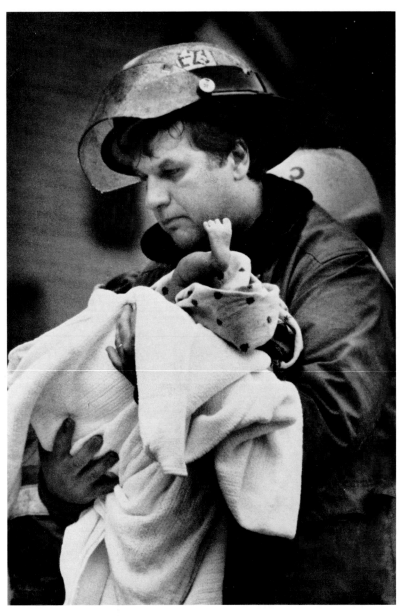

A Washington, D.C., firefighter rescues a baby from a building.

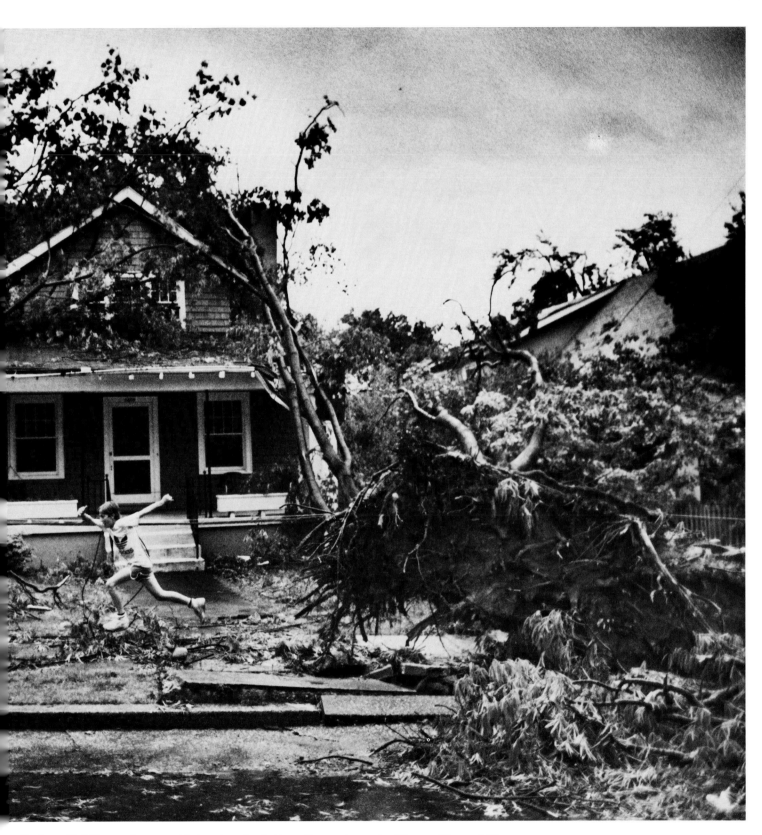

Joshua Goldberg plays amidst nature's clutter after a storm in Chevy Chase, Md.

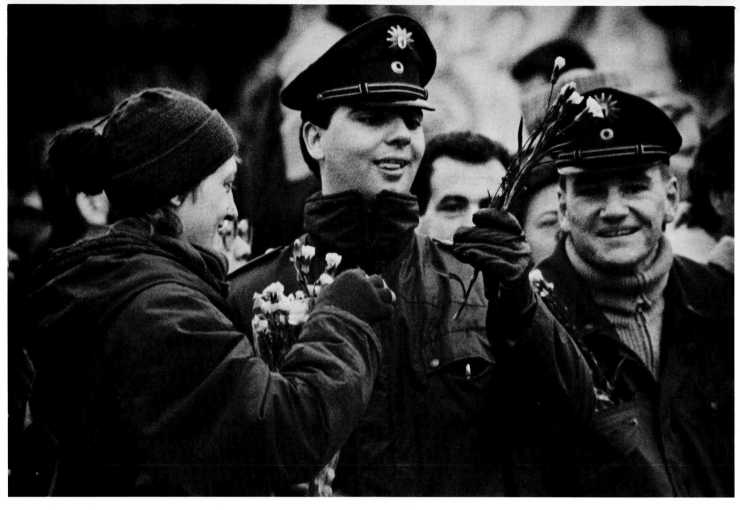

An East German woman passes out flowers to West German border guards.

The Berlin Wall comes tumbling down

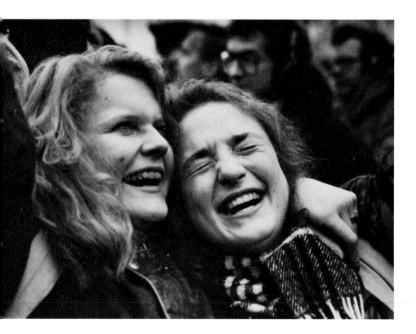

On Nov. 9, 1989, East Germany announced that it was opening its borders and allowing its citizens to travel freely outside the country. That night, 50,000 East Berliners streamed through the wall that had divided the city since 1961, celebrating with their Western neighbors, parading through the streets and dancing.

Many East Germans reacted with tears of joy to their first journey West, while border guards passively watched an act that had been so long forbidden. West Berliners perched atop the barrier that had epitomized the Cold War, welcoming those from East Berlin.

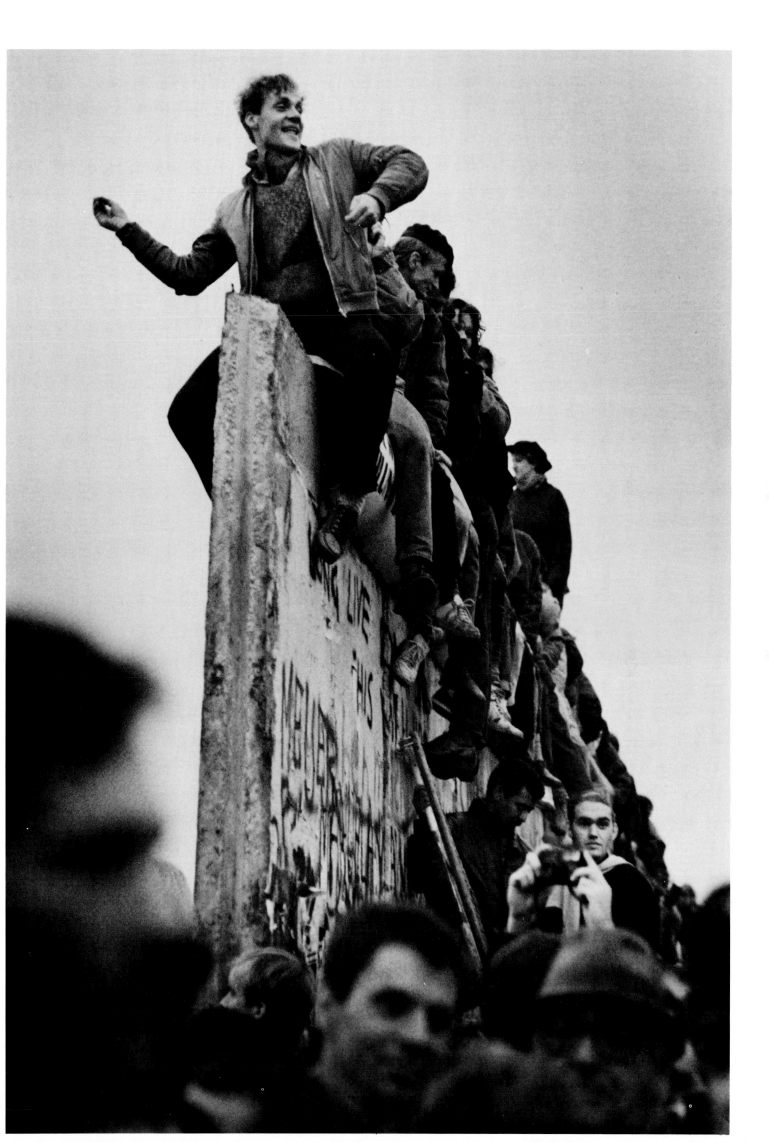

Cinderella at the Inaugural Ball

Robert and Valerie Gaines and their two children were among the many homeless in Washington, D.C., hoping to find a way back from their plight. But when Valerie began working as a computer operator for Sen. Rudy Boschwitz, R-Minn., she never expected to be invited to an inaugural ball.

When the invitation arrived and a story about the Gaines family ran in *The Washington Post,* the community became involved in making the couple's night memorable. A formal gown and tuxedo, limousine service and hair styling were donated. "I feel like Cinderella," Valerie said as she dressed for the Clean Air Inaugural Ball.

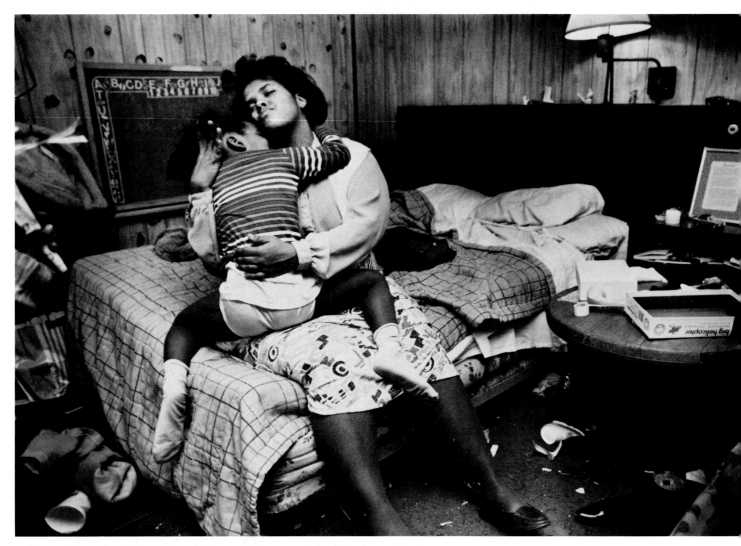

Valerie hugs her 4-year-old daughter, Nicki, in their room at the Capitol Inn, a homeless shelter in Washington, D.C.

A TV reporter interviews Robert as he has his hair washed at
Robin Weir Beauty Salon the morning of the inauguration.

Children at the Capitol Inn stare as a transformed Robert and Valerie leave to celebrate.

Valerie holds hands with Sen. Boschwitz as they sing *We Are the World* at the end of the enchanted evening.

Eugene Richards, Magnum

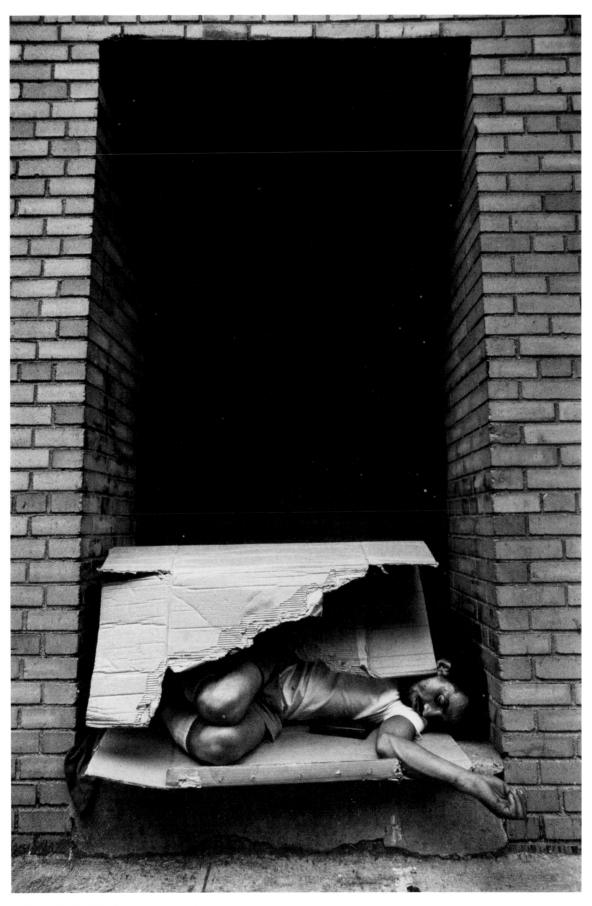

A New York City beggar.

Mary collects cans at the Port Authority Bus Terminal in New York. "Can people" sometimes earn more than $30 a day.

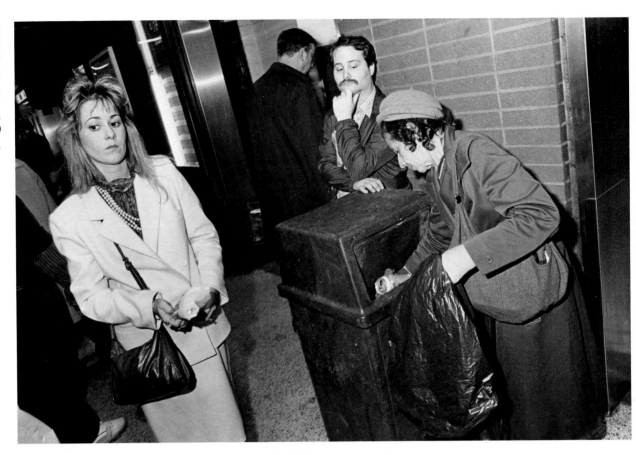

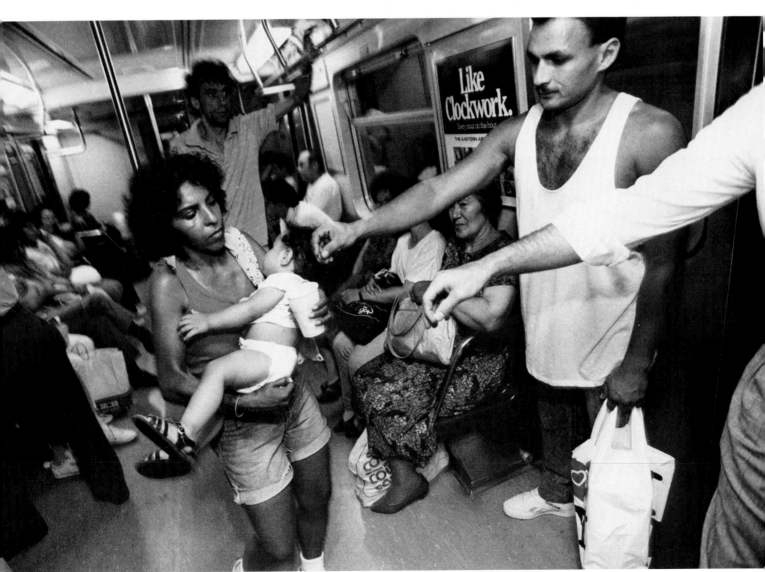

Marisol, her 14-month-old child in her arms, begs on the subway. On one trip, she collected $50 in an hour.

MAGAZINE POY / *EUGENE RICHARDS, 1ST PLACE*

Francis and his wife, Lena, have panhandled in New York along Lexington Avenue for eight years. Francis, a Vietnam veteran, uses the money he makes begging to buy cheap wine.

China
After the
Crackdown

Senior American Consul Jan de Wilde takes his family to the airport in Chengdu. They were the last American dependents in China during the unrest of 1989.

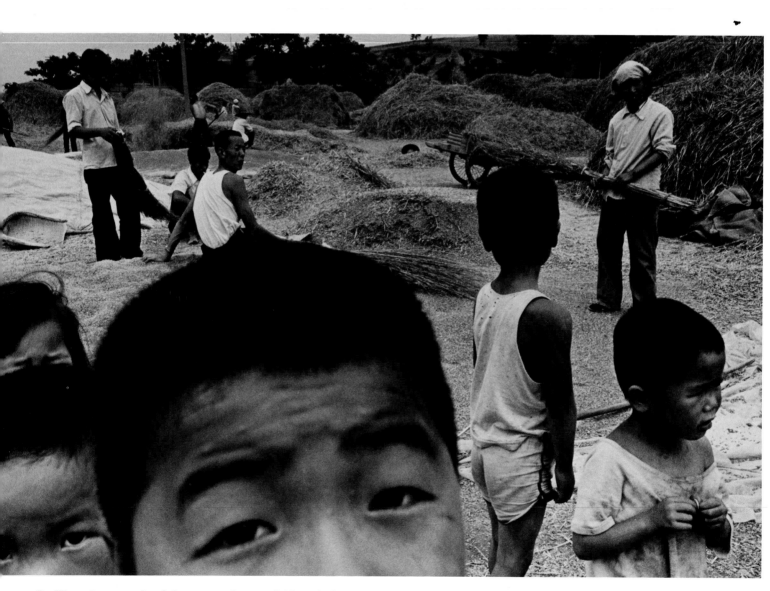

In Xian, just south of the mausoleum of China's first emperor, the wheat harvest is in full swing.

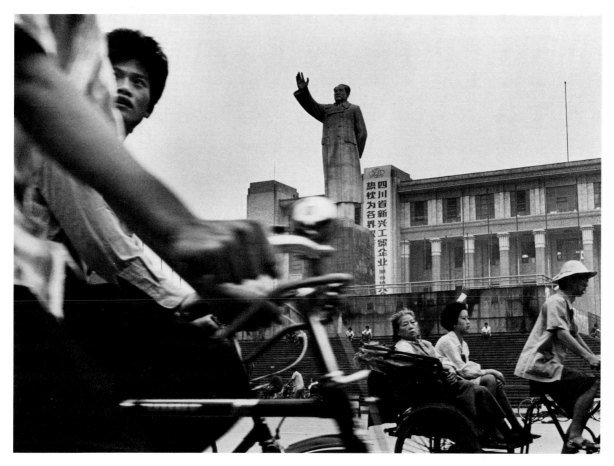

The central plaza in Chengdu, graced by a statue of Mao, was the site of protests in June. During the crackdown by soldiers, 50 people were killed and 350 wounded around the plaza.

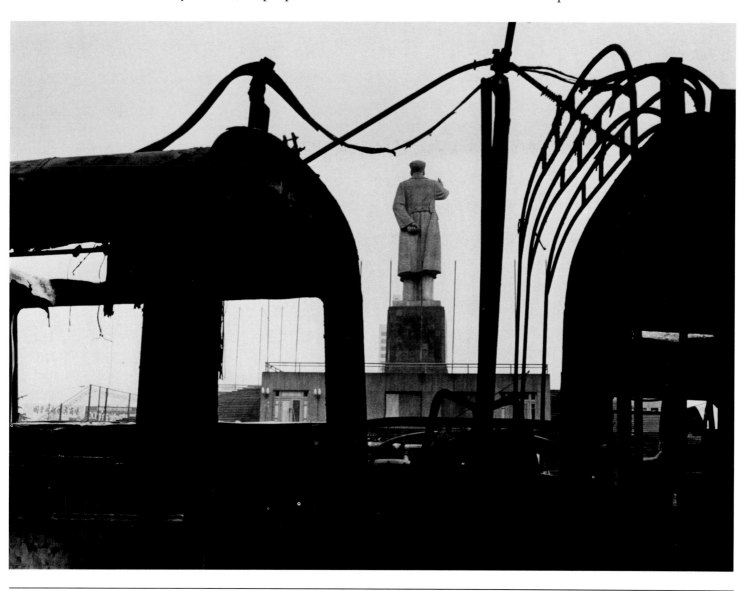

Wheat chaff clings to a farmer's back. Working day and night during harvest, China's farmers have no time for politics.

MAGAZINE POY / *EUGENE RICHARDS, 1ST PLACE*

A crack dealer flees police in North Philadelphia. The police haved dubbed the area "The Land of Oz."

Battle
for
the
Land
of Oz

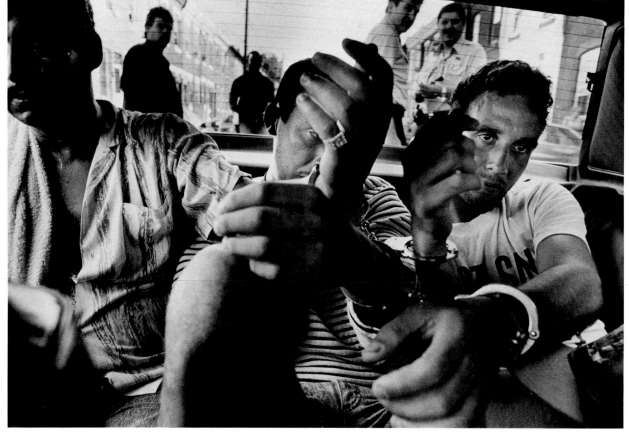

Three suspected drug dealers are held in a police car on a 96-degree day. The officers turned the heater on for added effect.

MAGAZINE POY / *EUGENE RICHARDS, 1ST PLACE*

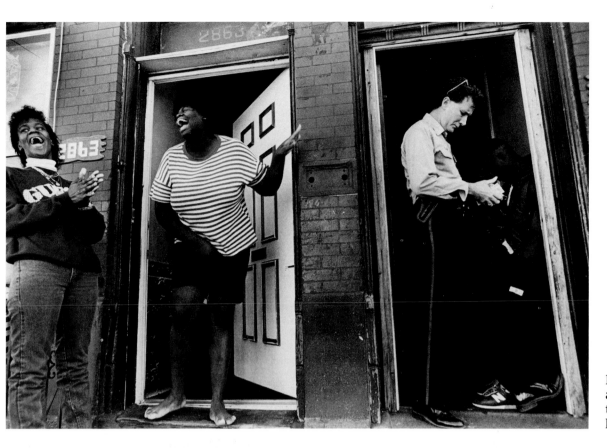

Drug busts in the area are so common that they are laughed about.

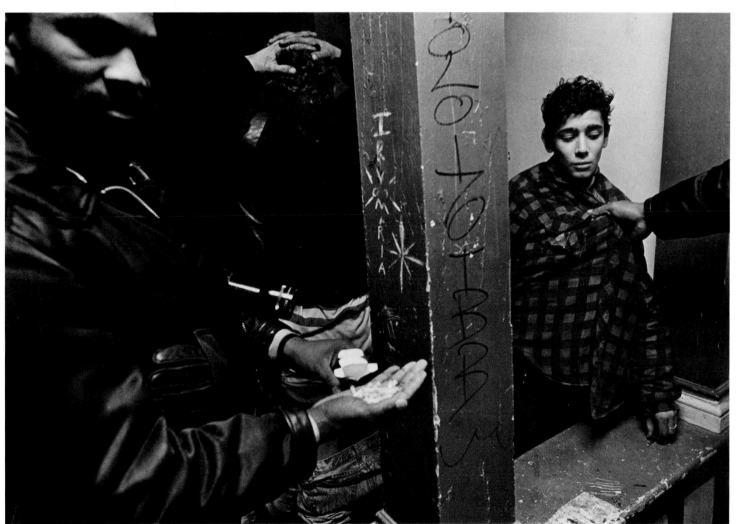

A 13-year-old boy is among those arrested in a crack house. The week before, the boy's brother was killed during a deal.

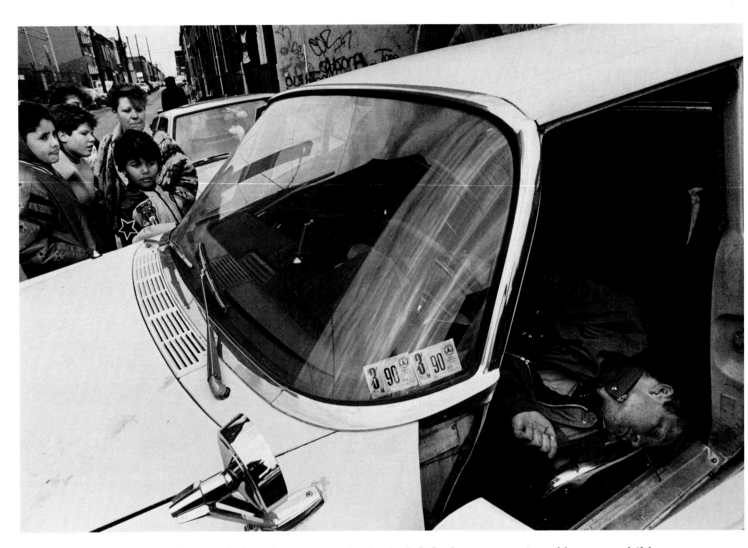

A 35-year-old man dies in his car of a heroin overdose. His body, left for hours, was viewed by many children.

Randy Olson, The Pittsburgh Press

Vincent Berkey, 14, makes his farewells before leaving home for plebe training at Valley Forge Military Academy.

'Amoeba Rambo' meets the military

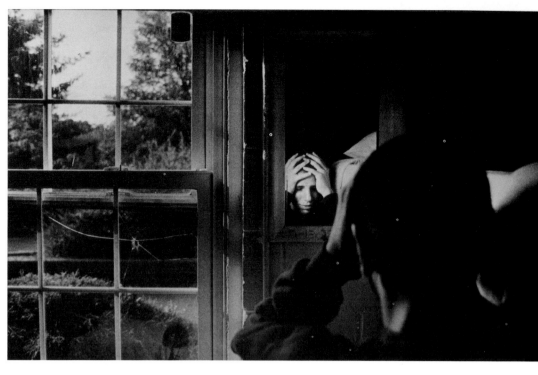

Vince, dubbed Amoeba Rambo, tries to adjust to his haircut at the academy.

Officer Antonio D'addio instructs Vince on the proper way to do a push-up.

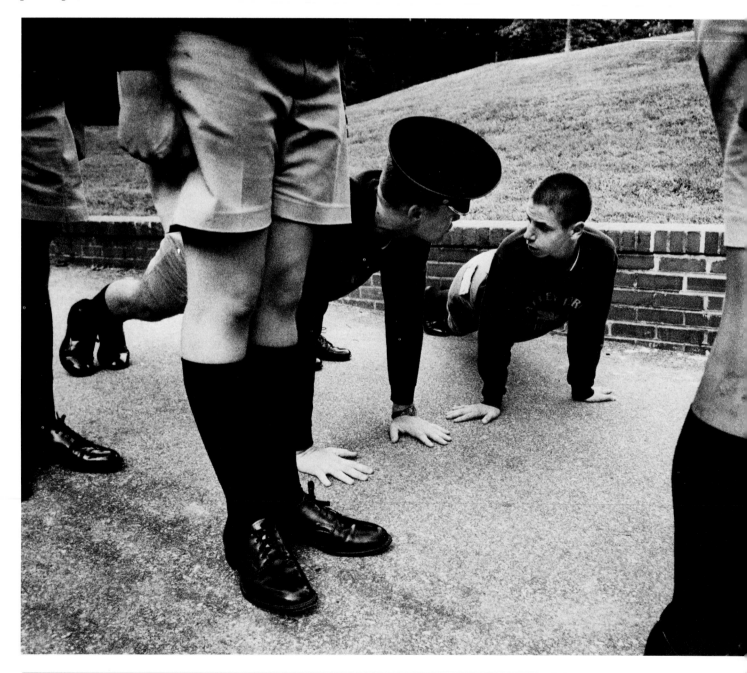

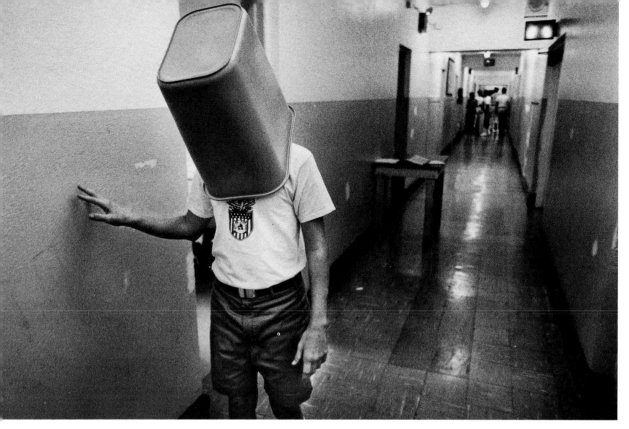

During the hazing at the academy in Wayne, Pa., Vince must walk the hall with a trash can on his head.

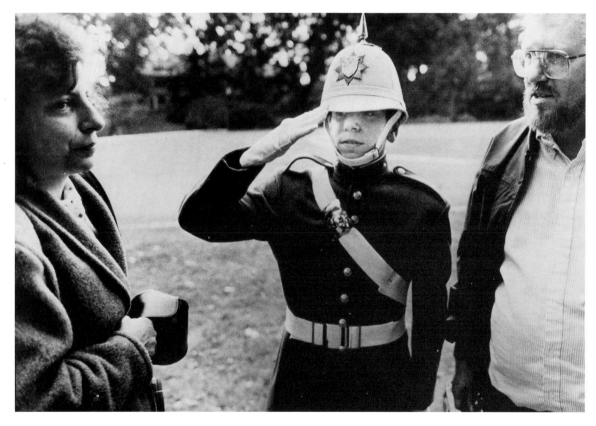

Vince salutes a passing officer on Recognition Day while his parents visit. Vince's graduation from plebe to cadet is viewed by his parents as the completed contract with their son.

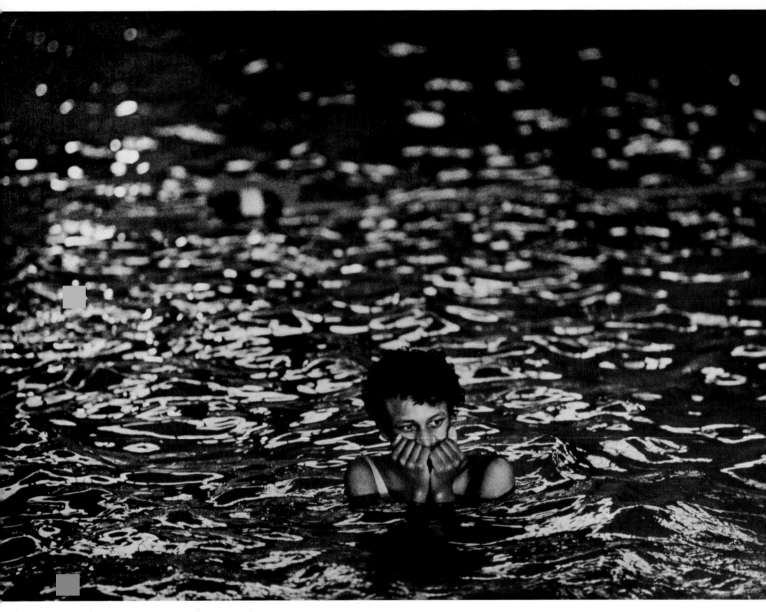

An autistic woman tries to overcome her fear of water during a therapy session.

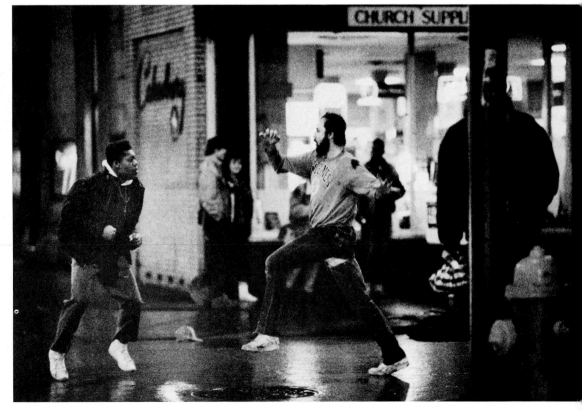

A knife fight that erupts in Krazi's Bar in Pittsburgh spills out into the street. The man at right suffers a cut but manages to take the knife from the other, then both men disappear into the night. A week later, police close the bar.

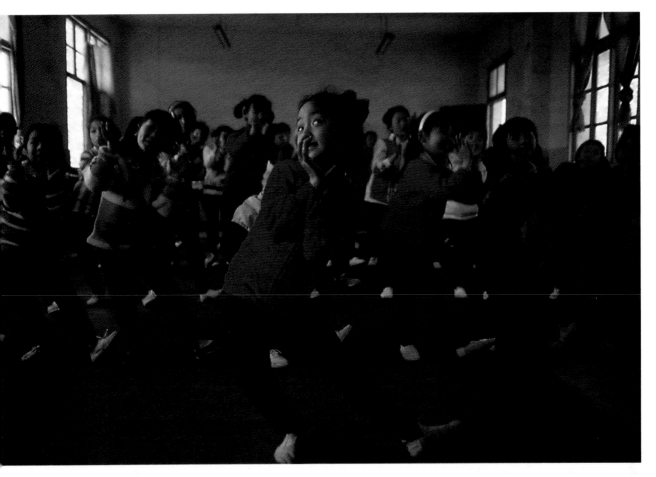

Pupils learn to dance at Wuhan Iron and Steel Kindergarten #2.

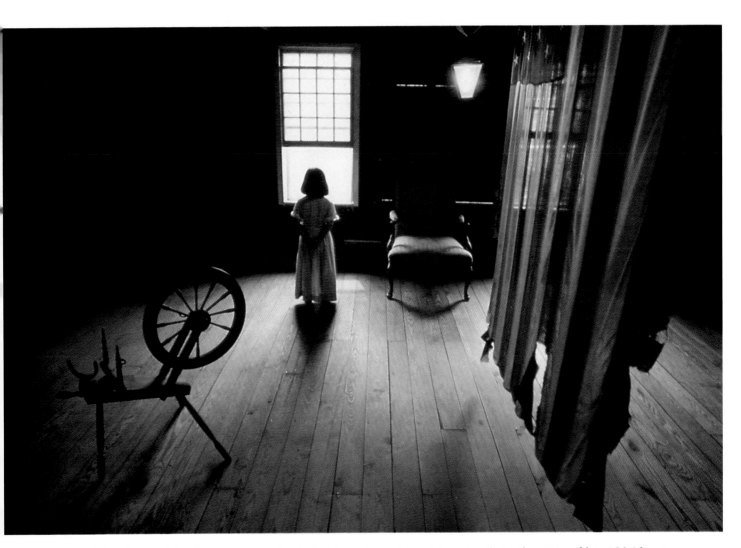

The great-granddaughter of the first commandant of Sainte Genevieve, Mo., stands in the attic of his 1806 home.

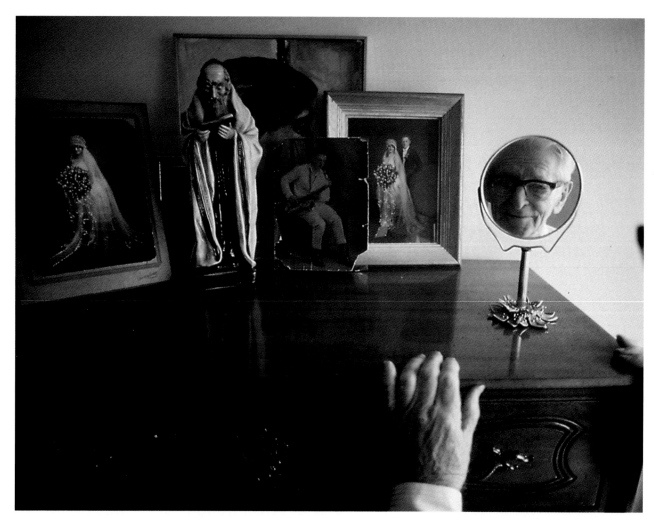

An aging saxophone player checks his appearance on his way out the door. He has outlived his wife, and now lives in a highrise building for Jewish seniors, where he keeps mementos of a full life.

David C. Turnley, Detroit Free Press/Black Star

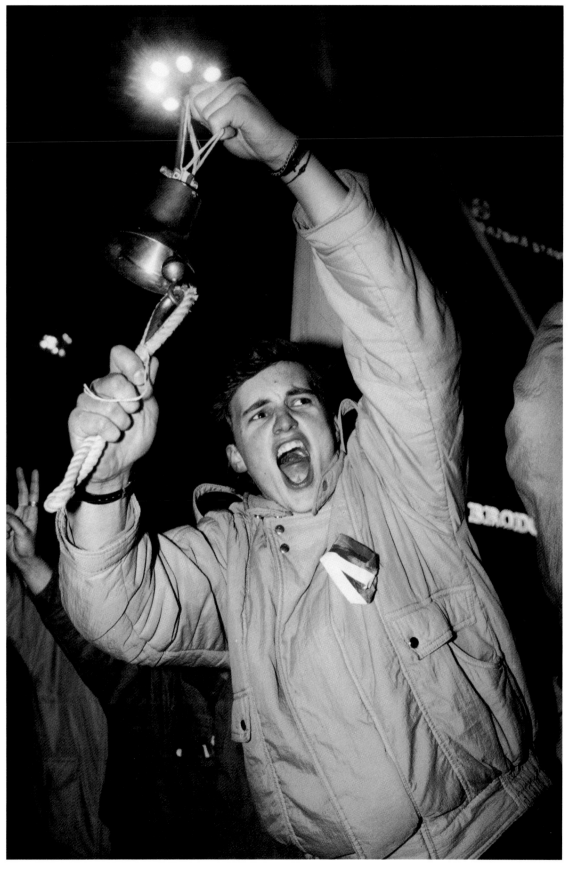

A young Czech rings a bell in Prague to celebrate the formation of the first non-Communist-dominated government in the country since 1948.

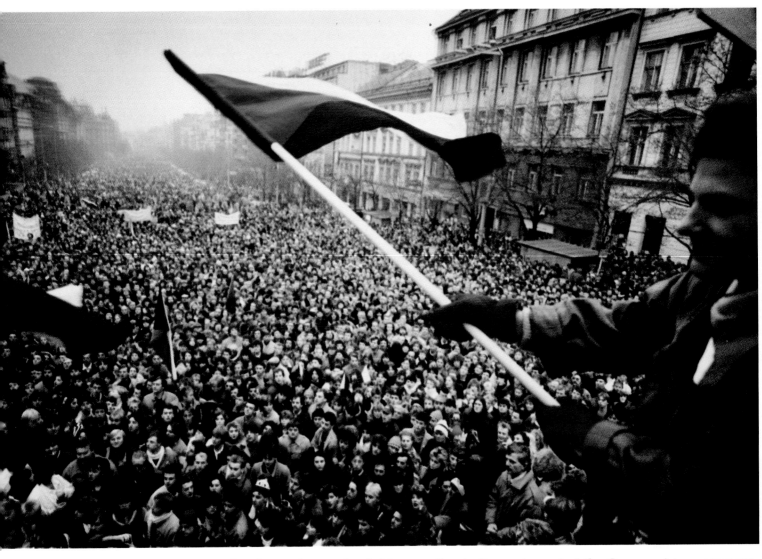

A man waves the flag of Czechoslovakia as thousands of citizens gather in Prague to protest the Communist government.

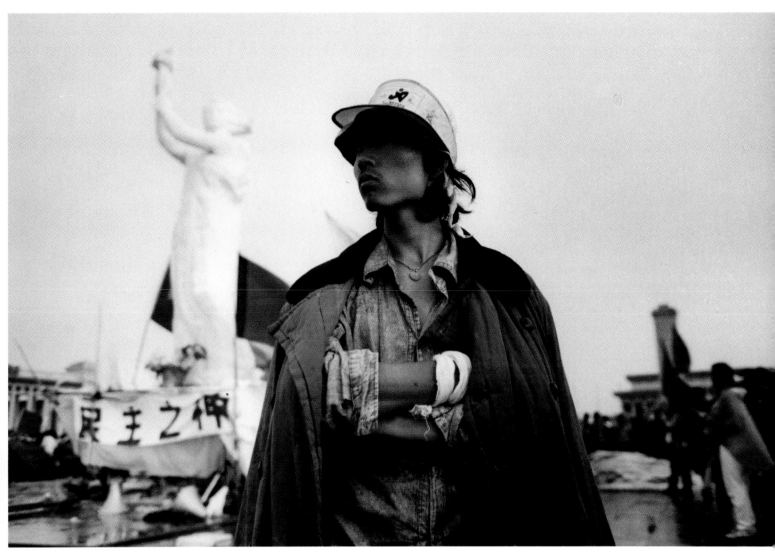

A Chinese student stands vigil in Tiananmen Square near the Goddess of Democracy. The statue later was destroyed.

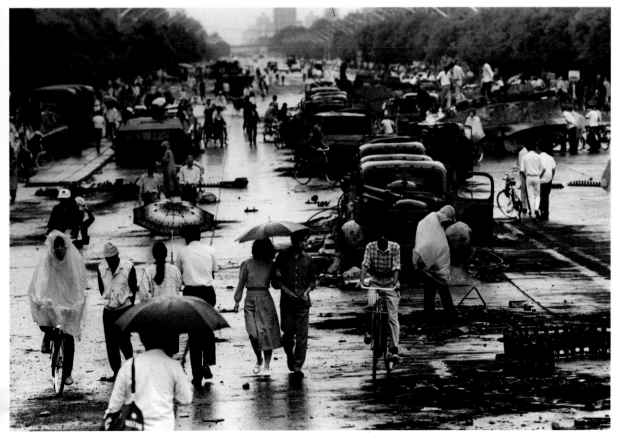

A Chinese couple walk past burned army vehicles near Tiananmen Square after the June massacre.

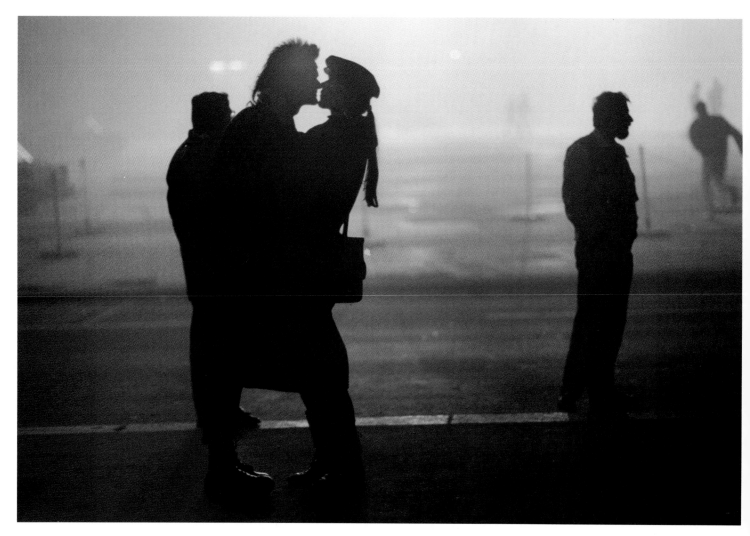

Two East Germans embrace after a massive demonstration in Leipzig.

Peter Turnley, Black Star for Newsweek

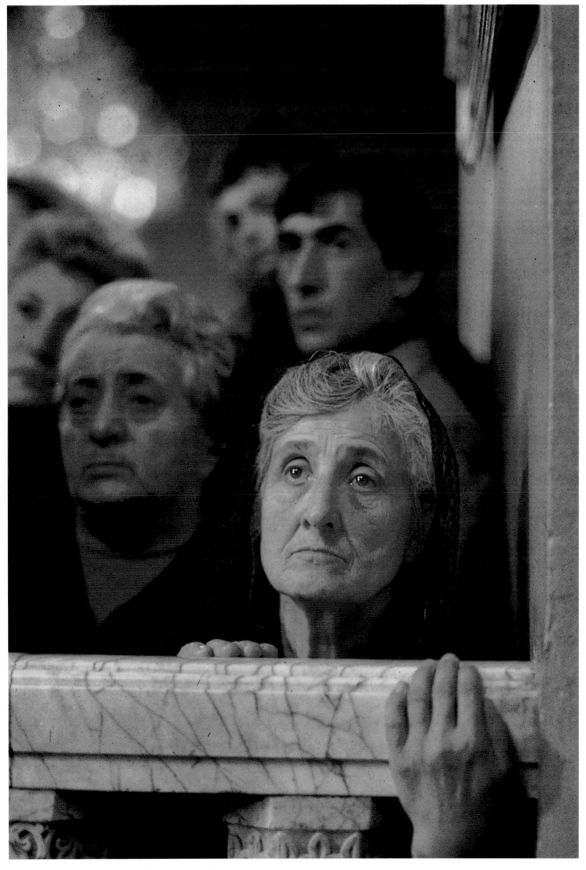

A year after a devastating earthquake, Armenians find solace for their grief in church. The Soviet republic is slowly rebuilding, but many still live in shacks, without running water.

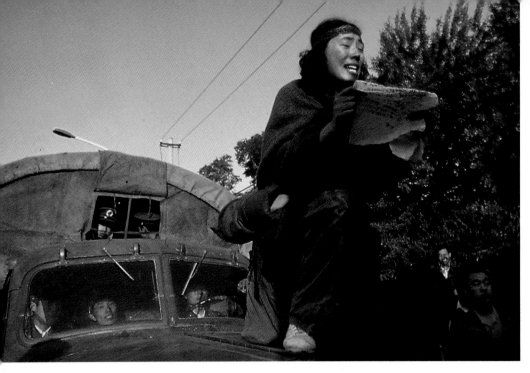

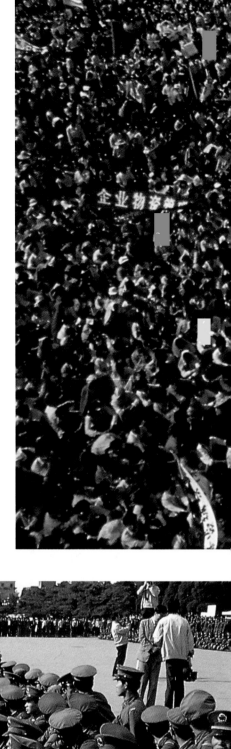

A Chinese woman on the hood of an army truck pleads with the soldiers not to use violence on the students protesting in Tiananmen Square.

Beijing Spring

In April, memorial services for former Communist Party chief Hu Yaobang were turned into political protests by Chinese students who called for democracy and leaders' resignations.

In May, 1,000 students launched a hunger strike in Tiananmen Square to press their demands. Supporters of the students came to the square, until 1 million people were protesting peacefully.

On June 3, the Chinese People's Liberation Army moved against the crowd, shooting indiscriminately. Estimates of the death toll of the "Massacre in Tiananmen Square" range from 300 to 3,000.

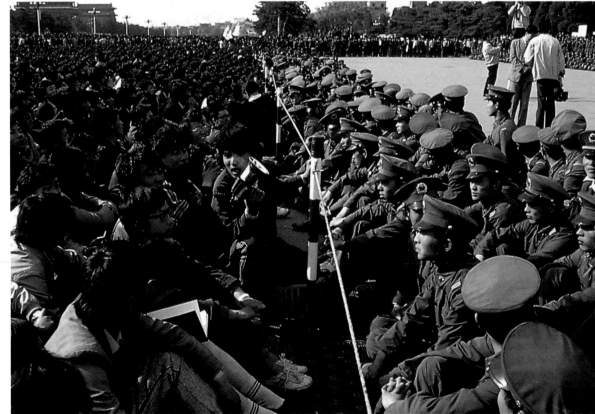

Police and students square off during the funeral of Hu Yaobang in Tiananmen Square.

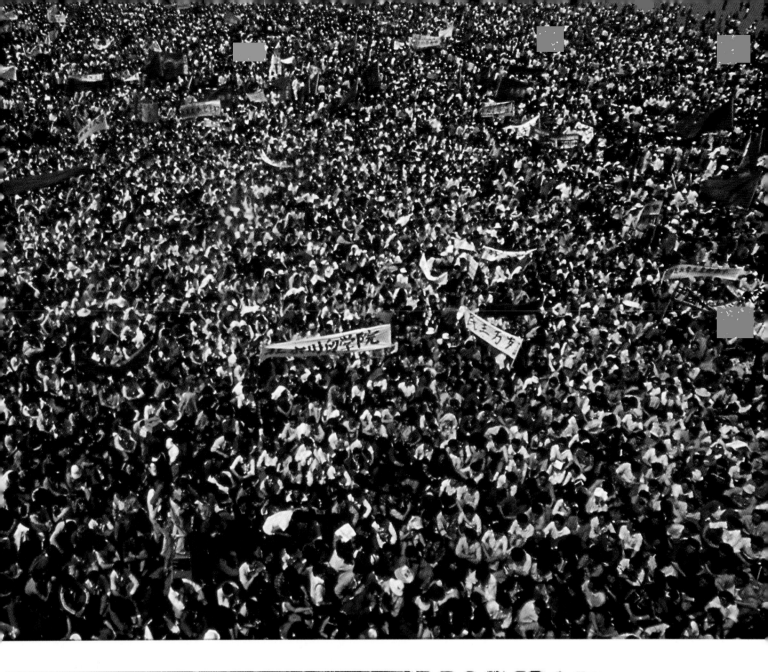

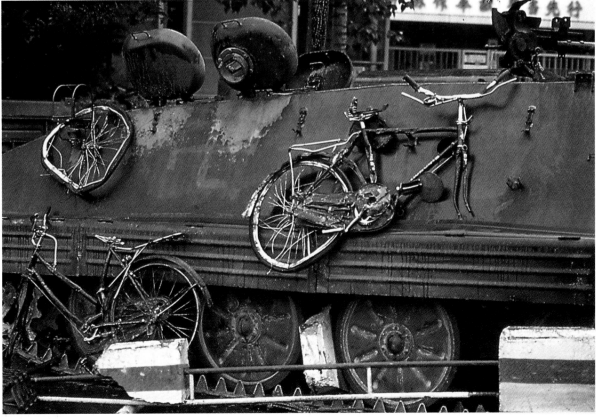

Destroyed bicycles
and a burned tank
are testimony to
the violence.

East Germany: Cry for Freedom

In October, Soviet President Mikhail Gorbachev visited East Germany to celebrate the country's 40th anniversary. At the time, 30,000 East Germans recently had made their way to West Germany, via Hungary, Poland and Czechoslovakia.

Speaking to a crowd in East Berlin, Gorbachev said, "We have heard demands such as the U.S.S.R. should take down the Berlin Wall and then people could believe in peaceful aims. Our Western partners should understand that questions regarding East Germany are not solved in Moscow but in Berlin."

East German leader Erich Honecker, who had run the country for nearly two decades, reaffirmed his hard-line stance and condemned international efforts toward the "destabilization of socialism."

The Berlin Wall stood firm — for one more month.

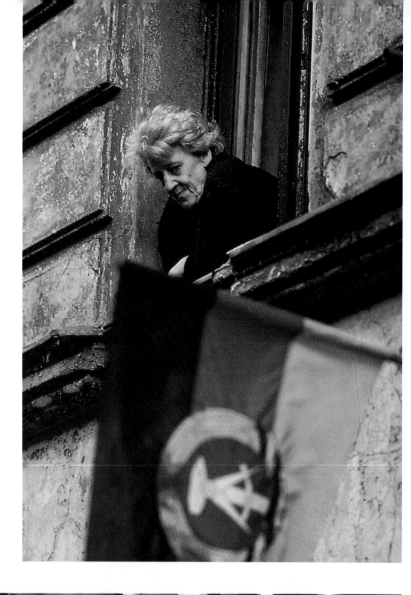

Life in East Berlin before the crack in the Wall: A resident watches the goings-on of a neighborhood; troops parade for the visiting Soviet president.

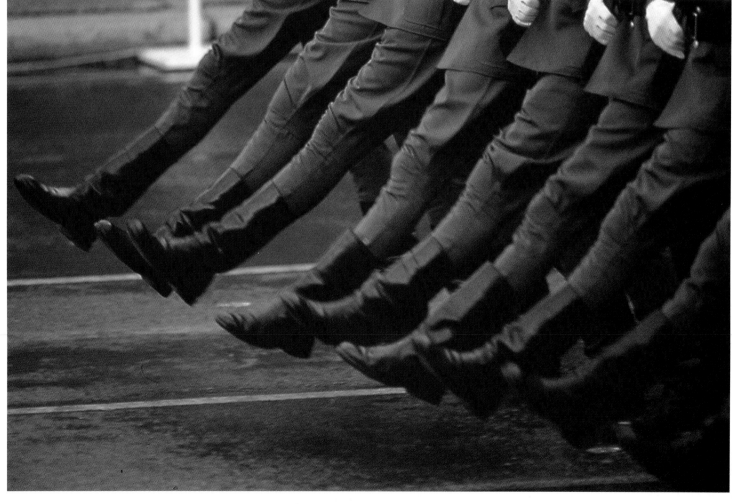

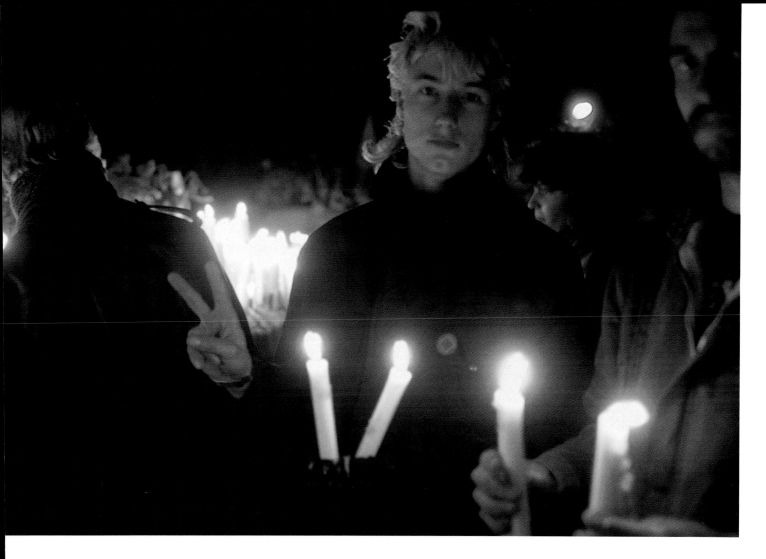

Protesters hold a candlelight vigil for democracy in East Berlin. After the official opening of the Berlin Wall, residents begin chipping away at the long-standing symbol of Communism.

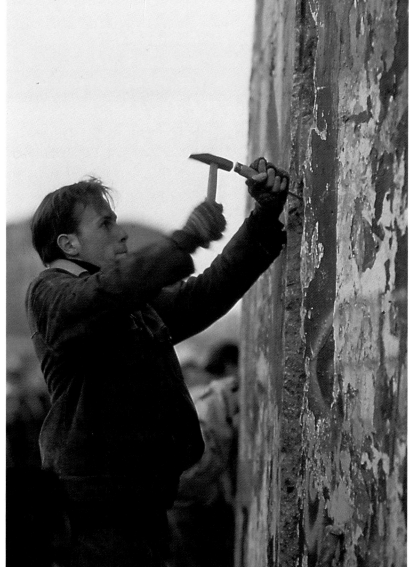

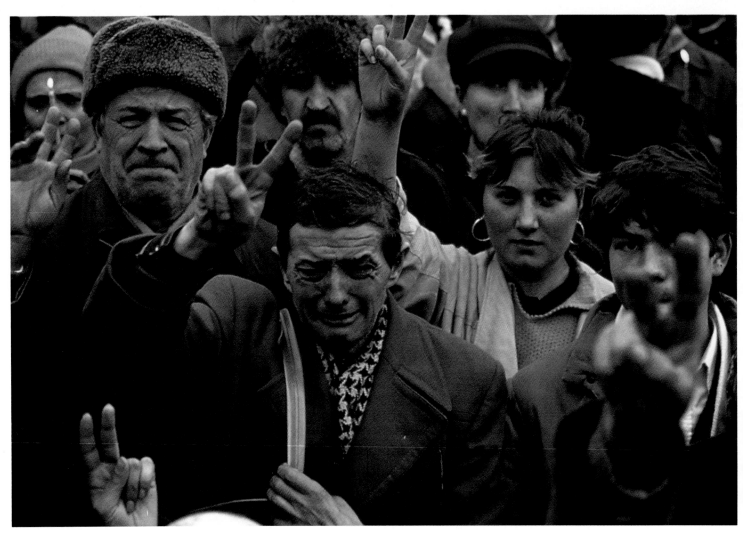

Tears of victory are shed after the popular revolution in Romania that overthrew Nicolae Ceausescu.

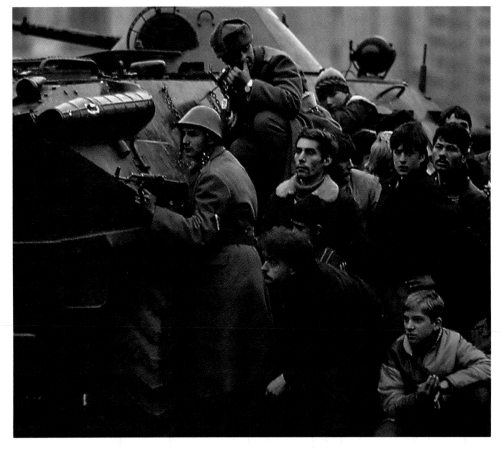

During the revolution, soldiers joined with civilians against Ceausescu's security forces. The National Salvation Committee took power Dec. 22.

Anthony Suau, Black Star

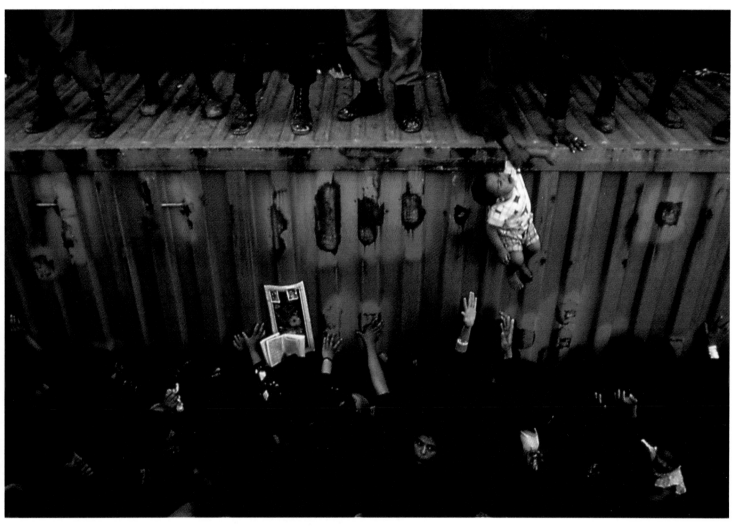

A baby is handed up to one of the soldiers guarding the tomb of the Ayatollah Khomeini in Iran. The soldier then touched the baby to a container near the body of the dead leader.

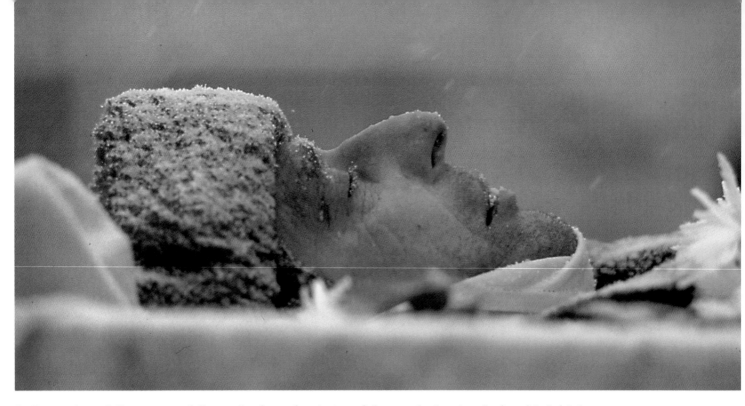

In Romania, a delicate snow falls on the face of a victim of the revolution just before his burial.

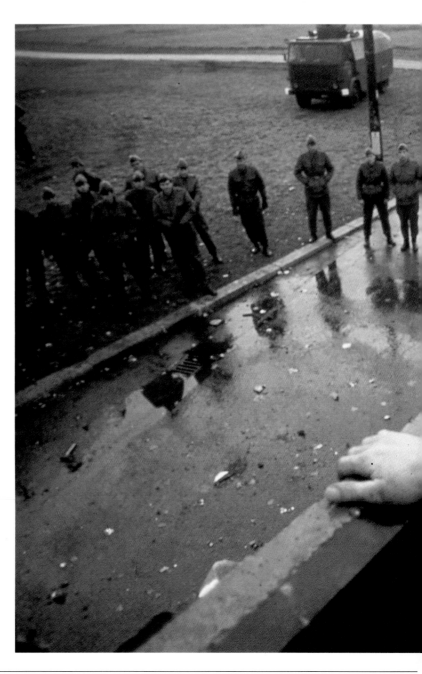

MAGAZINE POY / *ANTHONY SUAU, 3RD PLACE*

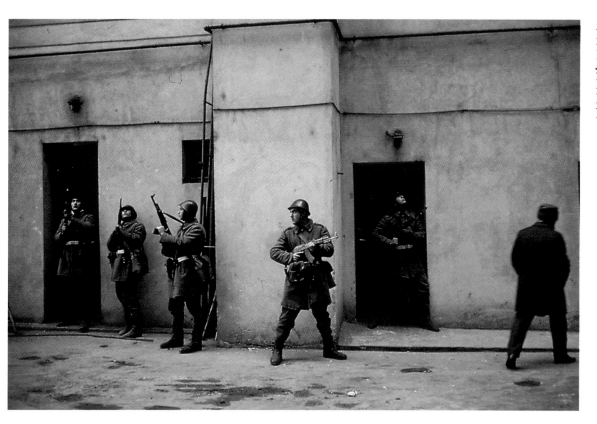

After most of the fighting subsides, Romanian soldiers search house to house for forces still loyal to slain leader Nicolae Ceausescu.

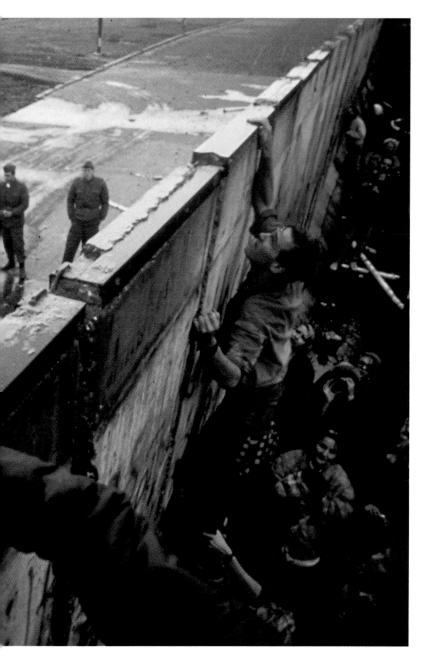

West Germans climb the Berlin Wall.

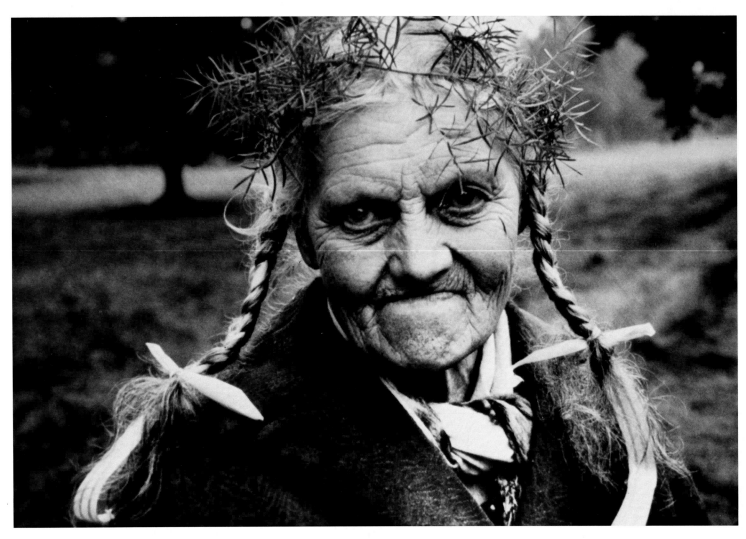

A woman wears a crown of thorns during a religious pilgrimage in Kalwaria, Poland.

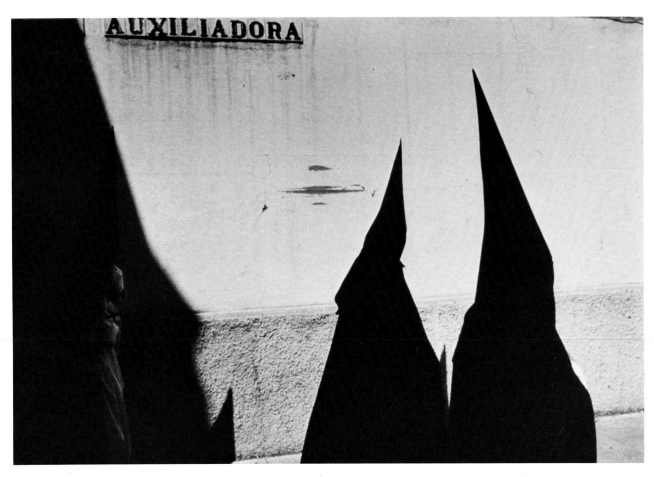

Men in Seville, Spain, wear hoods to hide their identities as they do penance during Holy Week.

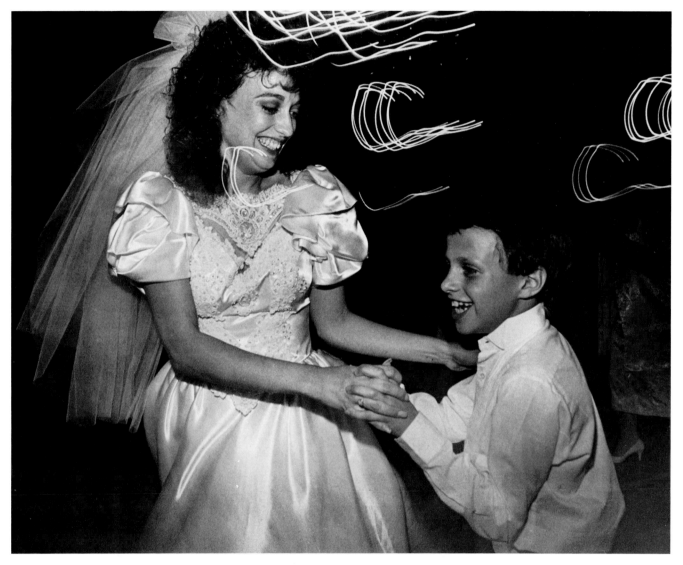

Mari-Lynn Hryskanich dances with her son, Craig, at her wedding reception.
APRIL SAUL, THE PHILADELPHIA INQUIRER, 1ST PLACE

Remarried . . . with children

Every day in America, 1,300 new stepfamilies are formed. Last summer, the Walkowitz children gained two new step-parents and five new stepsiblings. Their father, Alan, married Diana Banfield in May and their mother, Mari-Lynn, tied her second knot in July, with Frank Hryskanich.

Now Keith, Craig and Nicole live with Mari-Lynn and Frank in Sayreville, N.J. Twice a month, their stepbrother, 14-year-old Bryan, and stepsister, 16-year-old Dawn, visit from Bergen County.

In Edison Township, Alan and Diana live with her 18-year-old son, Kenneth, and are visited by Keith, Craig and Nicole several times a month. Diana's other children, John, 19, and Pamela, 21, live on their own.

The logistics of the extended stepfamily are complicated, but in this the Walkowitzes and Hryskaniches are not alone. There are almost 4.5 million stepfamilies in the United States, and almost 7 million children are living with a stepparent.

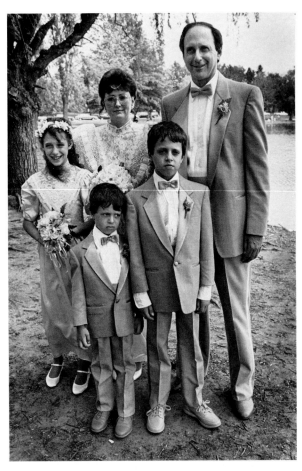

Alan Walkowitz and his bride, Diana, with his children, Nicole, 11, Keith, 5, and Craig, 9.

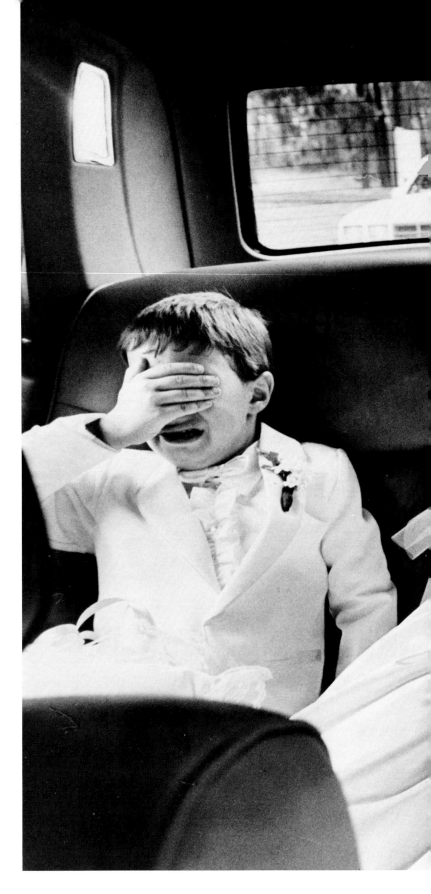

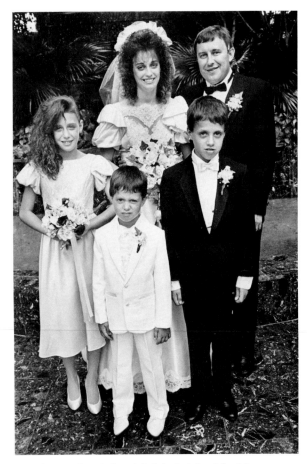

Frank Hryskanich with his bride, Mari-Lynn, and her children, Nicole, Keith and Craig.

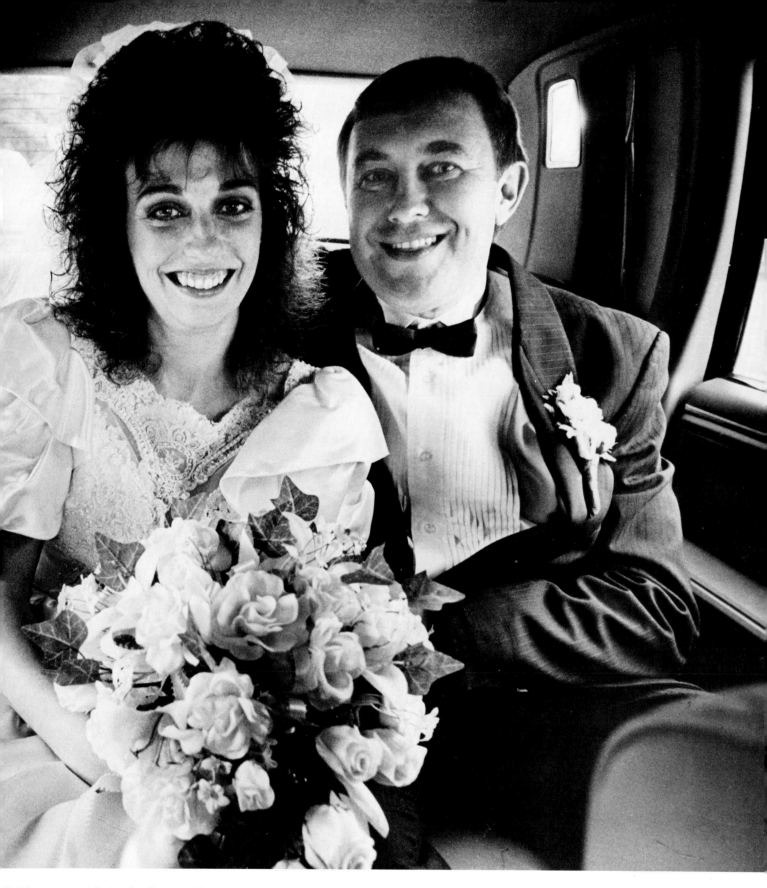

Keith gets to ride in the limo with mom and stepdad.

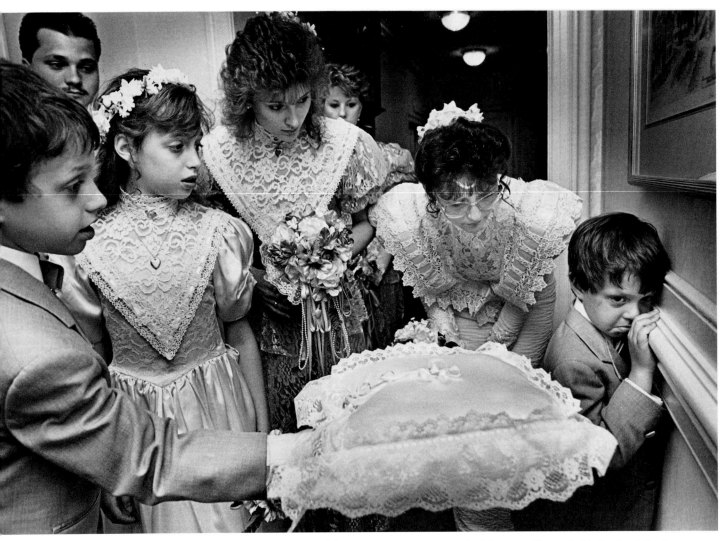

Keith refuses to be ring bearer for his father's wedding. Trying to persuade him are (from left) Craig, Nicole, Pamela and Diana. Keith ended up watching the ceremony through a window.

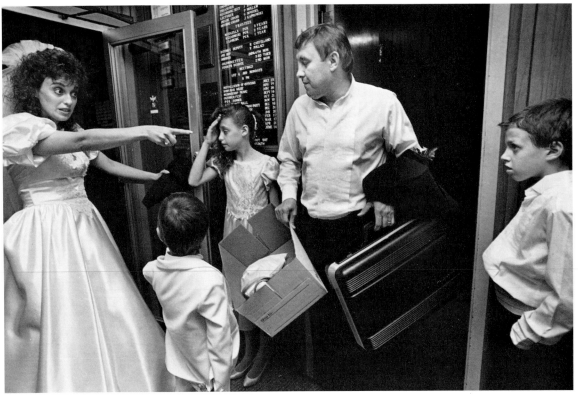

As Mari-Lynn's reception ends, she realizes her children forgot their street clothes.

NEWSPAPER FEATURE PICTURE STORY / *APRIL SAUL, 1ST PLACE*

Frank videotapes his stepdaughter Nicole's elementary-school graduation while his wife, Mari-Lynn, chats with her ex-husband, Alan. The two men are on such good terms that Alan asked Frank to be his best man. Frank declined, however, because Diana and Mari-Lynn are not on speaking terms.

Chantara Nop (left) celebrates with Vandeth Nal, a friend from Long Beach, as he nears his destination.

Return to the killing fields

When the Khmer Rouge took over Phnom Penh in 1975, Chantara Nop was a university student, planning a future as a teacher. Because educated people were killed, he changed his name and pretended to be an ice cream vendor. He spent the next four years laboring on a mobile work crew, existing on rice soup.

After the Vietnamese overthrew the leader of the Khmer Rouge, Nop returned to his village to learn that his four brothers had been executed.

His opposition to the Vietnamese regime soon forced him to flee the country. In 1989, Nop took the risk of returning to Phnom Penh to see his mother. "I don't care about my life," he said, "I just want to see her."

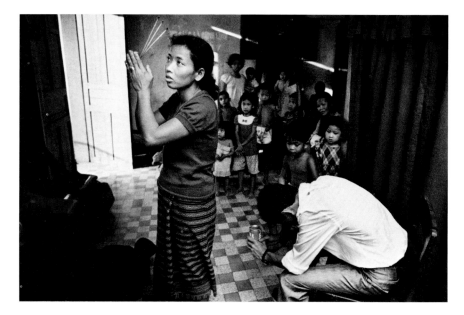

As his sister, Bopriek, offers a prayer to a Buddhist shrine, Nop agonizes over news that his extended family, having waited 10 days for his arrival, had returned to their villages the day before.
BRUCE CHAMBERS, LONG BEACH (CALIF.) PRESS-TELEGRAM
2ND PLACE

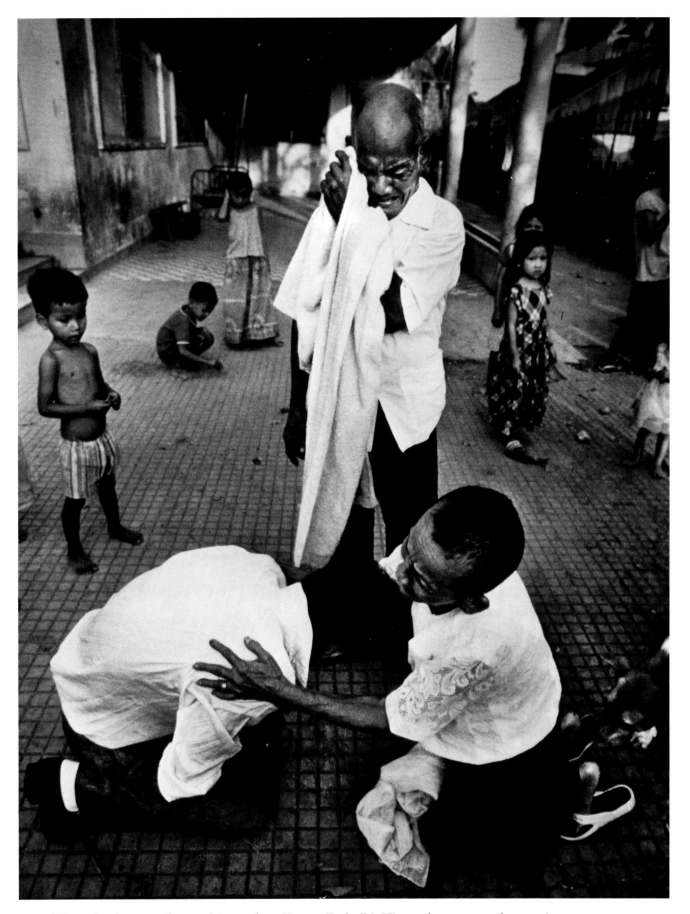

Nop falls to his knees to honor his mother, Young Trak, 76. His uncle weeps at the reunion.

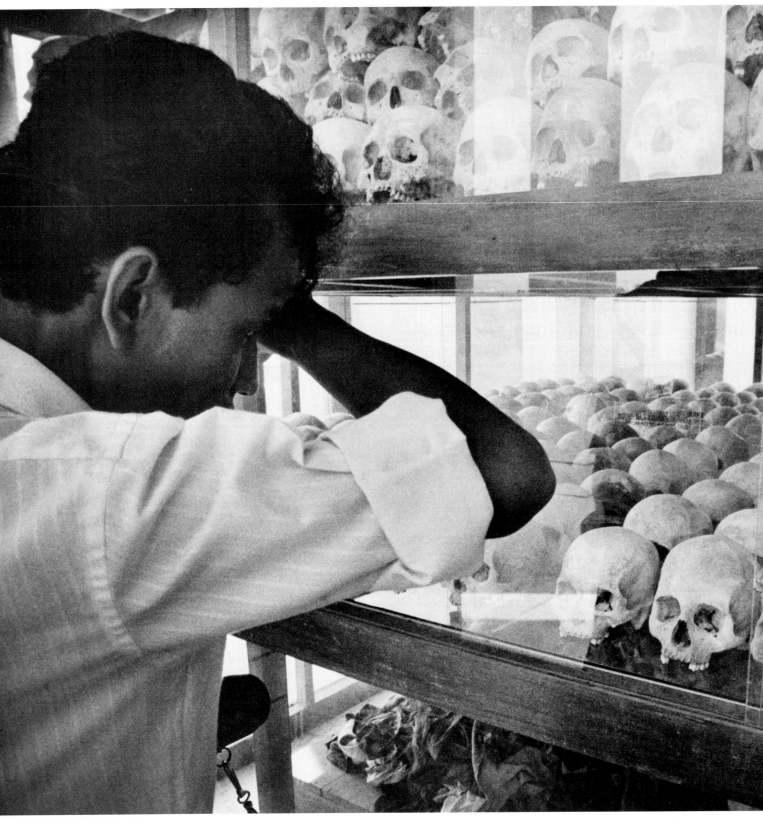

On a visit to the killing fields at Choeung Ek outside Phnom Penh, Nop realizes that any of the 8,985 skulls at the site could be one of his brothers, who were killed by the Khmer Rouge. The skulls are stacked in an 80-foot-high case.

NEWSPAPER FEATURE PICTURE STORY / *BRUCE CHAMBERS, 2ND PLACE*

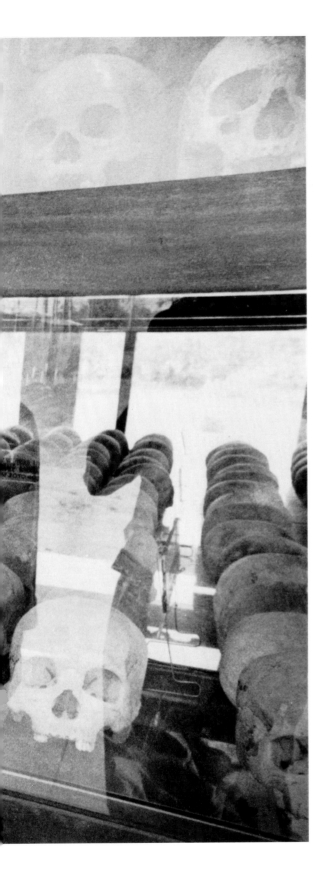

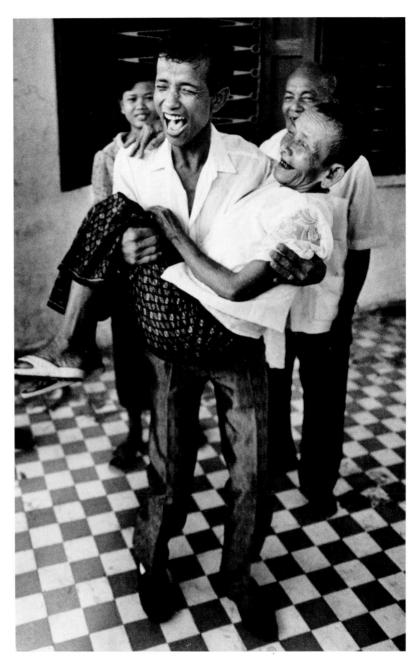

After the tears of joy dry, Nop clowns for a home video with his mother. These were the first family photos he had.

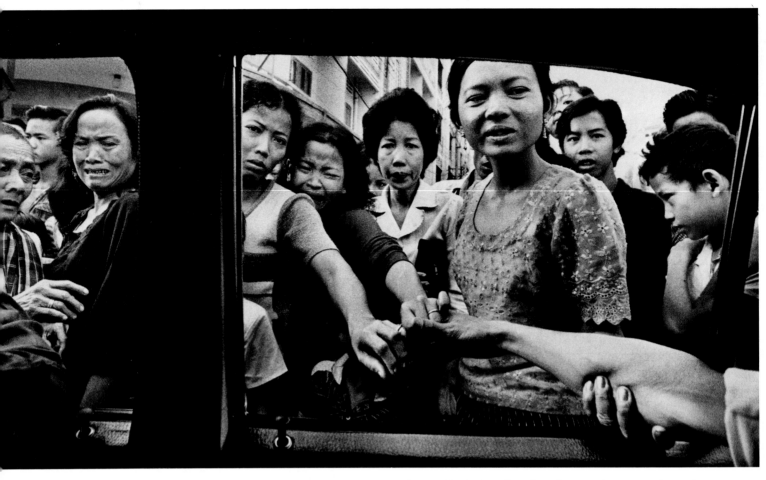

As Nop leaves, his sisters Bopriek and Narin grasp his hand in farewell while other family members stand nearby.

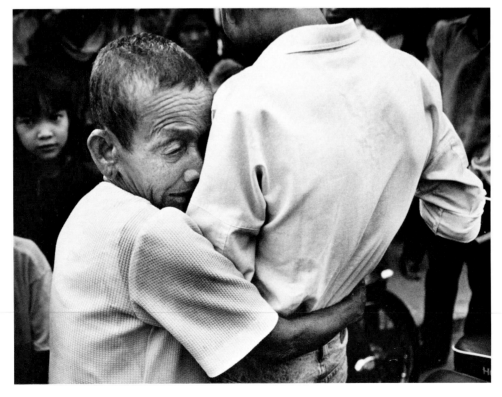

Young Trak gives her only living son a final embrace.

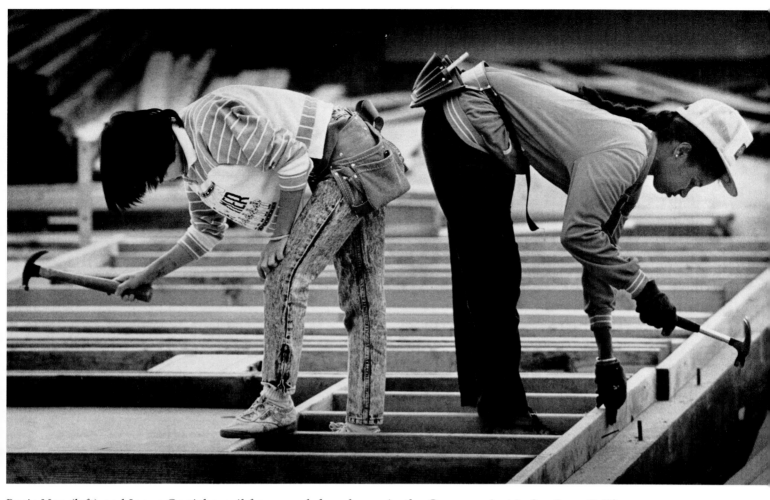

Rosie Ngo (left) and Japan Goniche nail framework for a house in the Guapa project in San Jose, Calif.

Sweat equity

The median price of a home in Santa Clara County, Calif., is around $230,000, which translates to mortgage payments of $2,000 per month for an average home buyer. Such facts do not bode well for the American Dream. PACT, People Acting in Community Together, decided to help some families overcome the facts and realize their slice of that dream.

Financing was acquired for land and construction materials, and 29 families were chosen to build Luke Court. Each family had to work a minimum of 40 hours a week on the Guapa project, in addition to their own jobs.

The Guapa project came in on budget, only two months later than scheduled.

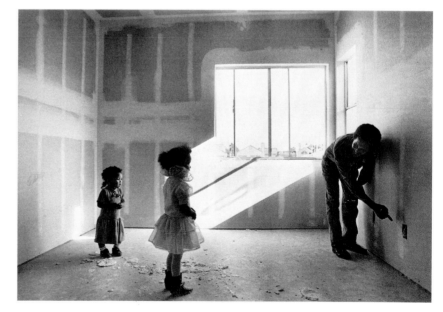

Isaac Berhe explains electricity to his daughters, Sened, 2, (left) and Segen, 4, in what will be their house in Luke Court.
JIM GENSHEIMER, SAN JOSE (CALIF.) MERCURY NEWS
3RD PLACE

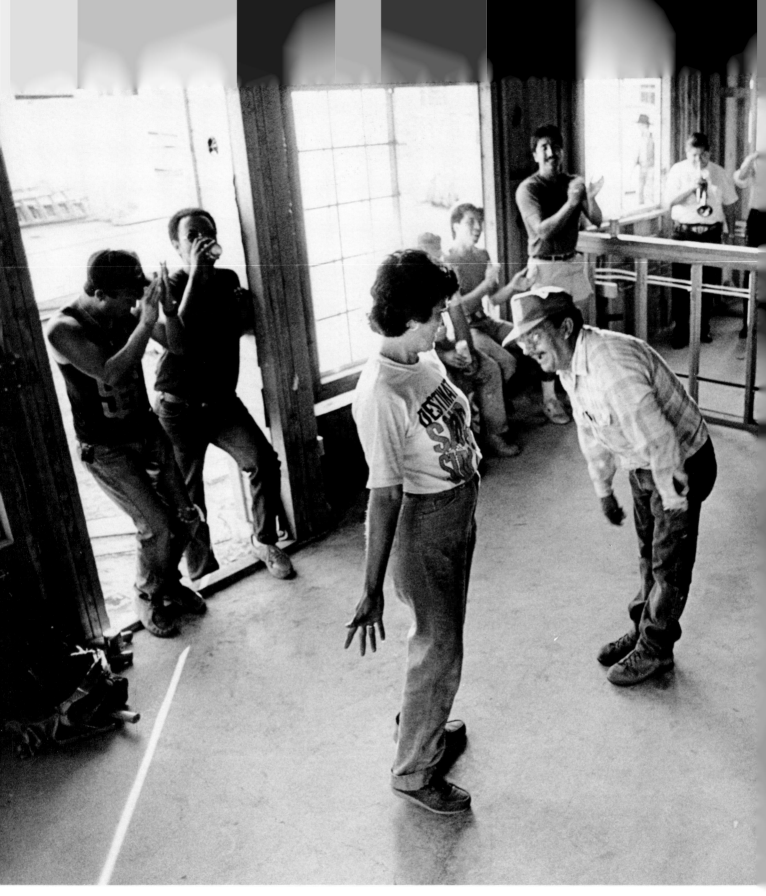

Apolonia Castruita and Guillermo Ibarra take a bow after dancing at a birthday party in what will be Ibarra's home.

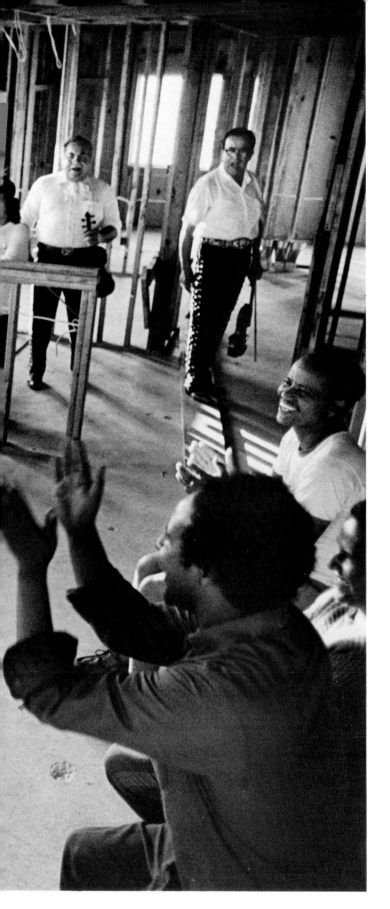

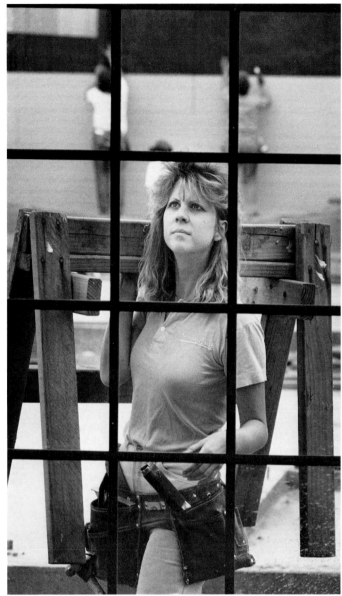

Christina Ortiz inspects a window her crew installed.

Estela Rios walks in the cul-de-sac of Luke Court.

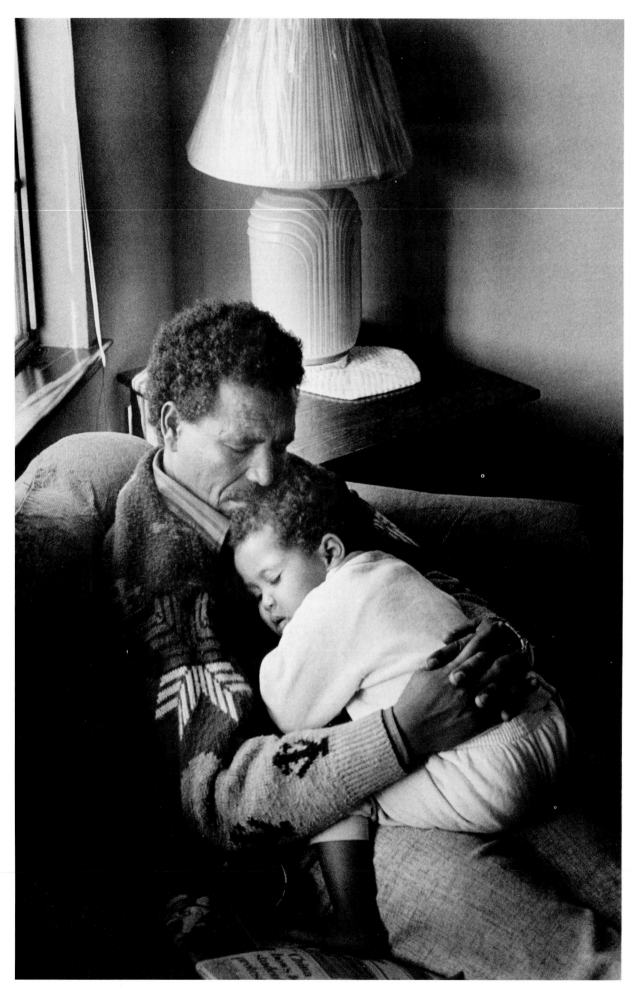

Isaac Berhe and his daughter, Sened, take a nap in their new home.

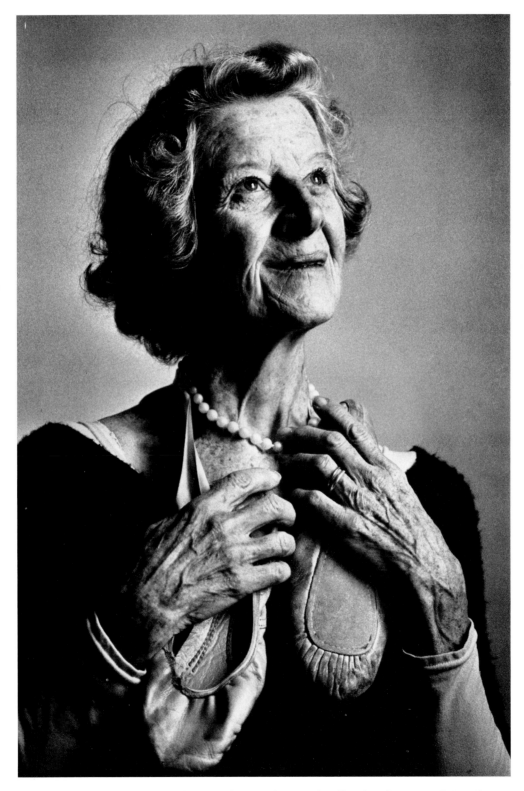

Charlotte Stinger, 79, a student at the Academy of Ballet, has been studying dance for 28 years.
LLOYD FOX, THE PHILADELPHIA INQUIRER, 2ND PLACE

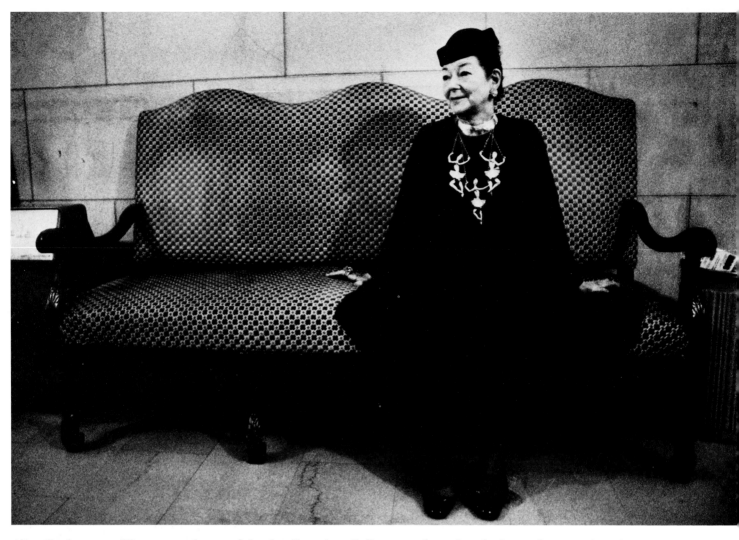

Alice Cushman, a 39-year employee of the San Francisco Ballet, rests from her duties as doorman's assistant.
PAT GREENHOUSE, THE OAKLAND TRIBUNE, 1ST PLACE

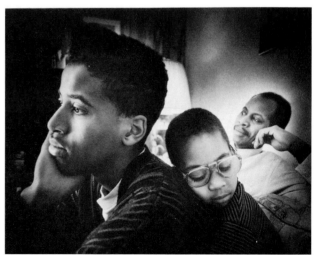

Despite the rise of violence in the Roxbury district of Boston, the Cornick family holds together.
YUNGHI KIM, THE BOSTON GLOBE
AWARD OF EXCELLENCE

Camera collector Bill Arps with his 1910 Folmer & Schwing.
DAVID ROGOWSKI,
THE FAIRFAX (VA.) JOURNAL
AWARD OF EXCELLENCE

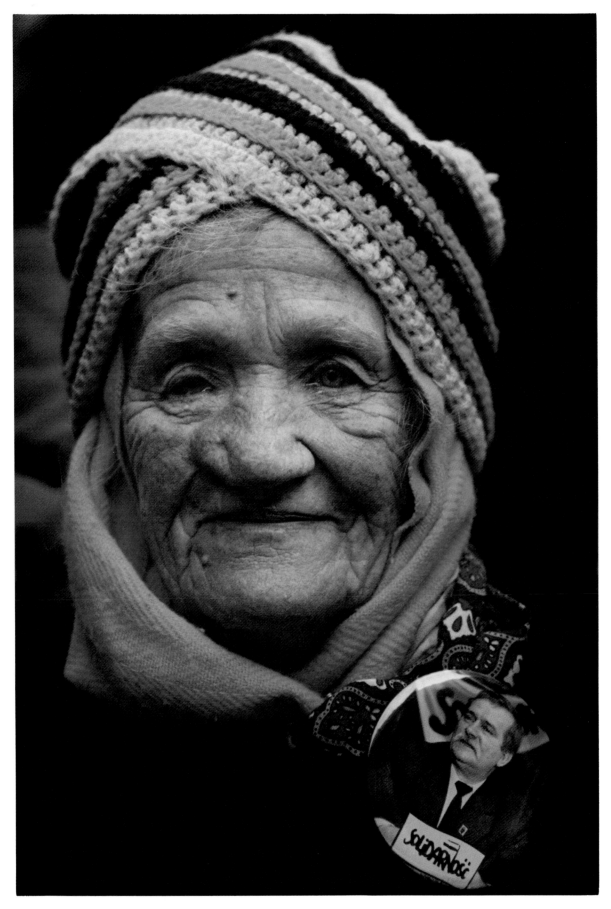

Victoria Kubal, a Chicago resident born in Poland, awaits the appearance of Solidarity leader
Lech Walesa at a rally in Daley Plaza.
RICHARD A. CHAPMAN, CHICAGO DAILY HERALD/SUN-TIMES, 3RD PLACE

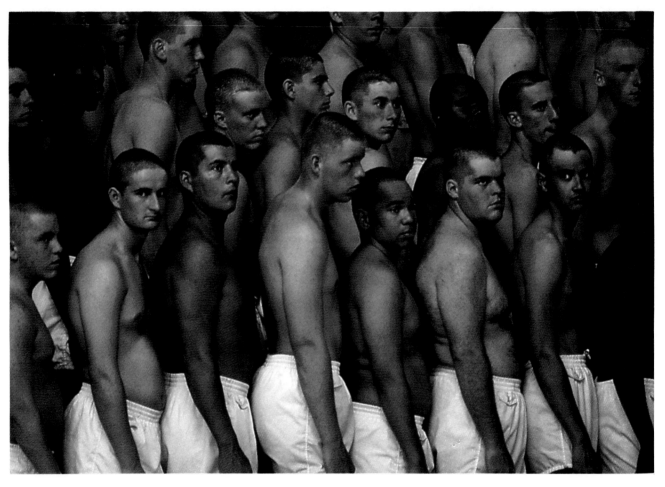

Sailors during the second day of boot camp line up for their swimming test.
KAREN KASMAUSKI FOR NATIONAL GEOGRAPHIC, 2ND PLACE

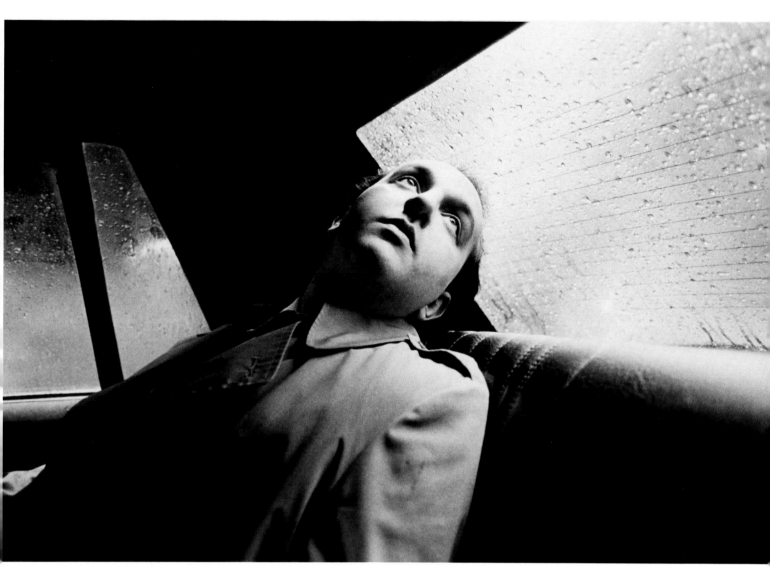

A Citibank executive rides a taxi home after another wearying day.
DILIP MEHTA FOR FORTUNE MAGAZINE, 1ST PLACE

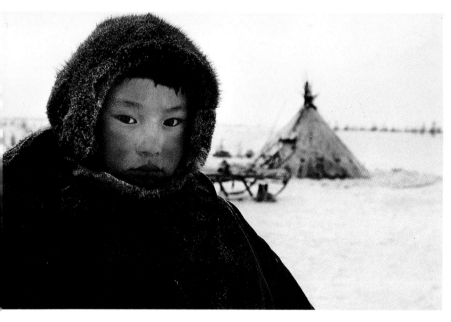

A Nentsy child, bundled against the sub-zero Arctic cold, stands in front
of a tepee made from reindeer hide.
STEVEN L. RAYMER FOR NATIONAL GEOGRAPHIC
AWARD OF EXCELLENCE

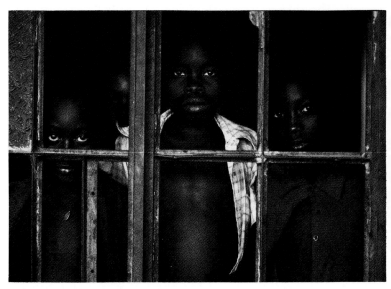

Orphans of AIDS victims live in an abandoned house in a small village in Uganda.
JOANNA B. PINNEO FOR THE COMMISSION MAGAZINE
AWARD OF EXCELLENCE

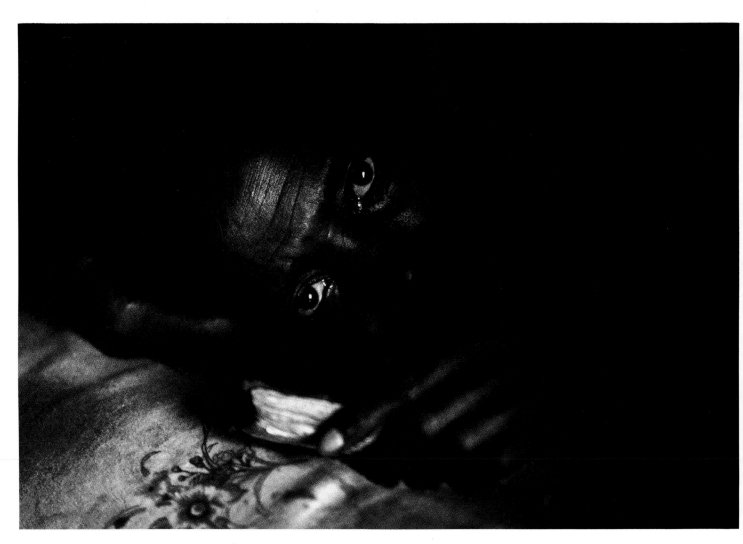

An AIDS victim lies dying in her bed in southwest Uganda, where the population has tested 30 percent positive for HIV.
JOANNA B. PINNEO FOR THE COMMISSION MAGAZINE, 3RD PLACE

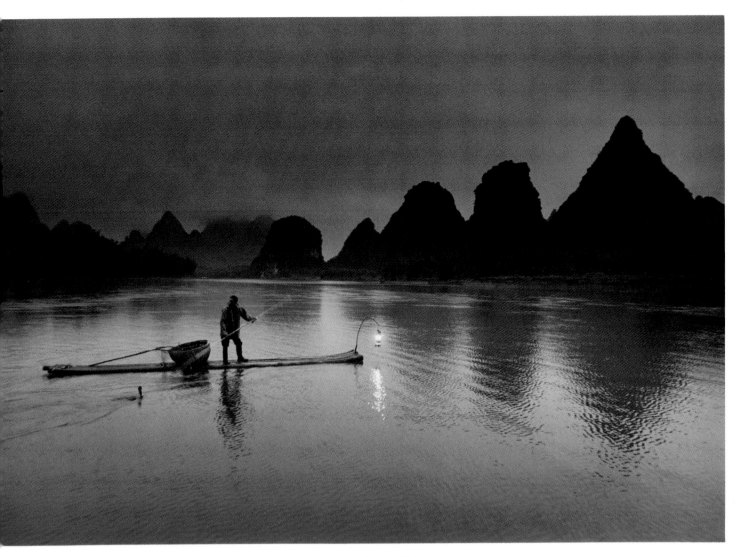

Li Pang makes his way home after a night of fishing in Yangshou, China.
BRADLEY E. CLIFT, THE HARTFORD (CONN.) COURANT, 2ND PLACE

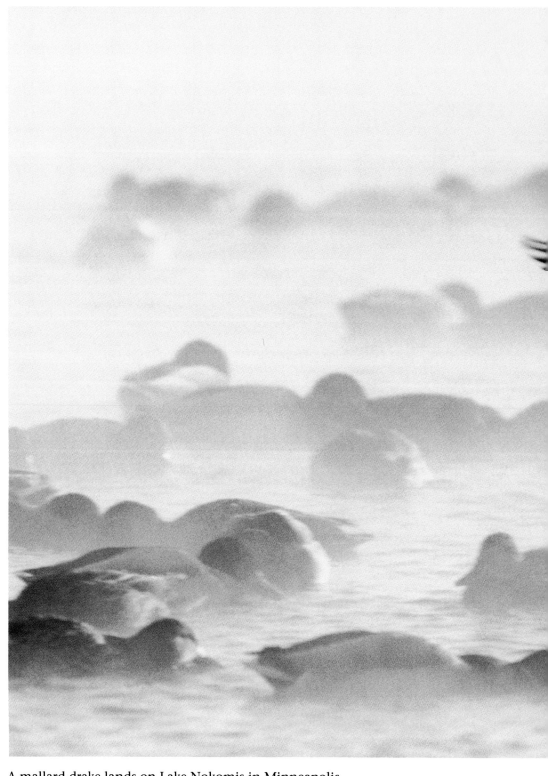

A mallard drake lands on Lake Nokomis in Minneapolis.
JEFF WHEELER, STAR TRIBUNE NEWSPAPER OF THE TWIN CITIES, *3RD PLACE*

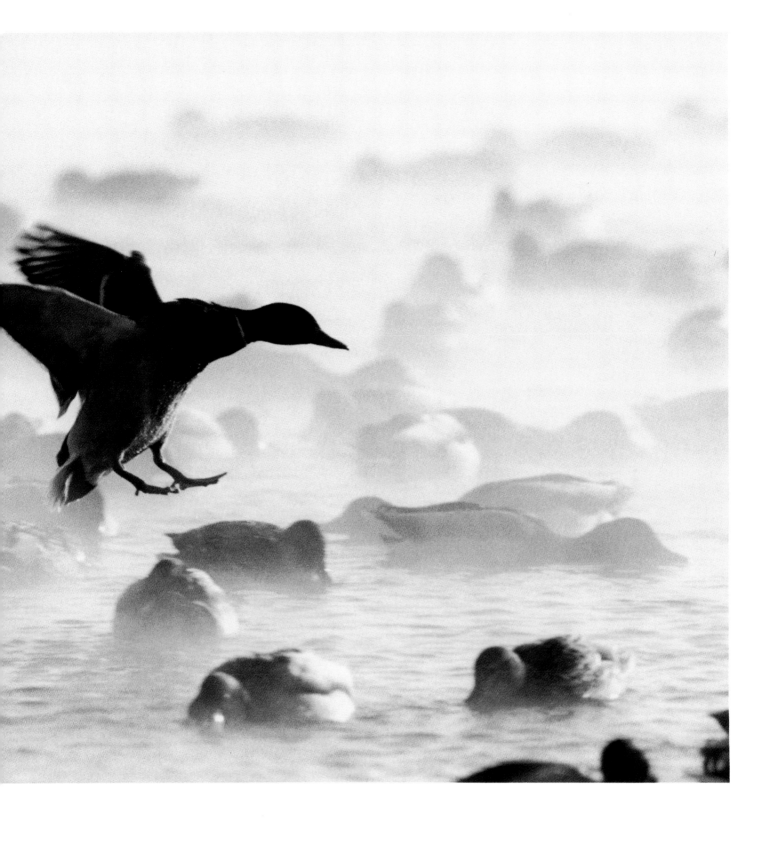

A sentry guards the Kremlin gate in Moscow.
NADIA BOROWSKI, THE ORANGE COUNTY (CALIF.) REGISTER, 1ST PLACE

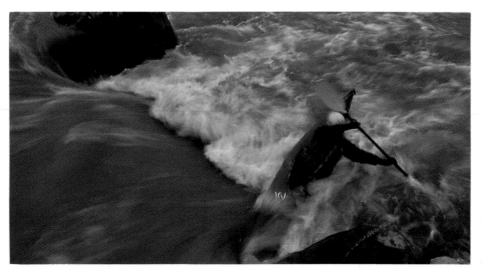

A kayaker negotiates the rapids of the Rappahannock River in Virginia.
ROBERT A. MARTIN, THE FREDERICKSBURG (VA.) FREE LANCE-STAR AWARD OF EXCELLENCE

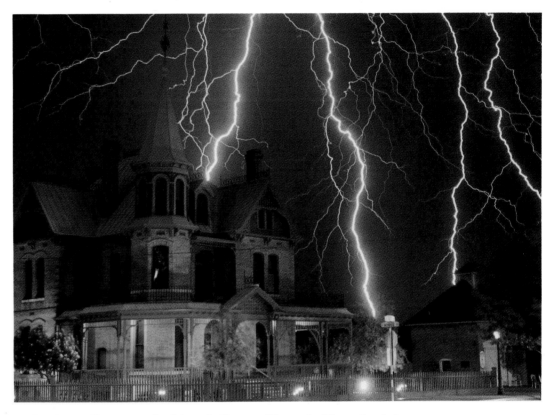

Lightning strikes over the historic Rosson House in Phoenix, Ariz.
MICHAEL CHOW, THE PHOENIX (ARIZ.) GAZETTE
AWARD OF EXCELLENCE

Trout fishermen enjoy the tranquility of Black Rock Pond in Middlefield, Conn.
JOE TABACCA, THE HARTFORD (CONN.) COURANT
AWARD OF EXCELLENCE

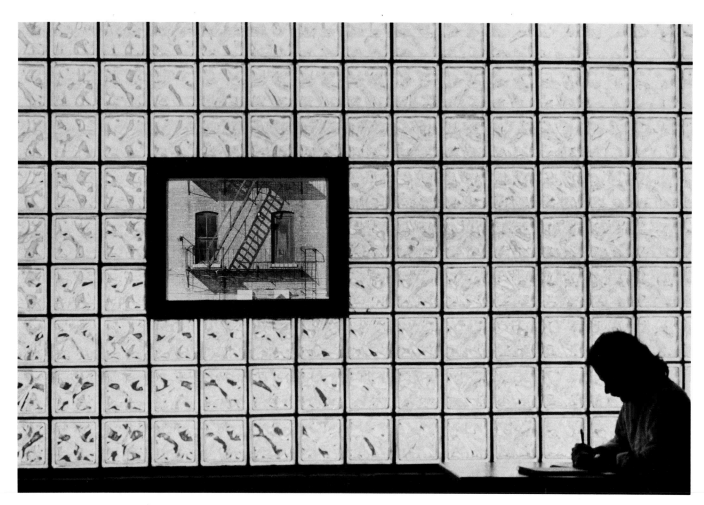

What appears to be a picture on the wall of a cafe is really a window showing a nearby building.
BOB THAYER, THE PROVIDENCE (R.I.) JOURNAL-BULLETIN
AWARD OF EXCELLENCE

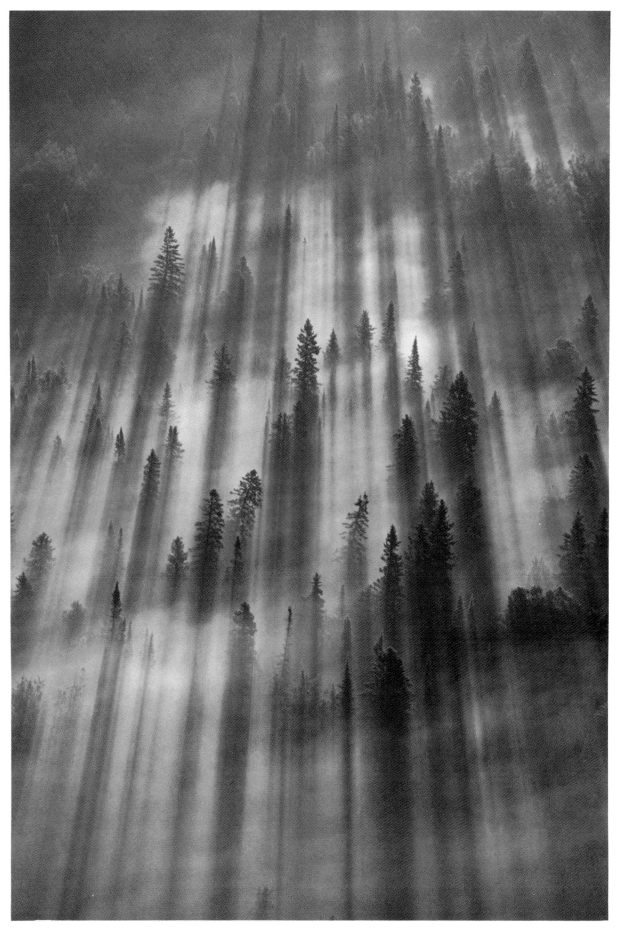

Dawn pierces a heavy fog in the Superior National Forest in northern Minnesota.
ANNIE GRIFFITHS BELT, NATIONAL GEOGRAPHIC
1ST PLACE

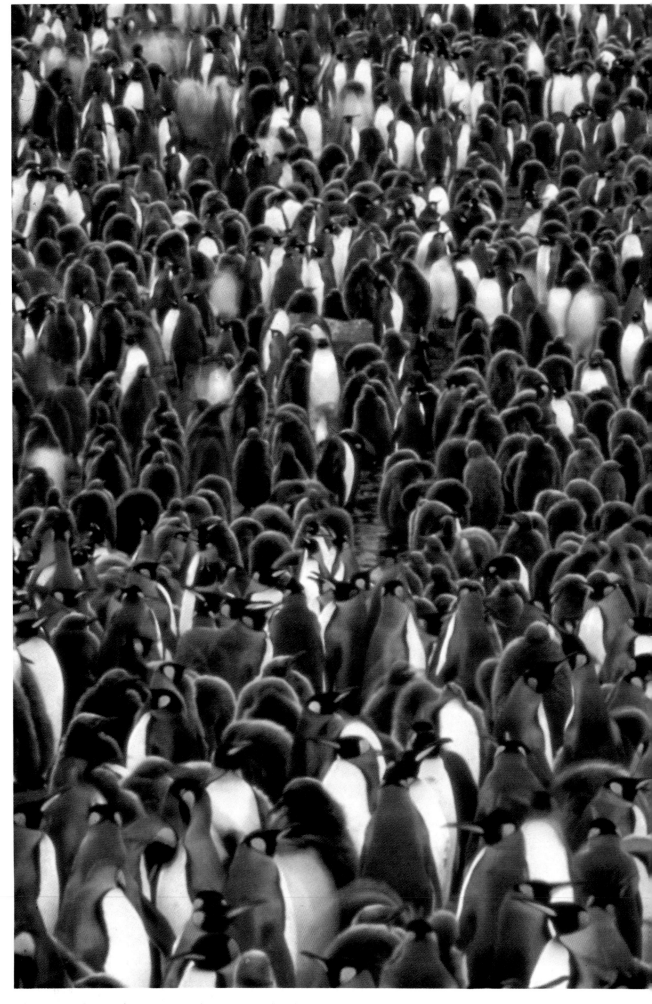

A King penguin colony on South Georgia Island.
FRANS LANTING, NATIONAL GEOGRAPHIC
2ND PLACE

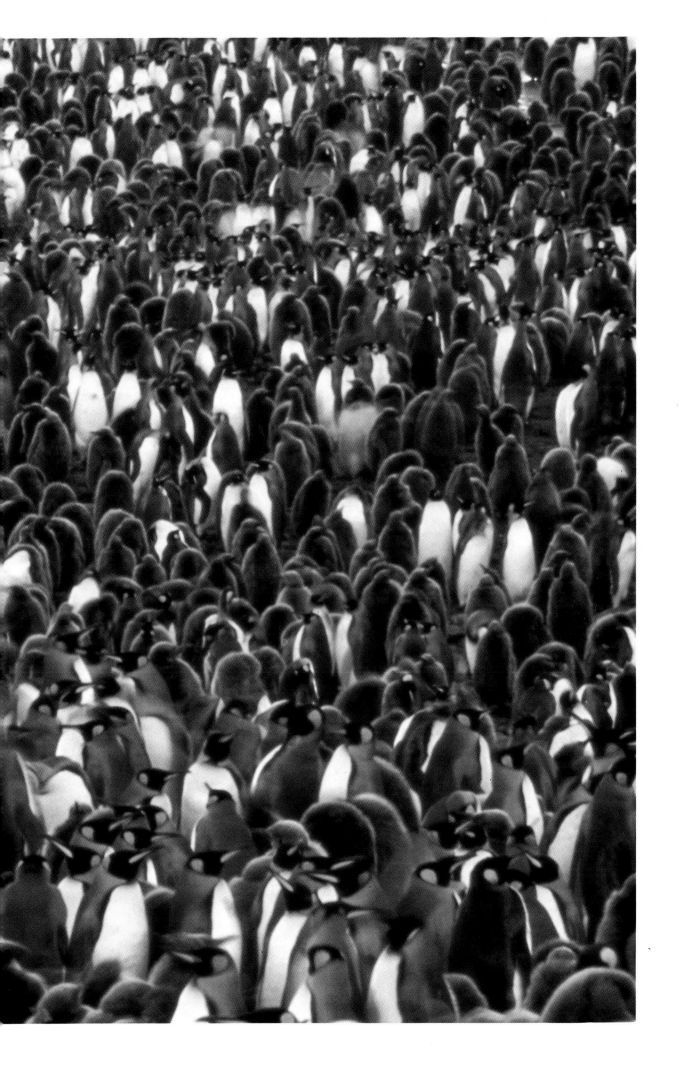

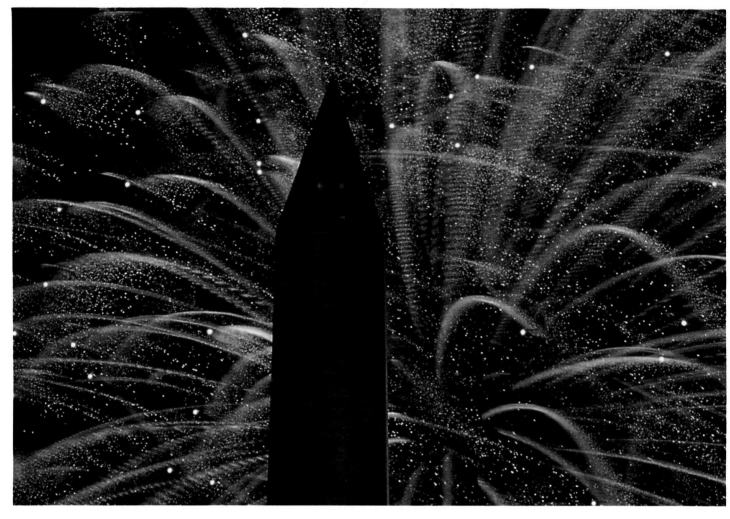

Fireworks explode over the Washington Monument on the Fourth of July.
PETE SOUZA, FREELANCE
3RD PLACE

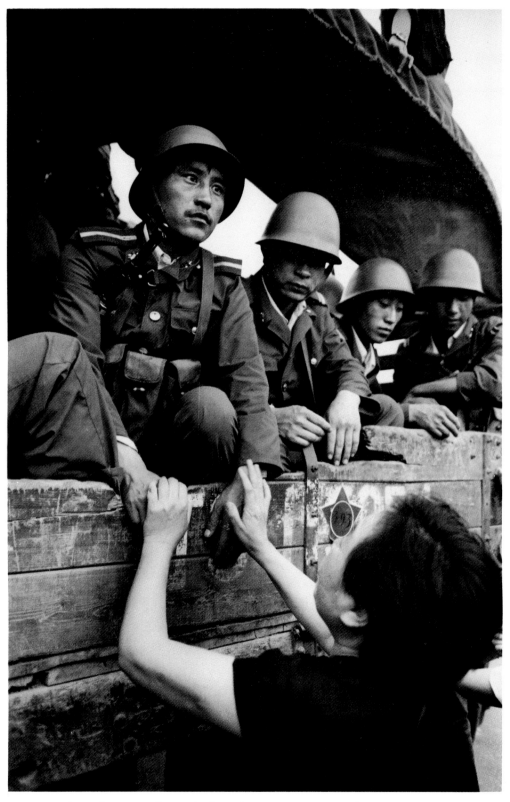

A woman begs for peace hours before the June massacre of protesters in Beijing.
DAVID C. TURNLEY, DETROIT FREE PRESS, 2ND PLACE, GENERAL

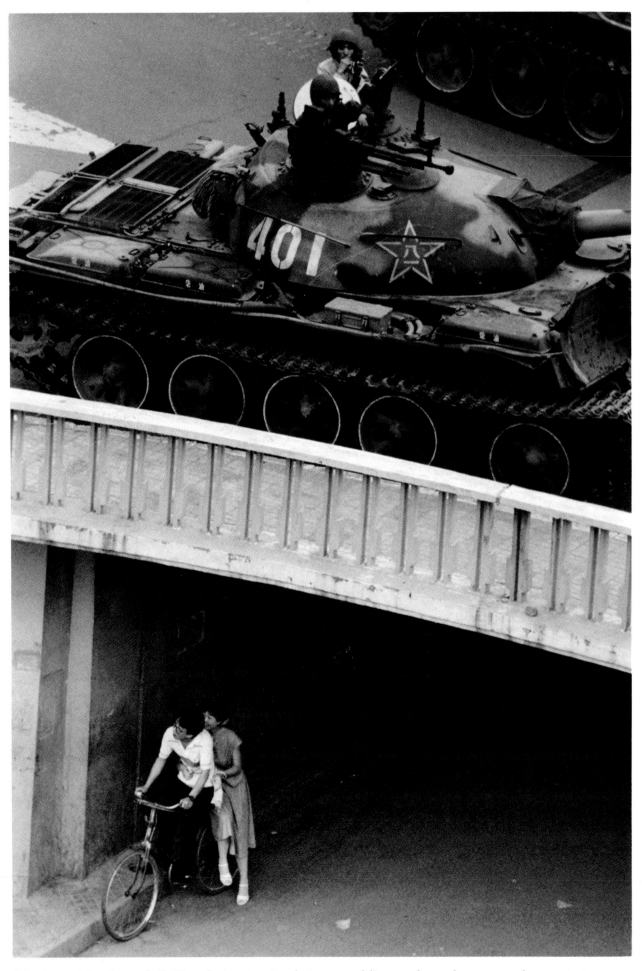

A tank rumbles through Beijing during tension between soldiers and pro-democracy demonstrators.
LIU HEUNG SHING, THE ASSOCIATED PRESS, 3RD PLACE, SPOT

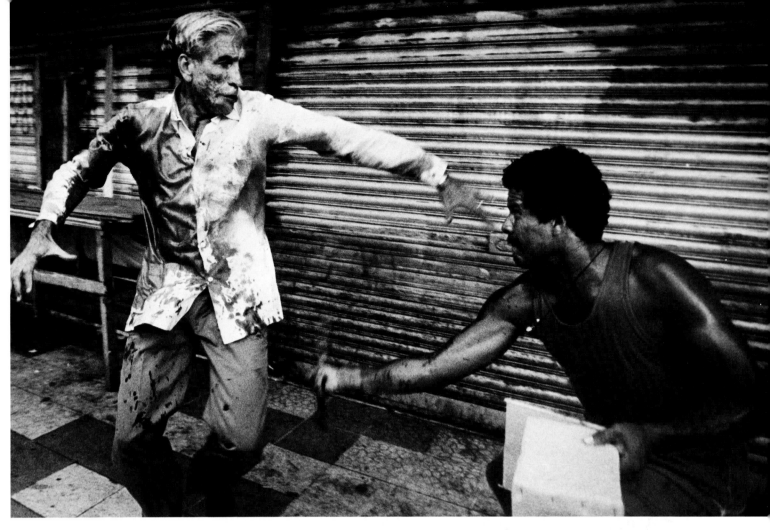

Panamanian vice-presidential candidate Guillermo Ford is battered by one of Gen. Manuel Antonio Noriega's thugs.
LES STONE, REUTERS, 1ST PLACE, SPOT

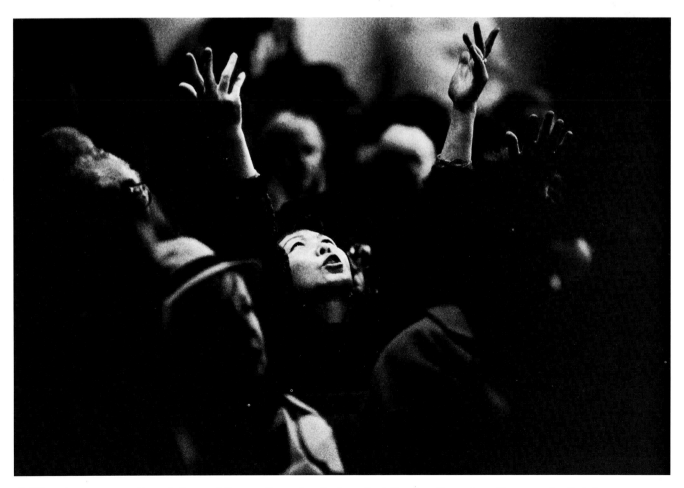

Californians mourn the victims of the earthquake that rocked the San Francisco Bay area in October.
ANGELA C. PANCRAZIO, THE OAKLAND (CALIF.) TRIBUNE, 1ST PLACE (TIE), GENERAL

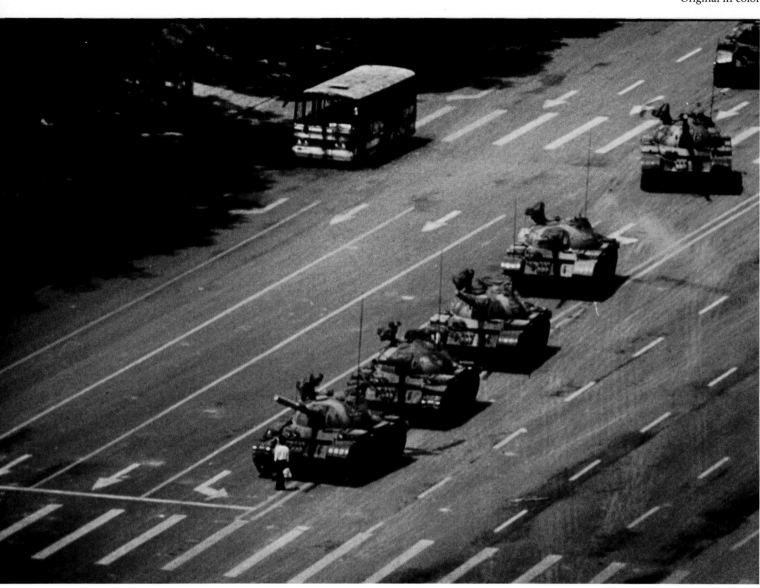

A lone student briefly halts the progession of violence during a crackdown on pro-democracy demonstrators in Beijing.
STUART FRANKLIN, MAGNUM, 3RD PLACE, SPOT

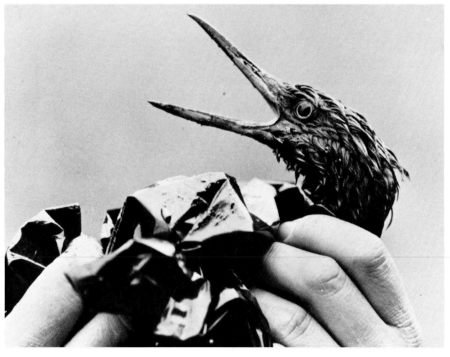

A bird drenched in crude oil from the Exxon Valdez voices its displeasure after being pulled from the oily waters of Alaska's Prince William Sound.
JACK SMITH, THE ASSOCIATED PRESS, AWARD OF EXCELLENCE, SPOT

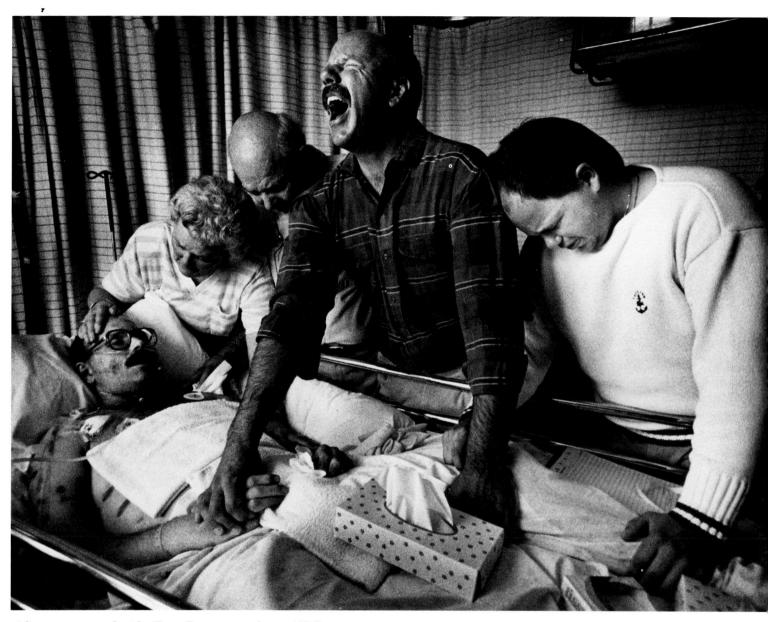

After a two-year battle, Tom Fox succumbs to AIDS.
MICHAEL A. SCHWARZ, ATLANTA JOURNAL-CONSTITUTION, 1ST PLACE (TIE), GENERAL

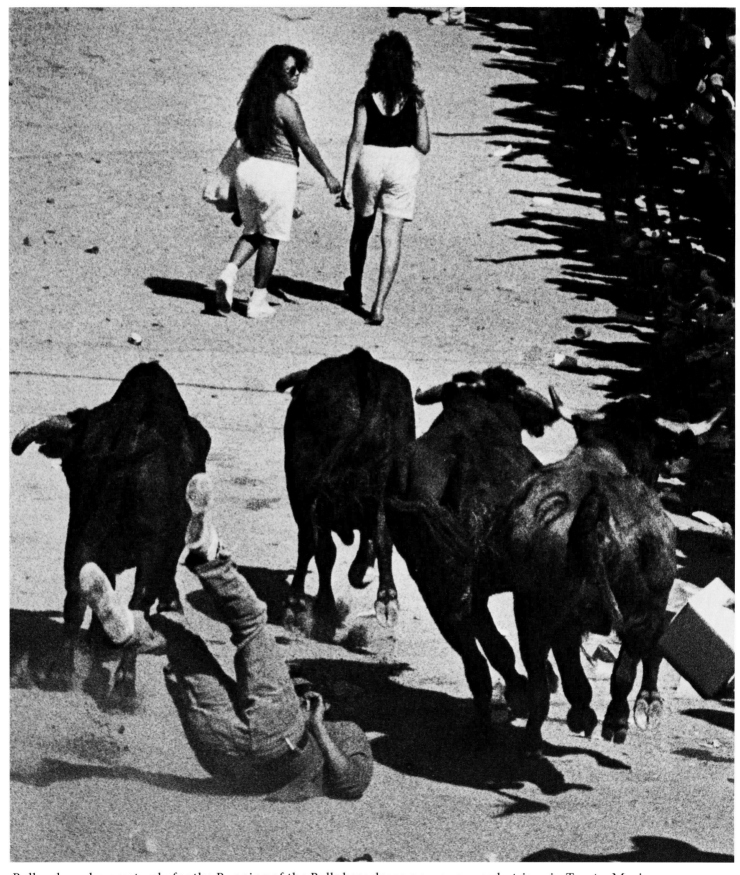

Bulls released prematurely for the Running of the Bulls bear down on unwary pedestrians in Tecate, Mexico.
DAVID MCNEW, FREELANCE, AWARD OF EXCELLENCE, GENERAL

NEWSPAPER SPOT & GENERAL NEWS

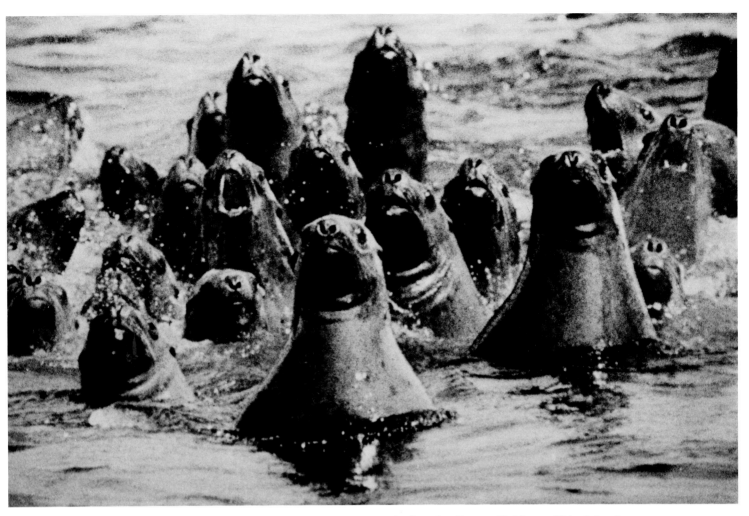

Sea lions bob through Alaska's oil-stained Prince William Sound after the Exxon Valdez spill in March.
JOHN GAPS III, THE ASSOCIATED PRESS, AWARD OF EXCELLENCE, GENERAL

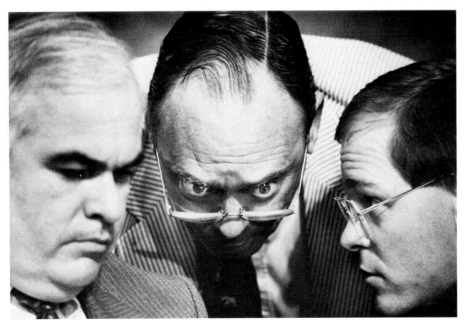

Lawmakers huddle for an impromptu conference during a subcommittee meeting in Florida's House of Representatives.
ALAN YOUNGBLOOD, OCALA (FLA.) STAR-BANNER, AWARD OF EXCELLENCE, GENERAL

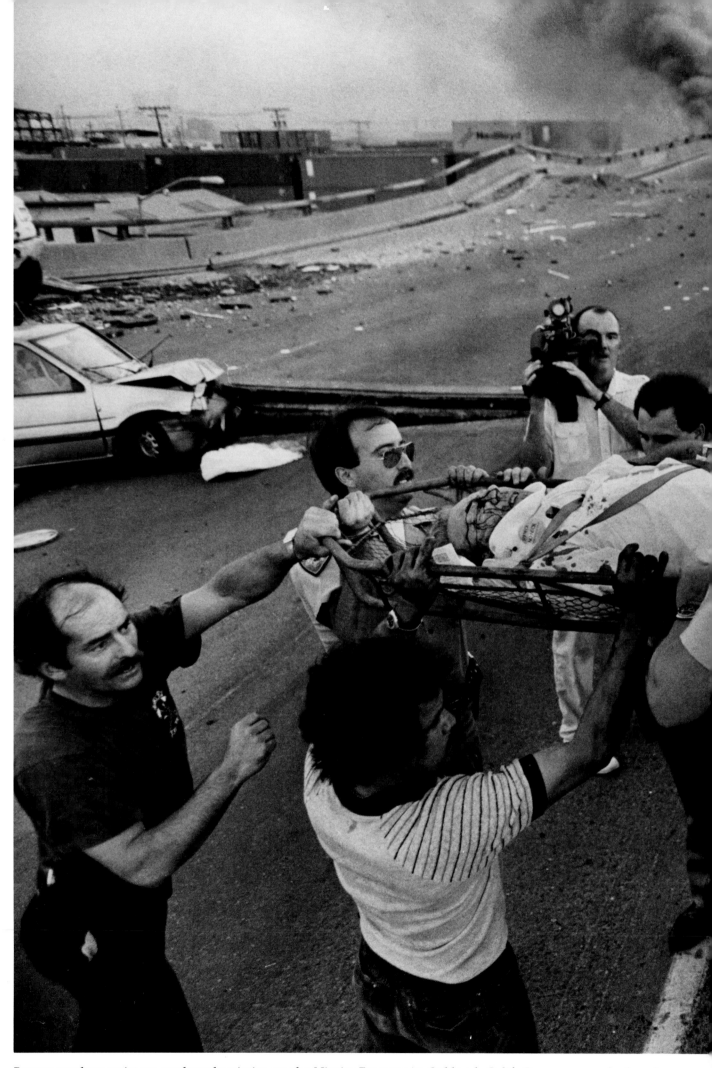

Rescue workers assist an earthquake victim on the Nimitz Freeway in Oakland, Calif. Cars were crushed and commuters were trapped when the freeway's top tier collapsed onto the lower level Oct. 17, killing 39.

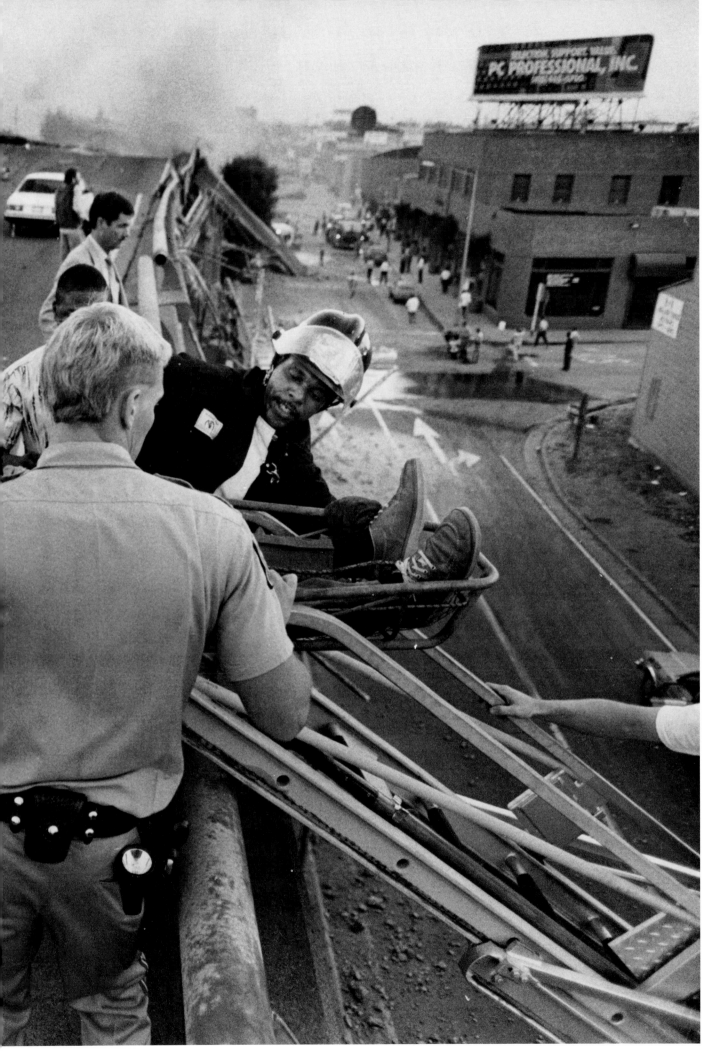

MICHAEL MACOR, THE OAKLAND (CALIF.) TRIBUNE, AWARD OF EXCELLENCE, SPOT

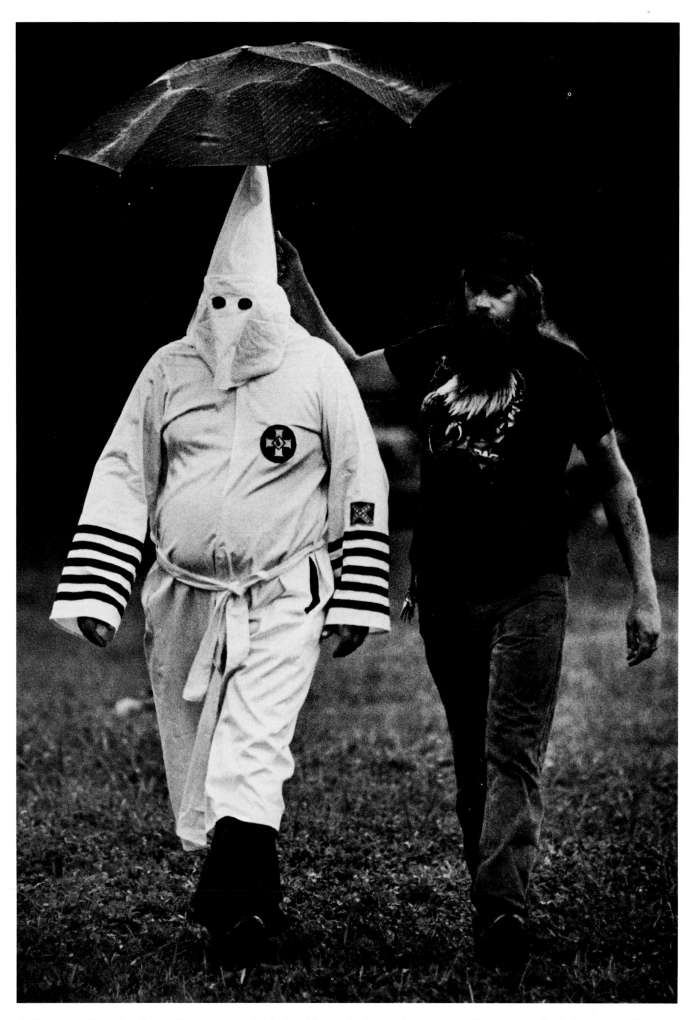

A disappointing day for a Klansman and "Animal" — rain has ruined a cross-burning rally in Lantana, Fla.
SCOTT WISEMAN, THE PALM BEACH (FLA.) POST, AWARD OF EXCELLENCE, GENERAL

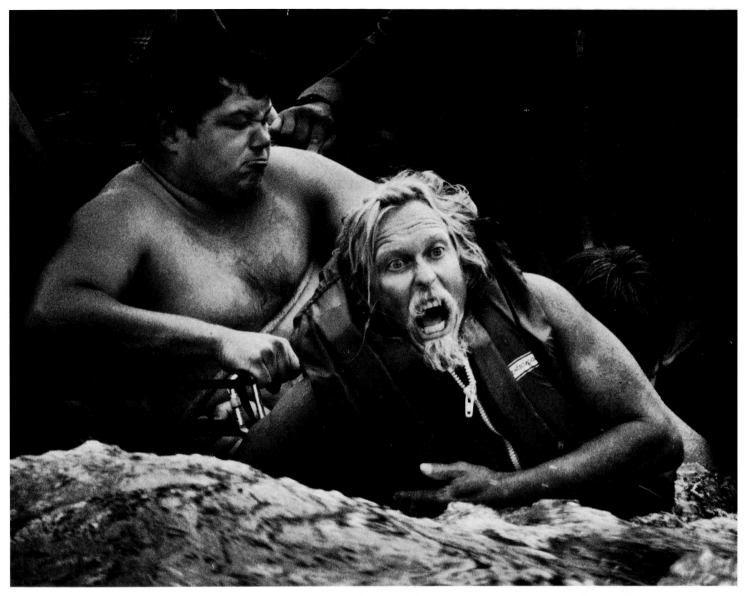

Richard Jacobs reacts as his foot is broken during his rescue from Rappahannock River. His foot was snagged on rocks.
ROBERT A. MARTIN, THE FREDERICKSBURG (VA.) FREE LANCE-STAR, AWARD OF EXCELLENCE, SPOT

Julio Castillo awaits rescue after impaling his jaw while climbing a fence. The 15-year-old New Yorker suffered no permanent injury. *STEVEN SPAK, FREELANCE, AWARD OF EXCELLENCE, SPOT*

Dallas rescuers remove their boat and a body after a three-day search for a drowning victim in the Trinity River.
LOUIS DELUCA, DALLAS TIMES HERALD, AWARD OF EXCELLENCE, GENERAL

Original in color

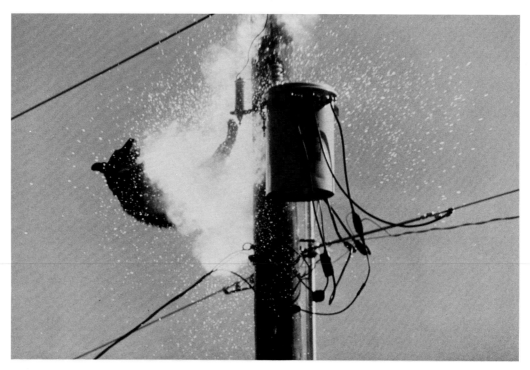

A tranquilized black bear is severely burned as it falls from a utility pole. The bear had wandered into Albuquerque searching for its cub. They later were reunited.
GREG SORBER, ALBUQUERQUE (N.M.) JOURNAL, AWARD OF EXCELLENCE, SPOT

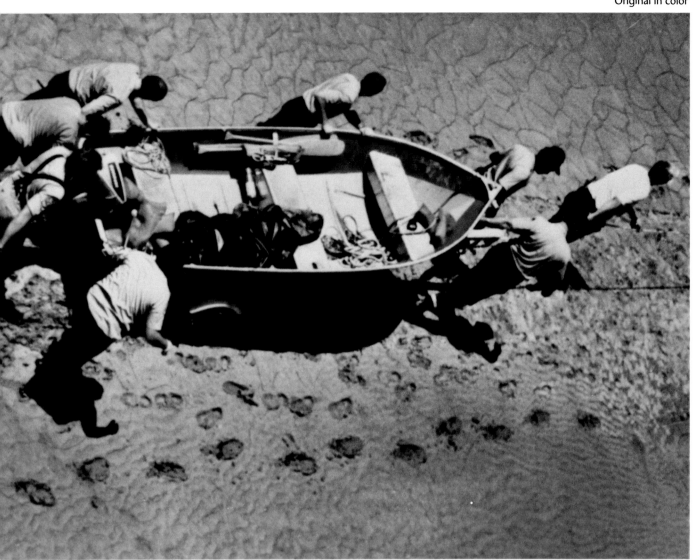

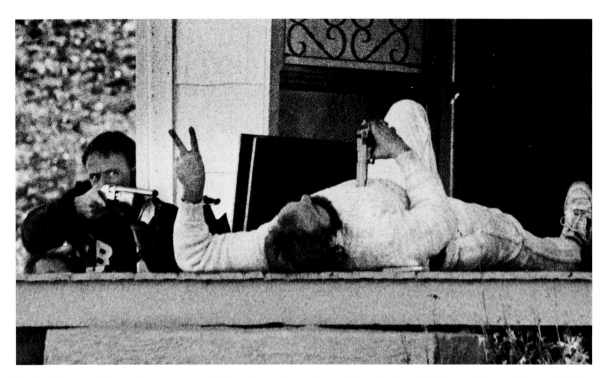

Jessie Castro Adams threatens suicide after a four-hour shoot-out with Knoxville police and FBI agents. A moment later, an officer shot the gun from Adams' hand.
MEL NATHANSON, THE KNOXVILLE (TENN.) JOURNAL, AWARD OF EXCELLENCE, SPOT

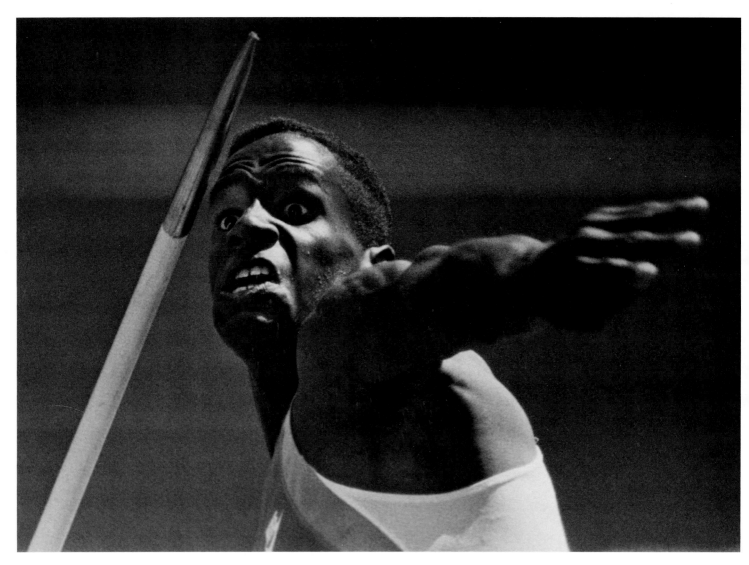

Matt Schelton of the University of Tennessee nails the last of his decathlon javelin throws during the Southeastern Conference Track and Field Championship in Gainesville, Fla.
STEPHAN SAVOIA, BATON ROUGE STATE-TIMES & MORNING ADVOCATE, 1ST PLACE, ACTION

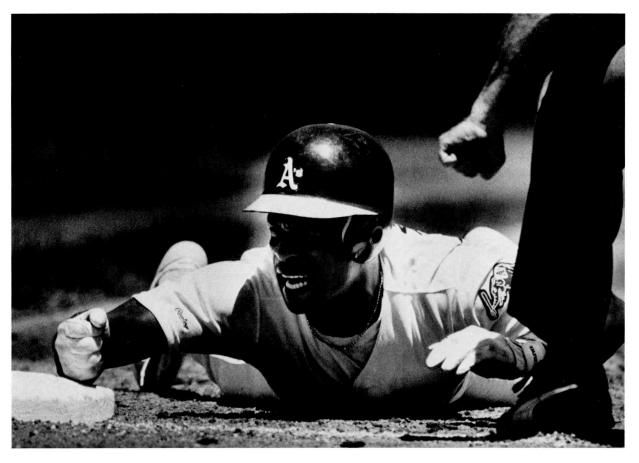

Oakland A's master base-stealer Rickey Henderson vents his frustration at getting picked off at first base during a home game against the Chicago White Sox in August.
JASON M. GROW, SAN FRANCISCO CHRONICLE, 2ND PLACE, ACTION

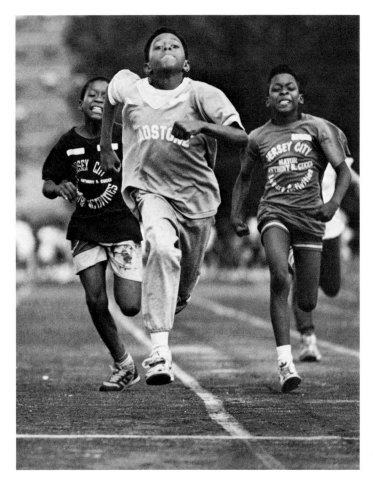

Young members of Jersey City Leisure Activities in New Jersey sprint in their quest to win the 100-yard dash at Lincoln Park. *JOHN GASTALDO, THE JERSEY JOURNAL, 3RD PLACE, ACTION*

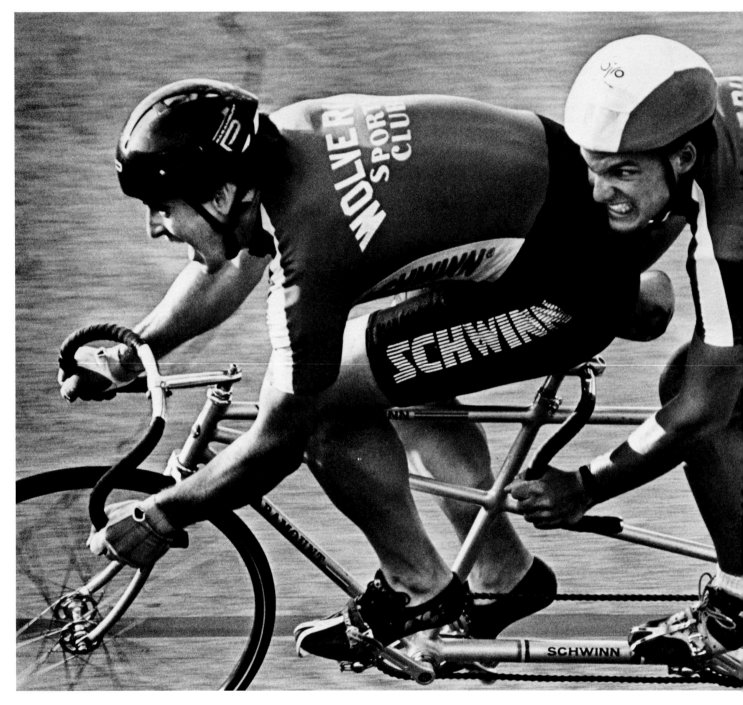

Guy Laidig (left) and Mark Allen bear down in the 400-meter tandem time trials during the U.S. Track Cycling Championship in Redmond, Wash.
BENJAMIN BENSCHNEIDER, THE SEATTLE TIMES, *AWARD OF EXCELLENCE, ACTION*

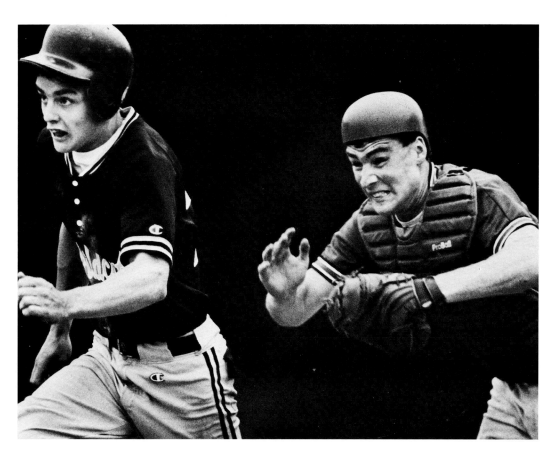

Durfee High School catcher Tim Furtado chases Weymouth South's Joseph Broderick back toward third base after a failed suicide squeeze attempt in Quincy, Mass.
GARY HIGGINS, THE QUINCY (MASS.) PATRIOT LEDGER
AWARD OF EXCELLENCE, ACTION

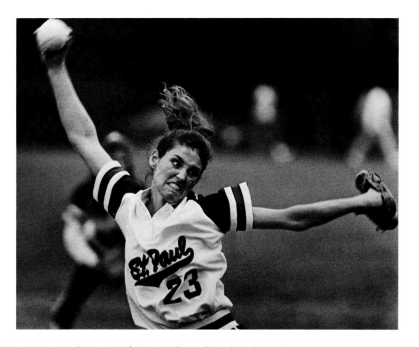

Keri Krupke, 17, of St. Paul High School pitches during a game against Mater Dei High School in Santa Ana, Calif.
PAUL RODRIGUEZ, THE ORANGE COUNTY (CALIF.) REGISTER
AWARD OF EXCELLENCE, ACTION

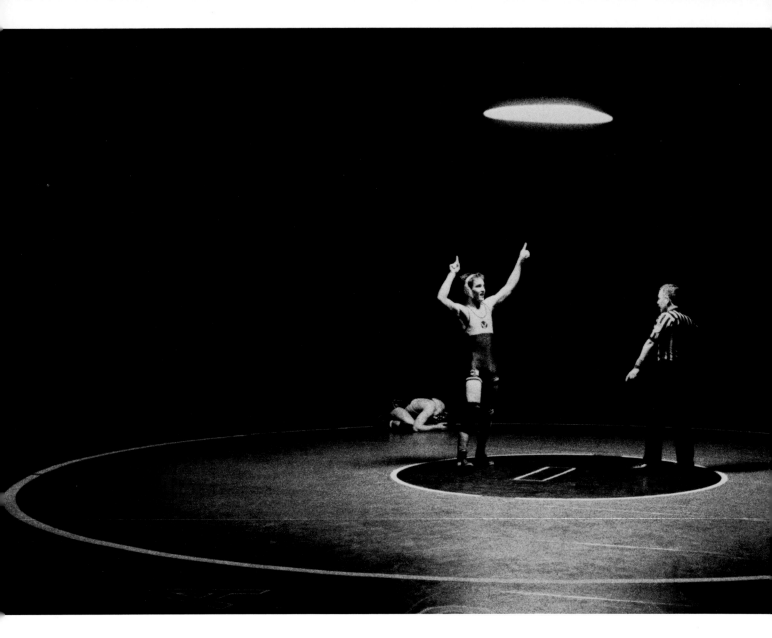

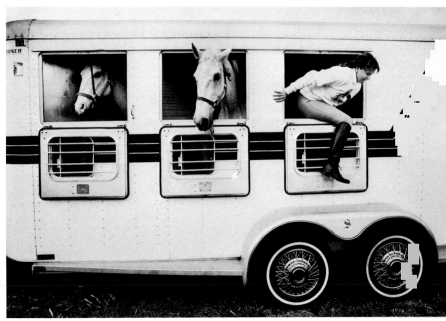

Ruth Menor, executive director of Vinceremos Riding Center in Lantana, Fla., climbs out of a horse trailer after a dressage training exercise at Hanover Horse Farm in West Palm Beach.
SEAN DOUGHERTY, FORT LAUDERDALE SUN-SENTINEL
2ND PLACE, FEATURE

Steve Soto of Clovis West High School celebrates a win over Ken Williams of Exeter High during the finals of the 138-pound class of the California Central Section Championship held in Arvin in February.
ROLLIN BANDEROB, THE CLOVIS (CALIF.) INDEPENDENT
1ST PLACE, FEATURE

Jason Hebert kisses his girlfriend, Alice Tennant, for luck before a semifinal match in the Virginia high-school wrestling championship. He won his match.
DENIS FINLEY, THE VIRGINIAN-PILOT/LEDGER STAR
3RD PLACE, FEATURE

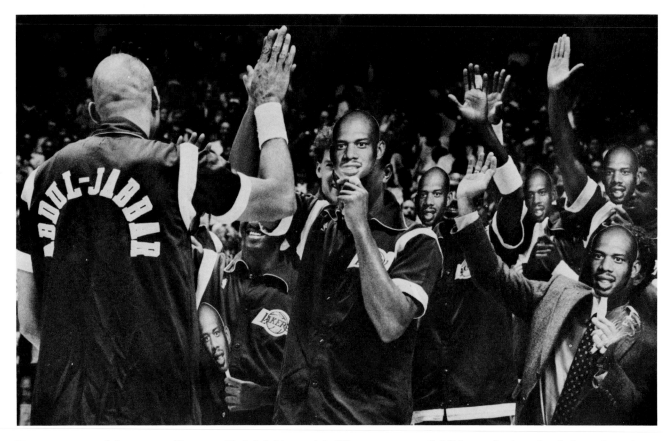

Teammates and fans greet Kareem Abdul-Jabbar with "Kareem on a stick" faces during the Laker player's last stop in Seattle before retiring.
DREW PERINE, THE EVERETT (WASH.) HERALD, *AWARD OF EXCELLENCE, FEATURE*

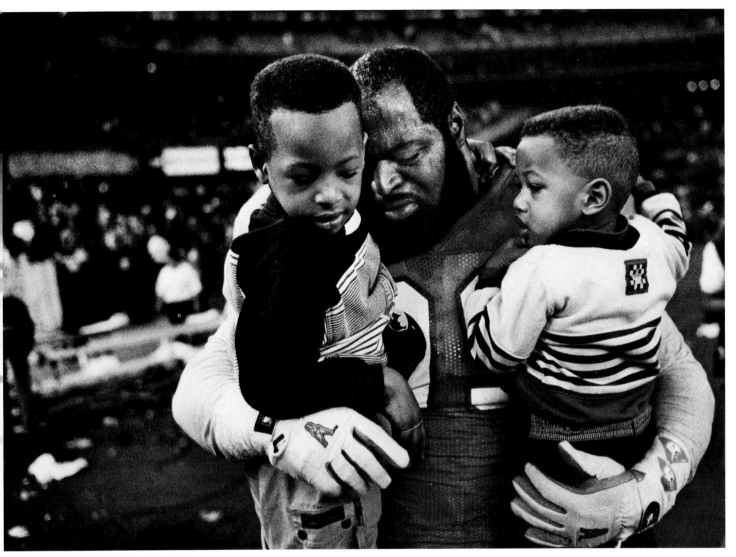

Houston Oilers nose tackle Doug Smith leaves the field in tears holding his sons, Doug Jr. (left) and Harrison after losing
to the Pittsburgh Steelers in an AFC wild-card game.
VINCE MUSI, THE PITTSBURGH PRESS, 1ST PLACE

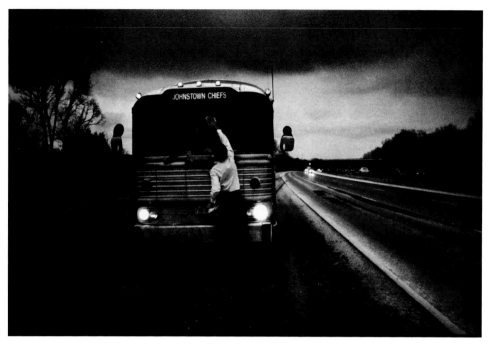

During a road trip, the bus driver is forced to stop because the windshield is too dirty to see. Coach Steve Carlson washes the window.

Coach Carlson tries to direct Marc Vachon's game plan.

Chiefs' captain Rick Boyd challenges the coach of the Nashville Knights for sending in an enforcer during a tense game.

'Slap Shot' revisited

The East Coast Hockey League is the game's low minors, where the hours are long and the pay short. On a weekend road trip, the Johnstown, Pa., Chiefs traveled by bus to Knoxville and Nashville, returning with two wins and a loss.

Head Coach Steve Carlson is best known for the part he played in the movie *Slap Shot*, about a team called the Charleston Chiefs. Carlson played one of the notorious Hanson brothers in the movie, which was filmed in Johnstown. When Carlson was hired, the team's name was changed from the Jets to the Chiefs.

Ten of the Chiefs' 16 players are college graduates, including three from Ivy League schools. They talk of how much they love the game, but also they talk of places they'd rather be: the National Hockey League, the International Hockey League or the American Hockey League.

To the residents of Johnstown, though, the Chiefs are heroes. Games bring in over 3,000 fans, and many of them line the path from the locker room to the ice, seeking autographs. Some of the games are locally televised.

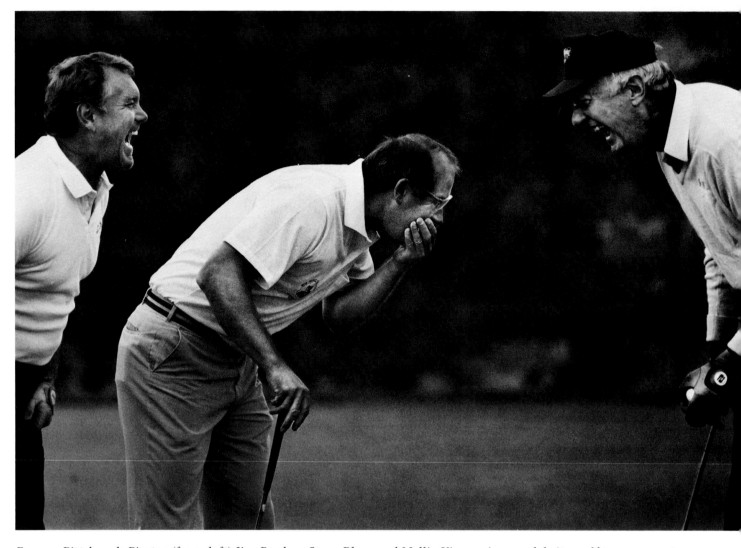

Former Pittsburgh Pirates (from left) Jim Rooker, Steve Blass and Nellie King enjoy a celebrity golf tournament.

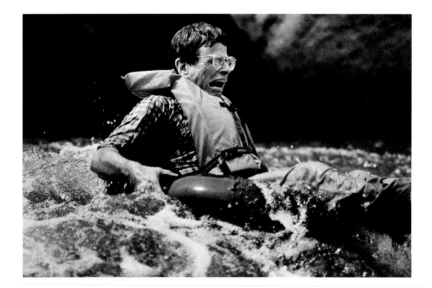

Mike Robertson braves the Youghiogheny River on a tube.

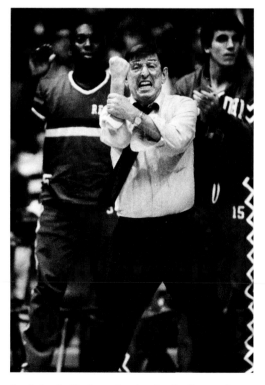

St. John's University basketball coach Lou Carneseca tries to make the referee aware of a foul.

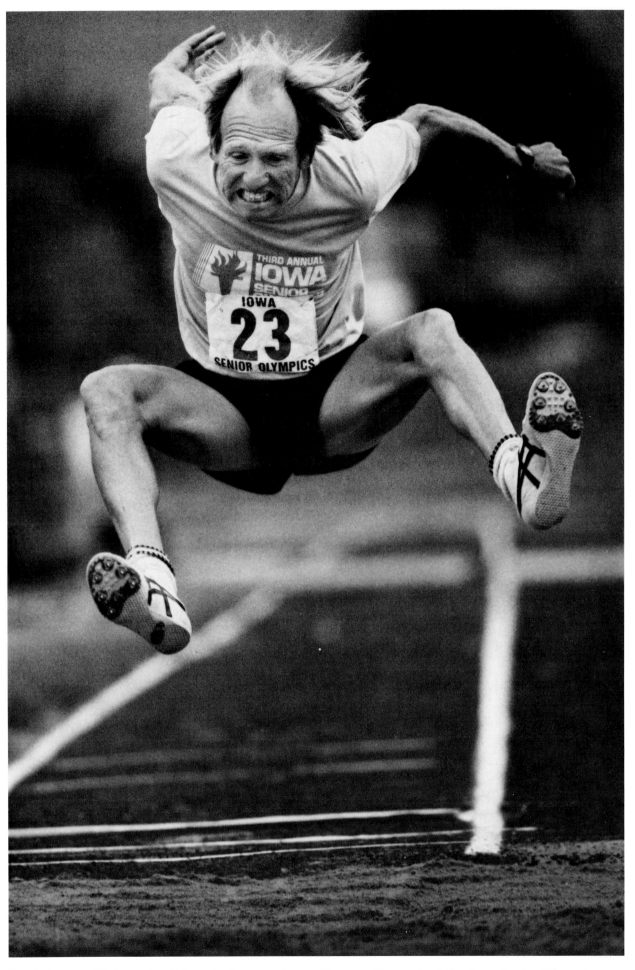

Frank Brown, 55, leaps to victory in the long jump. He won 13 events at the Iowa Senior Olympics.
DAVID PETERSON, THE DES MOINES REGISTER, 2ND PLACE

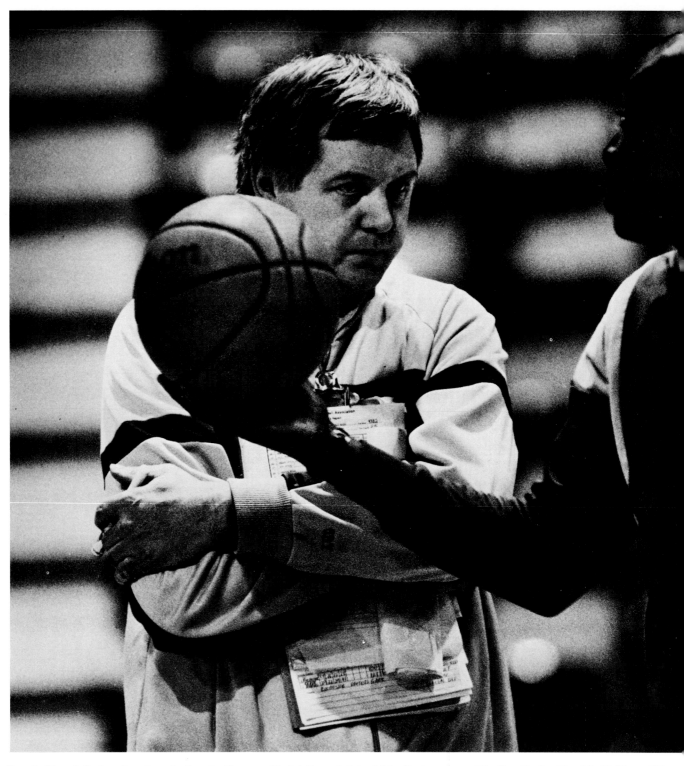

Lewis Lloyd (below) enjoys being in the spotlight the night of his first game with the Cedar Rapids Bullets. His coach (above) confronts him on his lack of defensive effort during a game.

Back from drugs

Professional basketball player Lewis Lloyd was banned from the NBA for substance abuse. As his two-year probation period was drawing to a close, he waited for reinstatement and a possible second chance in the NBA. He visited elementary schools, speaking out against the dangers of drug abuse. To get back in shape physically, he signed with the Cedar Rapids Bullets of the Continental Basketball League. Lloyd since has rejoined the Houston Rockets.

Getting the rust off his game has not been easy. One of Lloyd's biggest problem areas has been his slow defense.

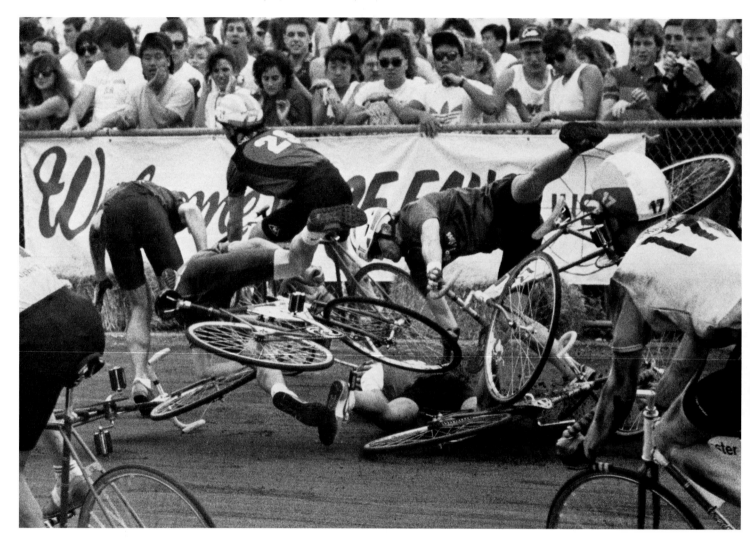

Riders collide during the Little 500 bike race at Indiana University. The annual race is a 50-mile stint on a cinder track.
ROB GOEBEL, THE INDIANAPOLIS STAR, 3RD PLACE

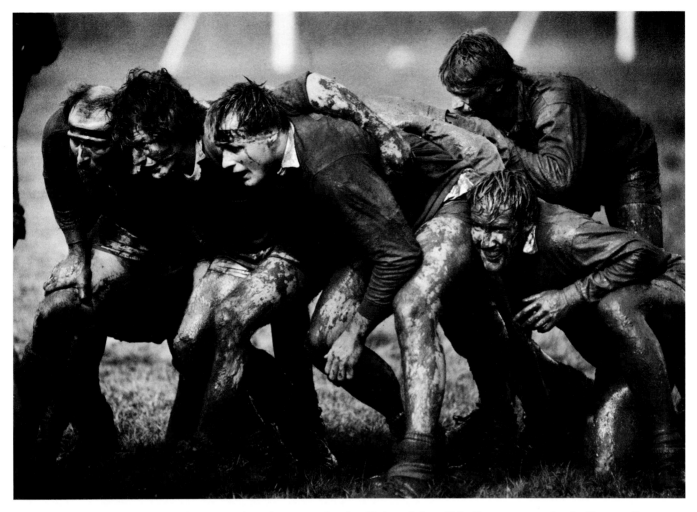

Rain and mud cannot stop the annual Midwestern Rugby Union Select Side Tournament in Indianapolis.

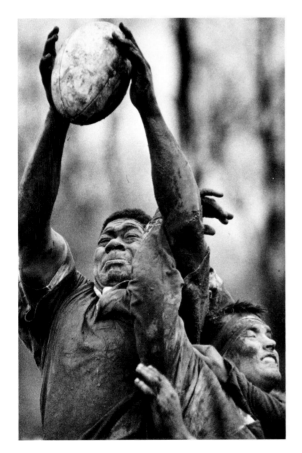

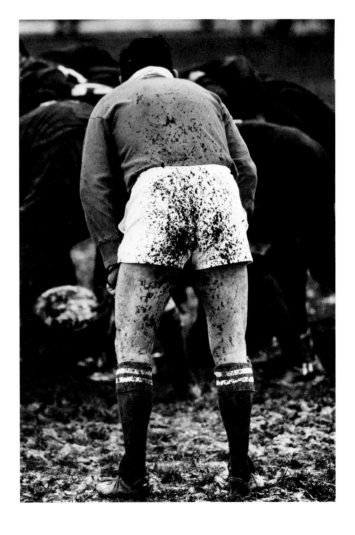

Players battle for the ball. Even the referee is slathered with mud during the tournament, in which teams from five states competed.

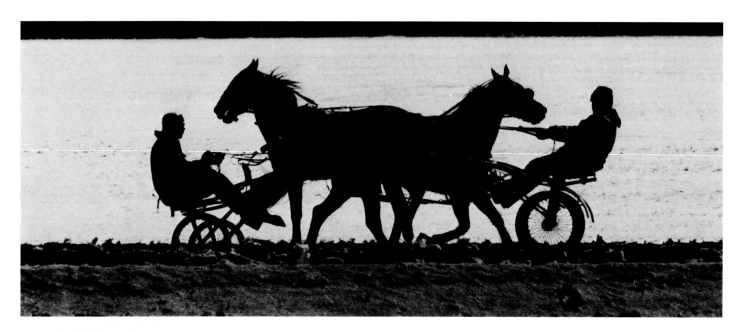

Pacing horses pass during practice in the snow at Indiana State Fairgrounds.

San Francisco 49ers quarterback Joe Montana and his daughter ride
in a parade after the Super Bowl win.
BRANT WARD, SAN FRANCISCO CHRONICLE
AWARD OF EXCELLENCE

Ingrid Krishansen crosses the finish line to win the Bay to Breakers 7.5-mile
race in San Francisco.
BRANT WARD, SAN FRANCISCO CHRONICLE, AWARD OF EXCELLENCE

Two players on Cox High School's field hockey team
celebrate winning the Virginia State Championship.
LUI KIT WONG, THE VIRGINIAN PILOT/LEDGER-STAR
AWARD OF EXCELLENCE

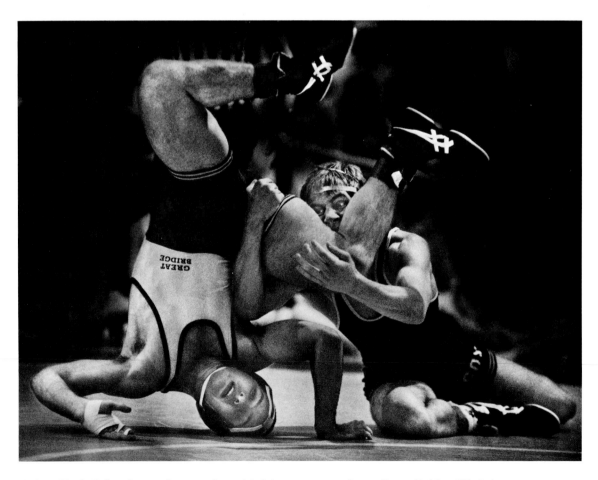

A Cox High School wrestler tangles with his opponent from Great Bridge High in a meet.
LUI KIT WONG, THE VIRGINIAN-PILOT/LEDGER-STAR, AWARD OF EXCELLENCE

Original in color

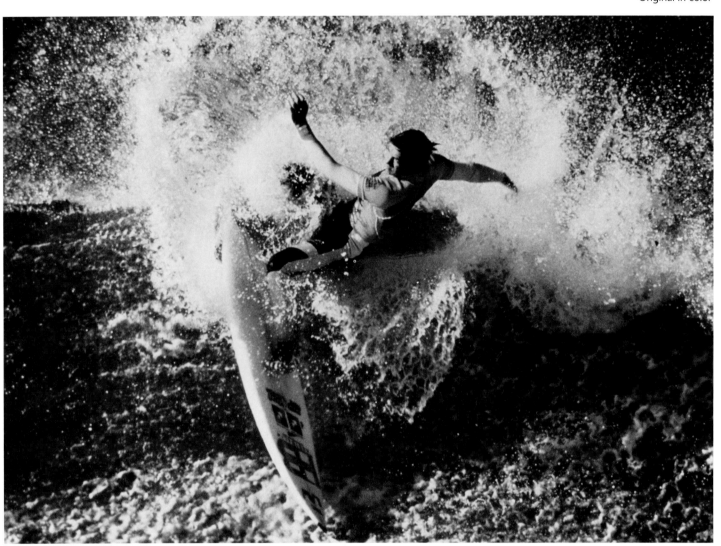

Pro surfer Simon Law of Newcastle, Australia, does a snapback during the Katin Memorial at Hungtington Beach, Calif.
ROBERT BECK FOR SURFER MAGAZINE, 1ST PLACE

Summer swim.
DOROTHY LITTELL FOR BOSTONIA MAGAZINE, 2ND PLACE

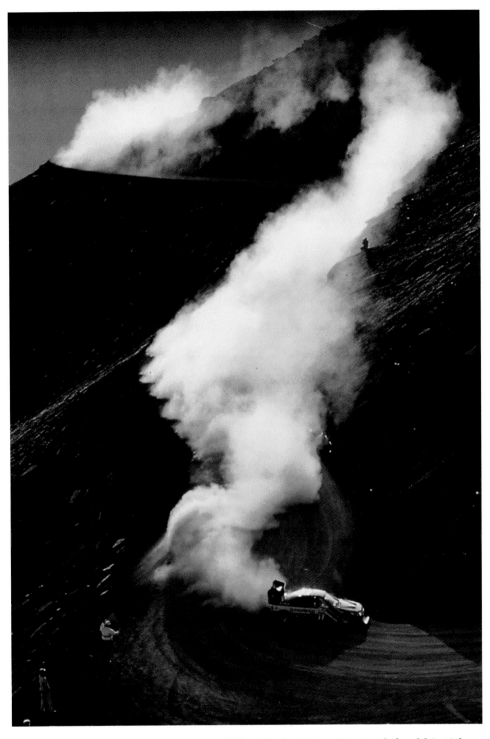

Finnish driver Ari Vatanen races up Pikes Peak attempting to defend his title,
Fastest Man on the Mountain, at the Pikes Peak Hill Climb in Colorado.
MARK REIS, COLORADO SPRINGS GAZETTE TELEGRAPH, 3RD PLACE

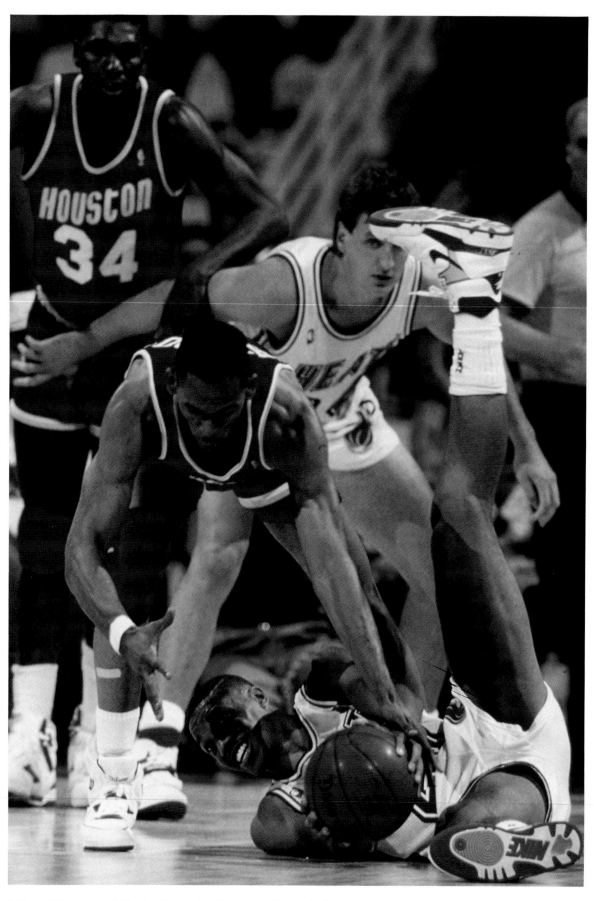

Miami Heat guard Kevin Edwards dives for a loose ball in a game against the Houston Rockets.
BILL FRAKES FOR SPORTS ILLUSTRATED, 1ST PLACE

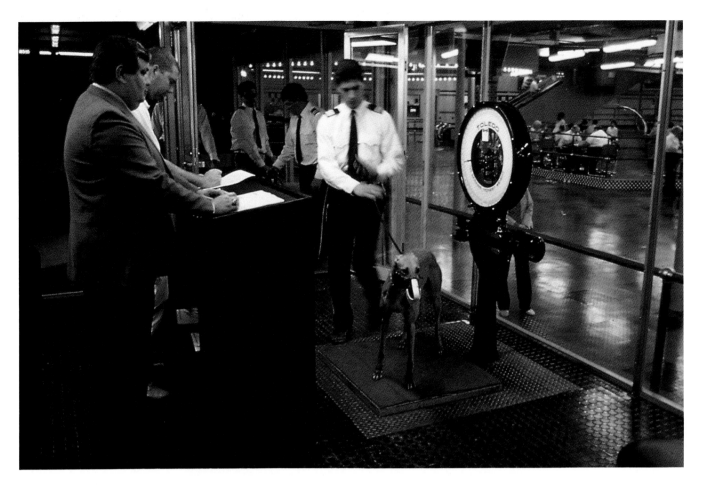

A greyhound is weighed at Wonderland Track, Boston. Dogs are handicapped according to speed and weight.

Oshkosh Juliet was the world's fastest dog in 1989. She won the Race of Champions at Mile High Kennel Club in Denver in June. The event is dog racing's equivalent to the Kentucky Derby.

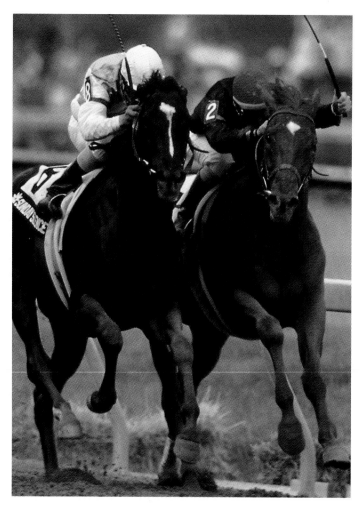

Sunday Silence and Easy Goer, the top 3-year-olds of
1989, come down to the wire in the Preakness Stakes.

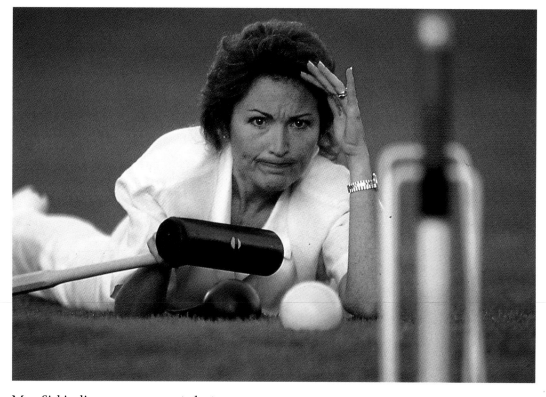

Mrs. Sirkin lines up a croquet shot.

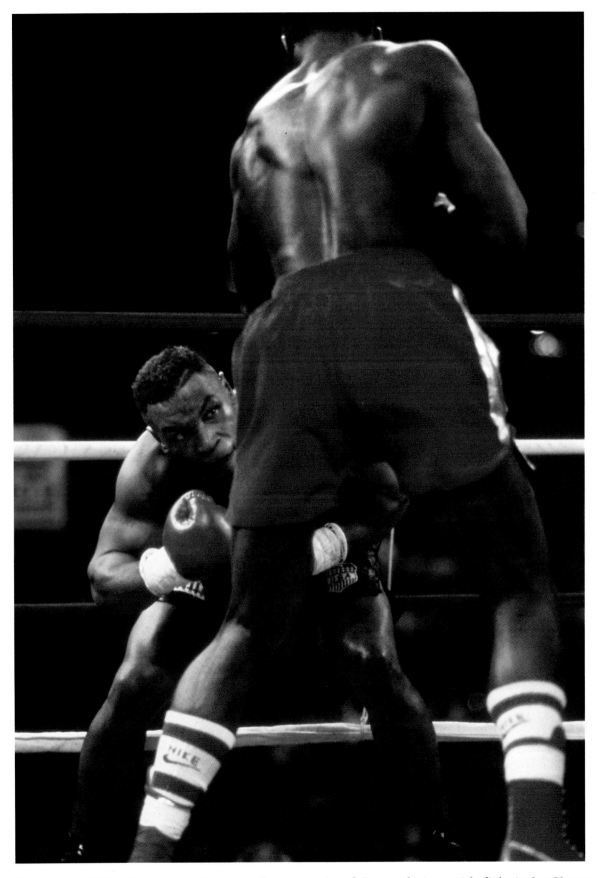

Heavyweight Mike Tyson crouches to strike against Frank Bruno during a title fight in Las Vegas.
ANDREW HAYT, SPORTS ILLUSTRATED, 2ND PLACE

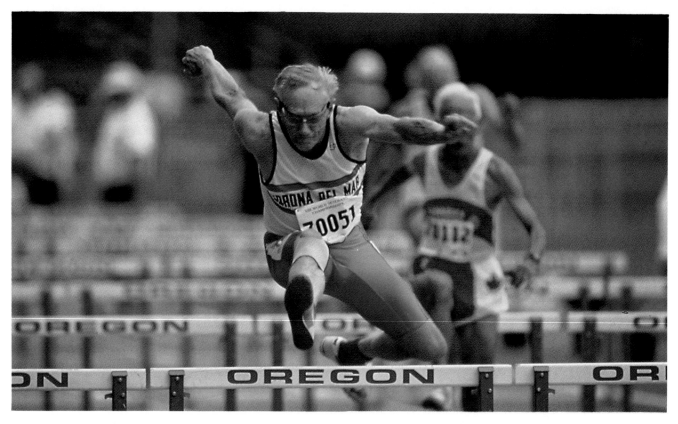

A contestant in the 70-year-olds class of 110-meter hurdles heads for first place.

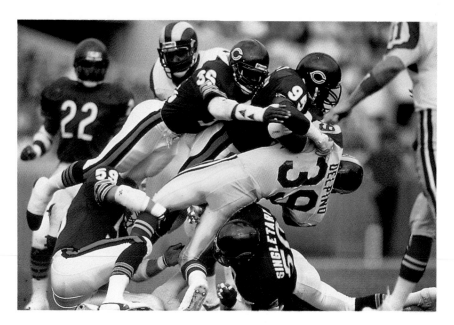

L.A. Ram Robert Delphino is gang-tackled by the Chicago Bears.

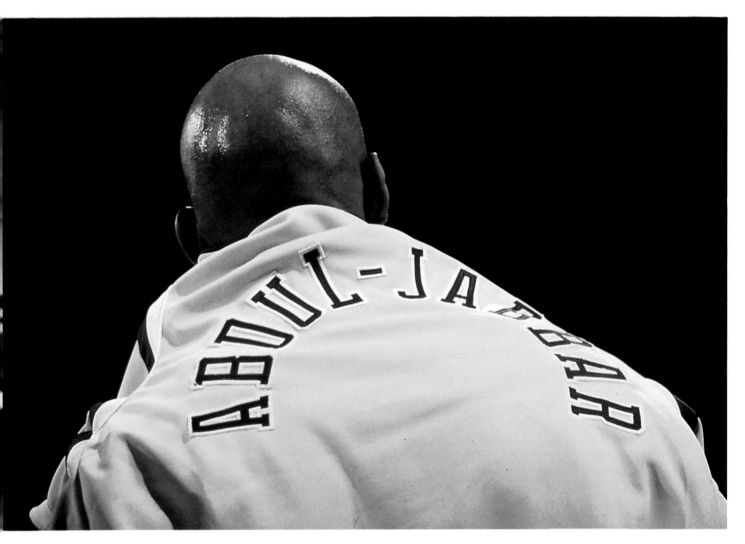

The L.A. Lakers center retires.
ROBERT BECK, ALLSPORT USA
3RD PLACE

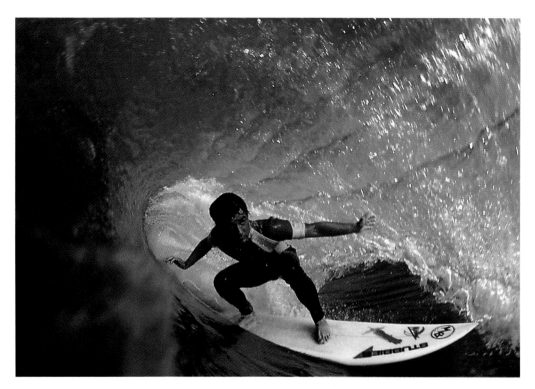

Surfer Scott Crump pulls into a Carlsbad tube.

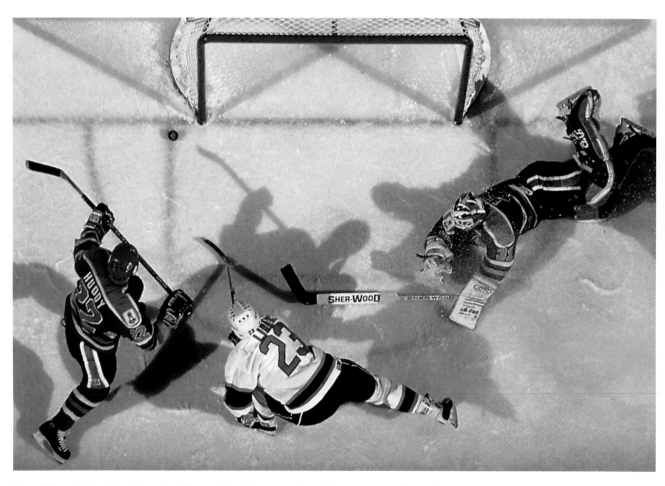

Igor Liba of the Los Angeles Kings hits the post in a shot against the Edmonton Oilers in Game 6 of the National Hockey League playoffs.

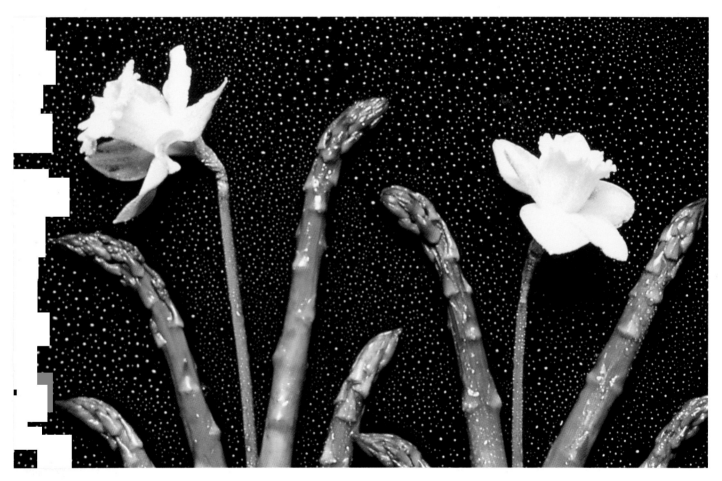

Springtime asparagus
ELLEN M. BANNER, FREELANCE
2ND PLACE

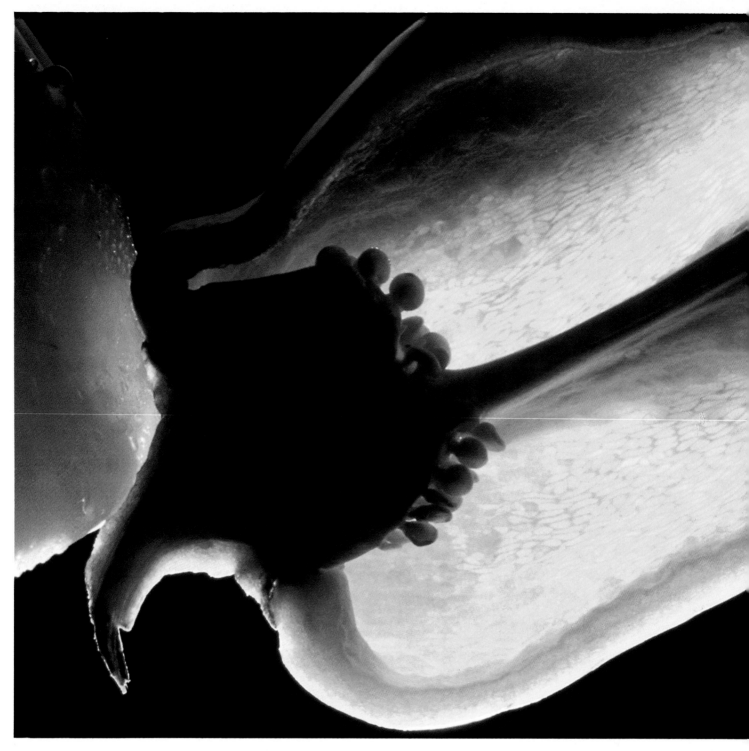

Fresh peppers
KEVIN CLARK, BELLEVUE (WASH.) JOURNAL-AMERICAN
1ST PLACE

Dessert pears
PAUL E. RODRIGUEZ, THE ORANGE COUNTY (CALIF.) REGISTER
AWARD OF EXCELLENCE

Delectable honey
JOHN TROTTER, THE SACRAMENTO BEE
3RD PLACE

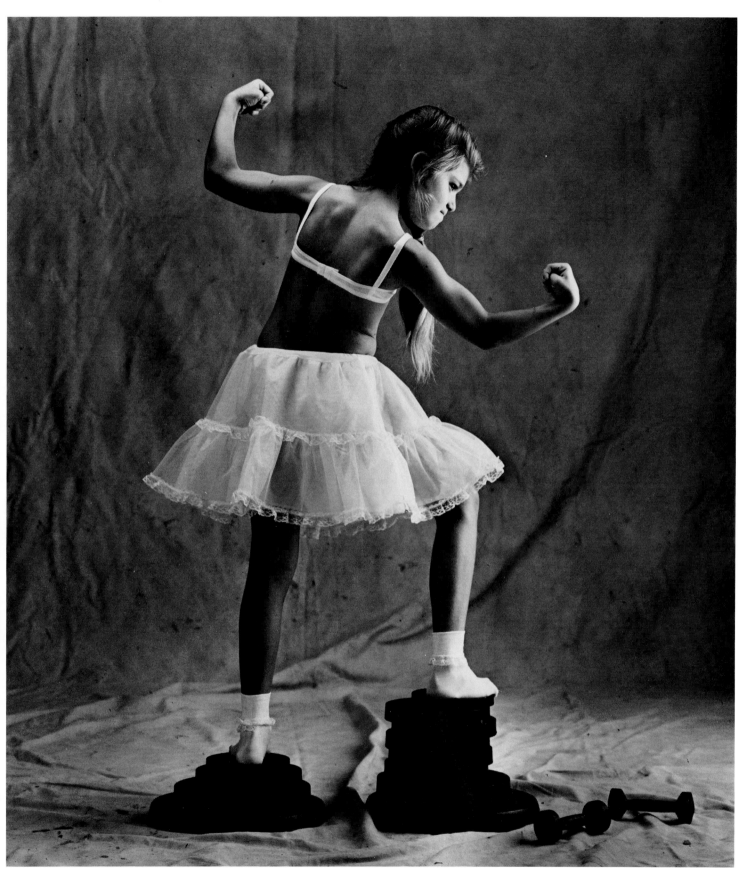

Training bra
MICHAEL BRYANT, THE PHILADELPHIA INQUIRER
1ST PLACE

Accessories after the fact
MICHAEL BRYANT, THE PHILADELPHIA INQUIRER
AWARD OF EXCELLENCE

Primping for the prom
SMILEY N. POOL, AUSTIN (TEXAS) AMERICAN-STATESMAN, 2ND PLACE

Ties have it
PAT DAVISON, THE ALBUQUERQUE (N.M.) TRIBUNE
3RD PLACE

Casual panache
MICHAEL KIERNAN,
NEW HAVEN (CONN.) REGISTER
AWARD OF EXCELLENCE

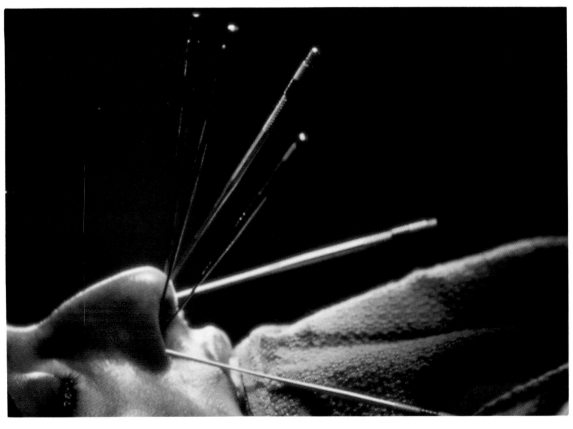

A cocaine solution is used as an anesthetic and to constrict blood vessels in cosmetic surgery.
JOSE AZEL, CONTACT PRESS IMAGES, 2ND PLACE

Nautical fashion, vintage 1989.
GARY S. CHAPMAN, THE LOUISVILLE COURIER-JOURNAL SUNDAY MAGAZINE, 3RD PLACE

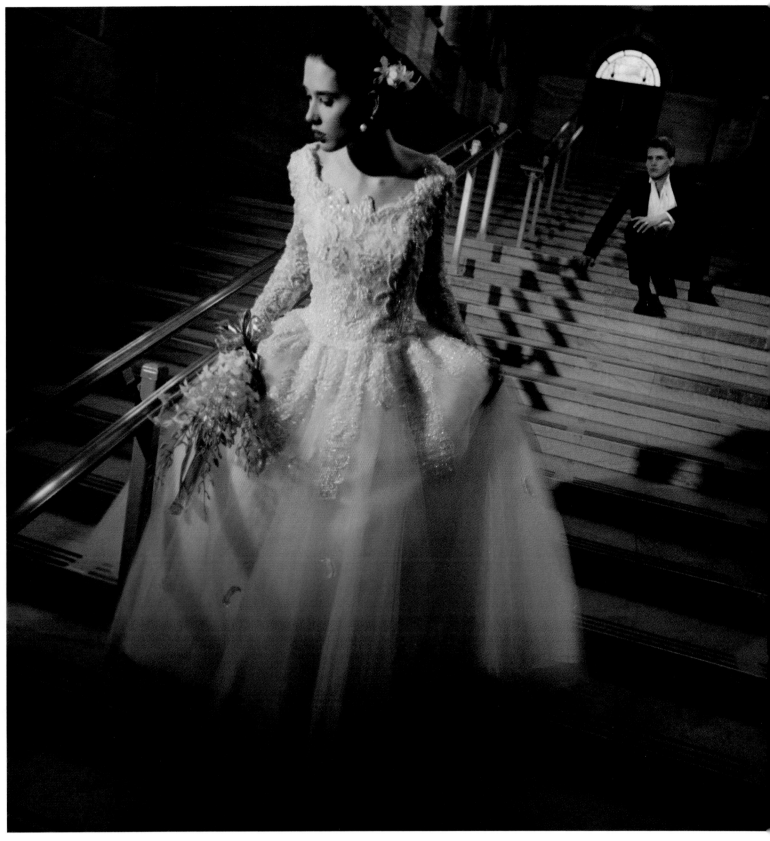

A rush of bridal silk.
DONNA TEREK, MICHIGAN MAGAZINE, 1ST PLACE

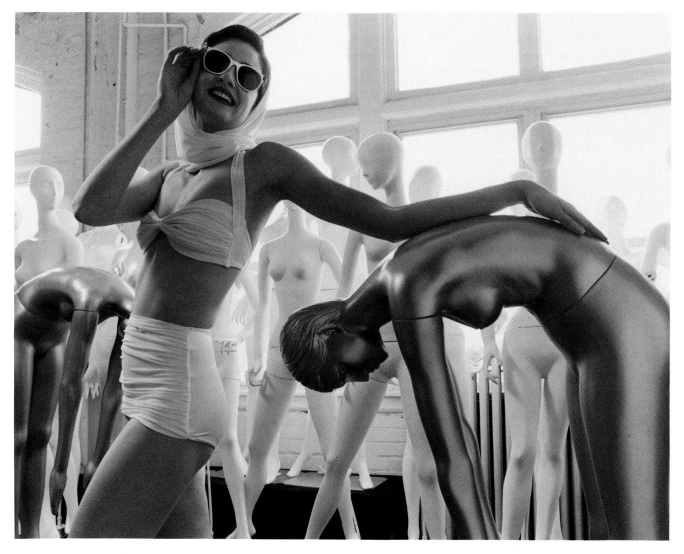

Spring swimwear from the series "Body Talk."
DONNA TEREK, MICHIGAN MAGAZINE, 3RD PLACE

Destruction of habitat has isolated chimpanzees and made them an endangered species.
JAMES BALOG, BLACK STAR, 3RD PLACE

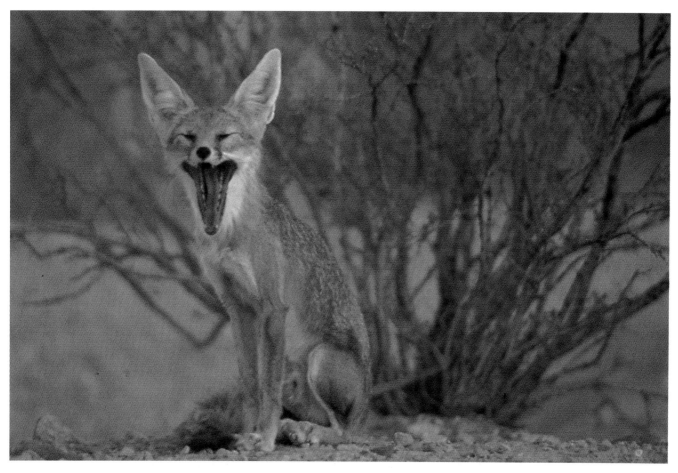

A kit fox awakens for a night of foraging in the Nevada desert.
CRAIG CHAPMAN, THE ORANGE COUNTY (CALIF.) REGISTER, AWARD OF EXCELLENCE

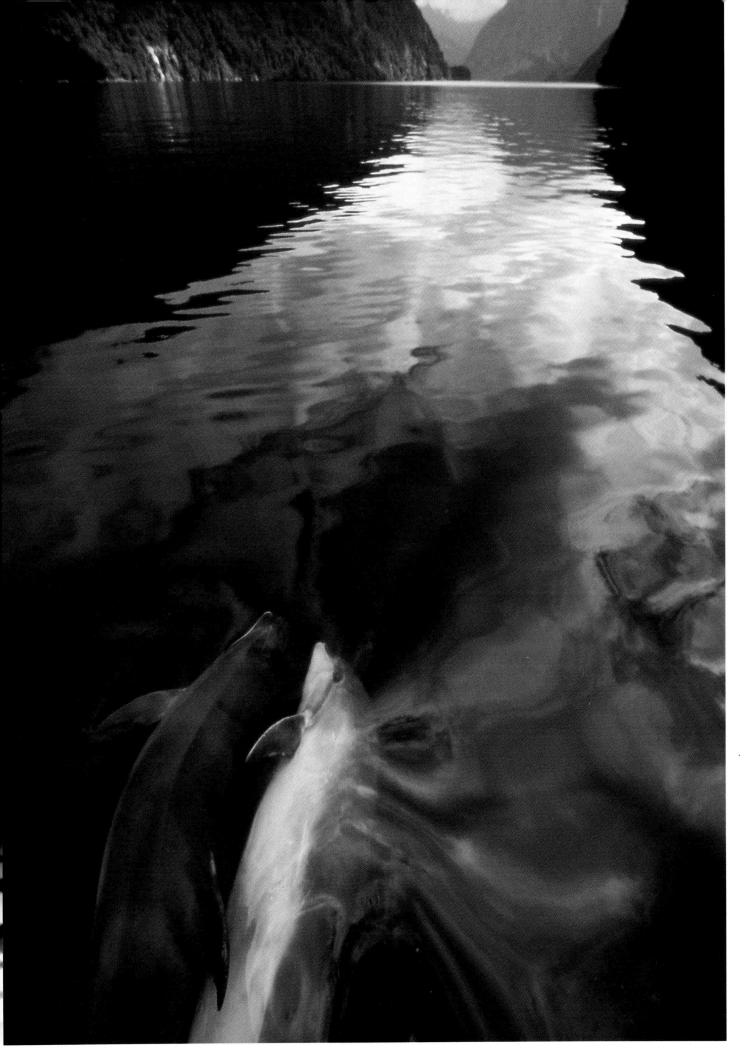

Bottle-nose dolphins swim in Fiordland National Park, New Zealand.
DAVID DOUBILET, NATIONAL GEOGRAPHIC, 1ST PLACE

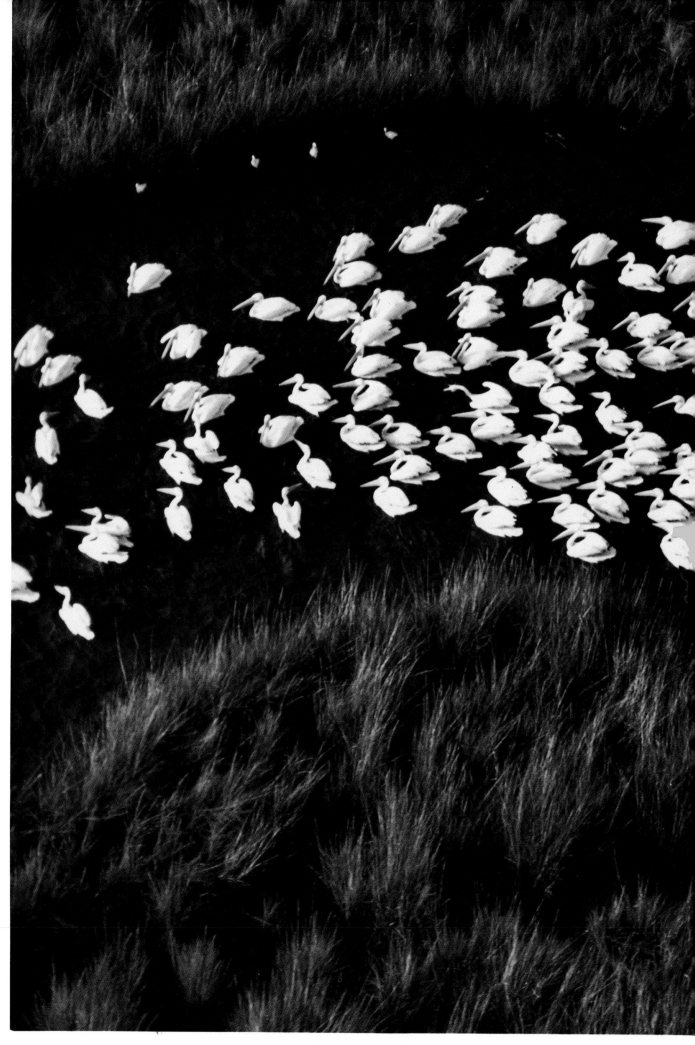

White pelicans swim through the salt marshes of the Mississippi River delta.
ANNIE GRIFFITHS BELT, NATIONAL GEOGRAPHIC, 2ND PLACE

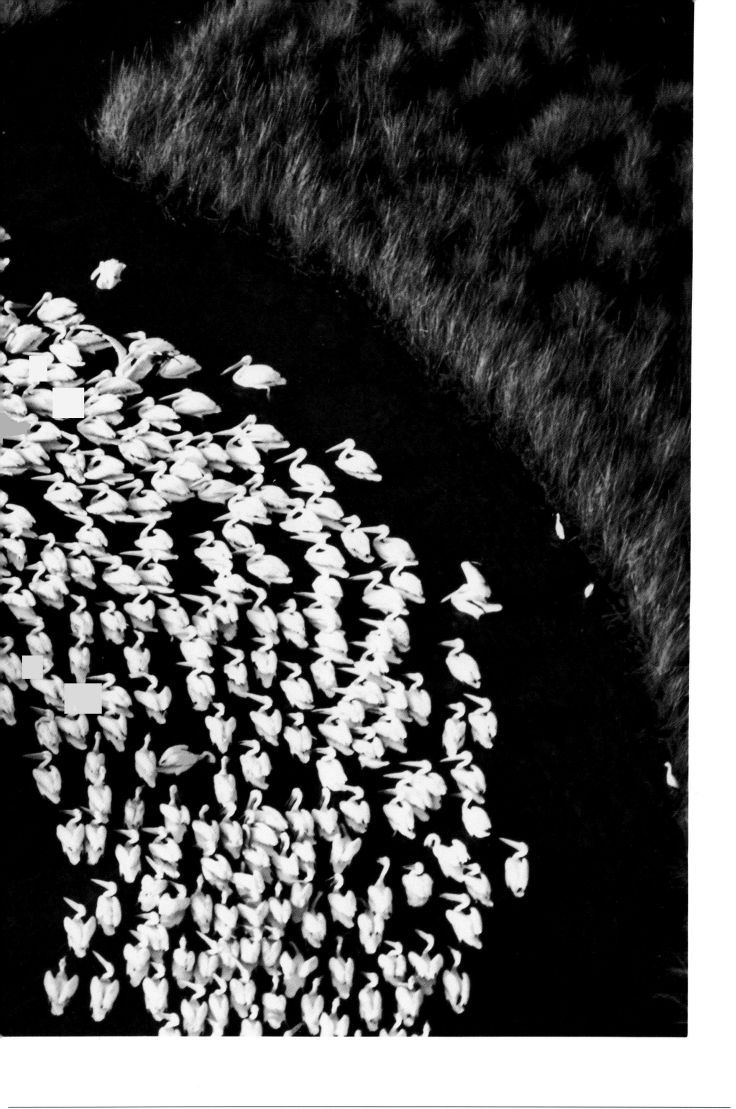

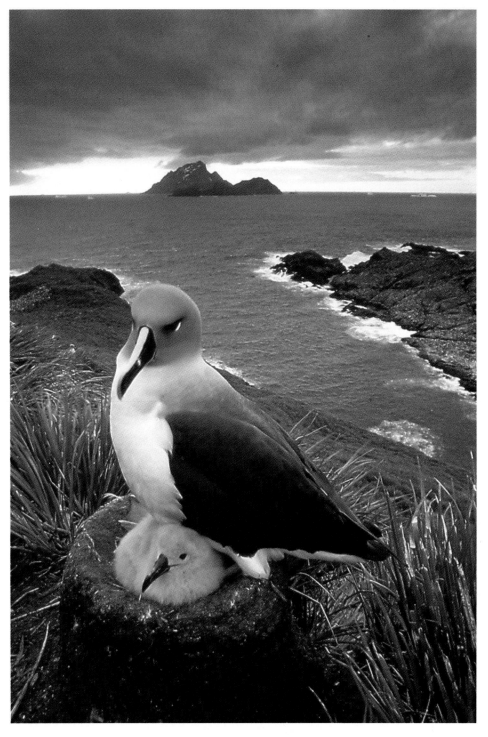

An albatross guards its nest on South Georgia Island.
FRANS LANTING, NATIONAL GEOGRAPHIC, AWARD OF EXCELLENCE

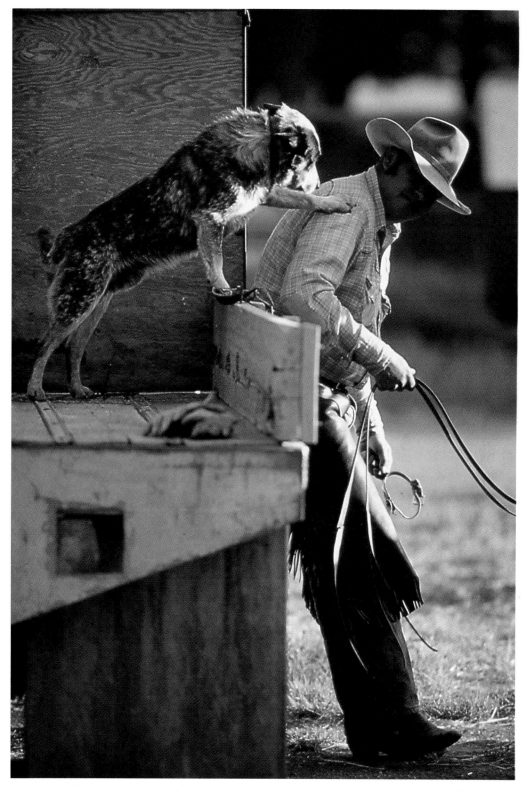

A ranch dog seems to be urging a cowboy to get moving during a branding at a cattle ranch in southeastern Oregon.
PHIL SCHOFIELD FOR NATIONAL GEOGRAPHIC, 1ST PLACE

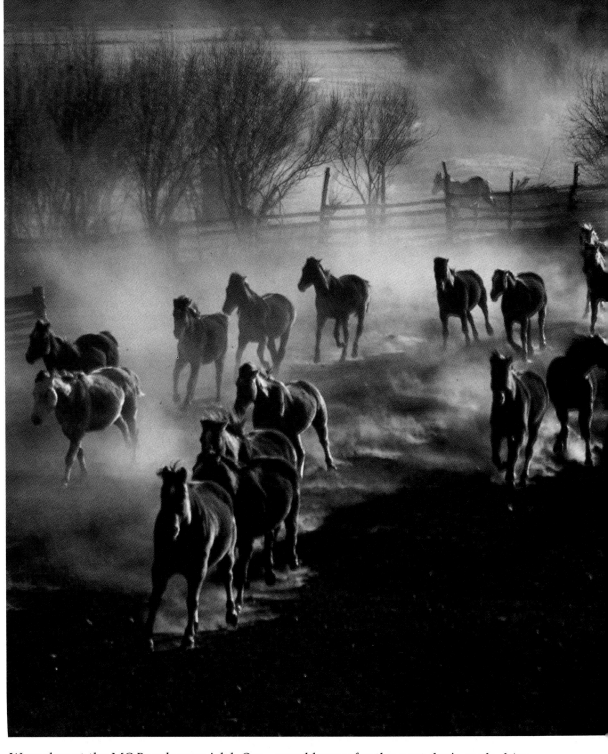

Wranglers at the MC Ranch near Adel, Ore., corral horses for the next day's cattle drive.

Buckaroos take a break at the MC Ranch. Their jobs are very much like the jobs of cowboys who rode the ranges in the 1800s.

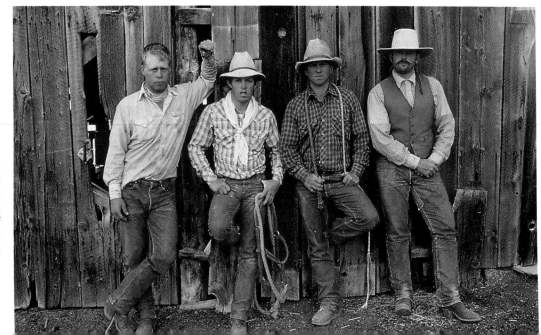

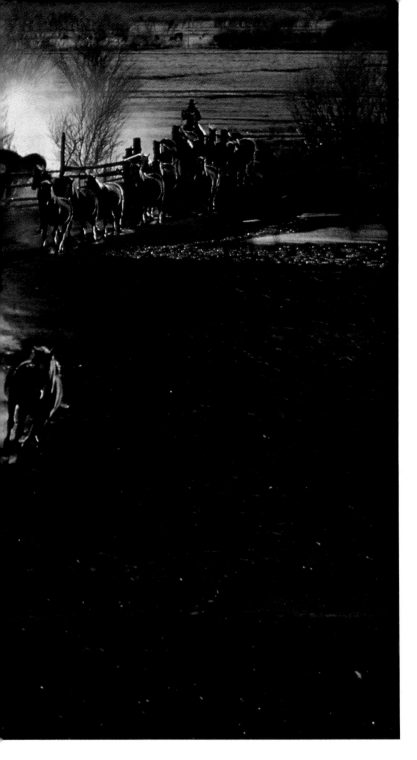

In the heart of the West

In sagebrush country – the Great Basin, Columbia Plateau, Colorado Plateau and Wyoming Basin – the romance of the old West still exists. Cowboys, known as buckaroos, still ride the range, nine-tenths of which is public land. Mustangs still run free across the broad, brush-covered expanses. The people are as tough and adaptable to extremes as the sagebrush that covers the land.

The relationship between man and nature is delicate in America's outback. Overgrazing damages wildlife habitats. The land's harsh conditions threaten some ranchers' livelihoods. But as long as cooperation exists among ranchers, environmentalists and the government, sagebrush country will survive and continue to produce the legends of the West.

PHIL SCHOFIELD FOR NATIONAL GEOGRAPHIC, 1ST PLACE

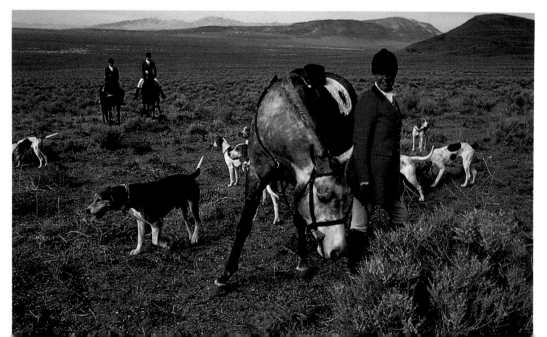

Lynn Lloyd and other members of the Red Rock Hounds Club of Reno, Nev., take a break from a coyote hunt. Dependent on ranchers for access to land, club members in turn help round up cattle.

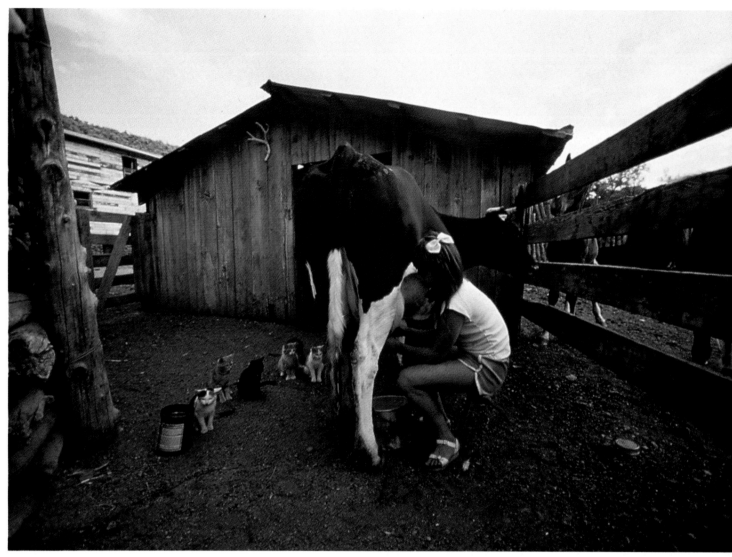

Kittens at the Stowell ranch in northern Nevada know that when Sherry, 11, milks the cow, dinner soon follows.

Fay and Wally Carlson of Eskdale, Utah, reared nine children in sagebrush country. "There's no keeping up with the Joneses out here," Wally says.

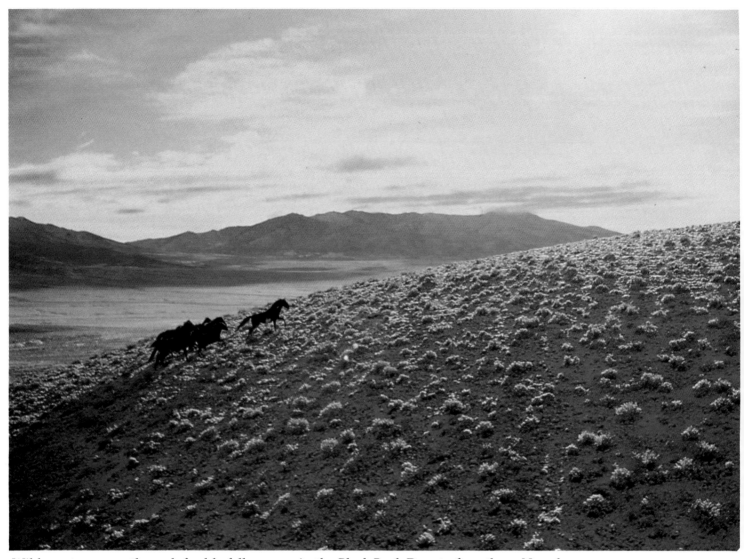

Wild mustangs run through freshly fallen snow in the Black Rock Desert of northern Nevada.

MAGAZINE PICTURE STORY / *PHIL SCHOFIELD, 1ST PLACE*

A boy in Sikoroni, Mali, leads an elder who has been blinded by onchocerciasis.
EUGENE RICHARDS FOR THE NEW YORK TIMES, 2ND PLACE

Winning the war on river blindness

An estimated 18 million people in Africa, parts of Latin America and the Middle East carry in their bodies a parasitic worm that causes severe itching, skin disfigurement, and in more than 300,000 cases, blindness. They all suffer from onchocerciasis, a tropical disease commonly called river blindness because the tiny black flies that spread it breed in fast-moving water.

But now there is hope for communities falling prey to the centuries-old disease. Recently, doctors discovered that ivermectin, originally developed for use against livestock parasites, protects people from the disease's worst symptoms, including blindness. Although it cannot restore the sight of those already blinded, the drug can protect the children and may be the beginning of the end of the ancient scourge.

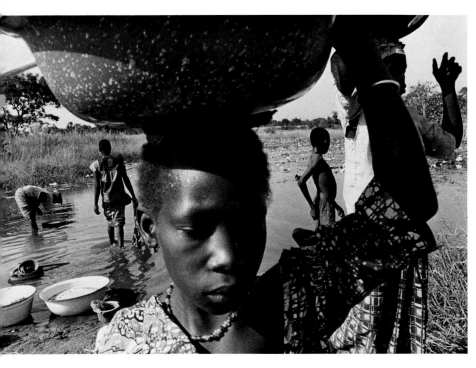

Women bathe in a river where black flies, carriers of the parasites that cause river blindness, often breed.

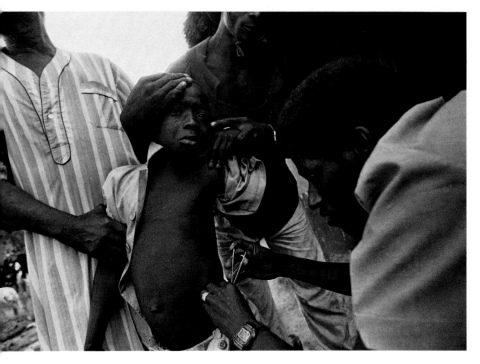

Doctors can detect the presence of onchocerciasis simply by snipping bits of skin and examining them under a microscope.

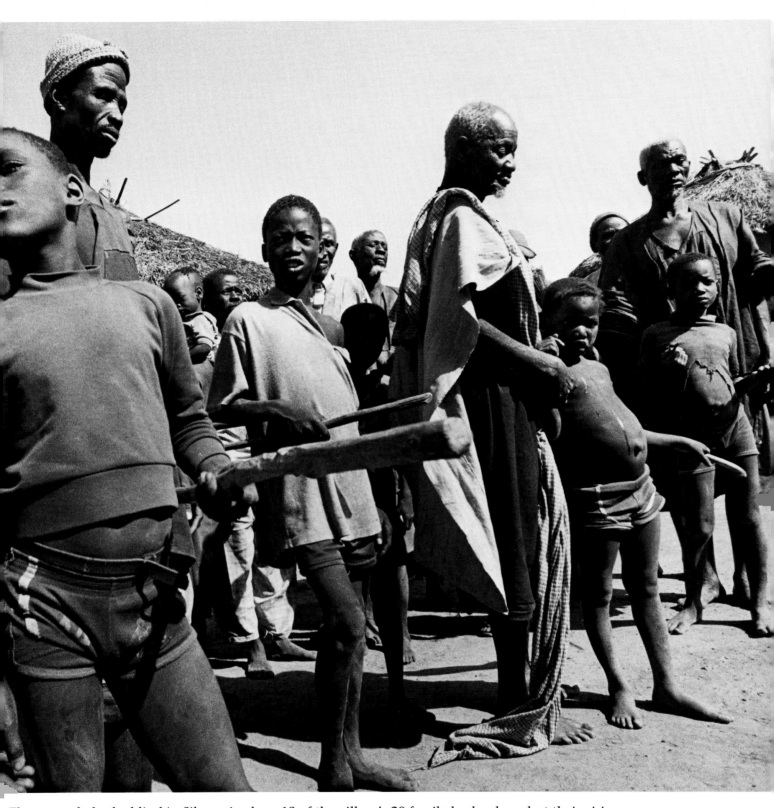

The young help the blind in Sikoroni, where 13 of the village's 20 family leaders have lost their vision.

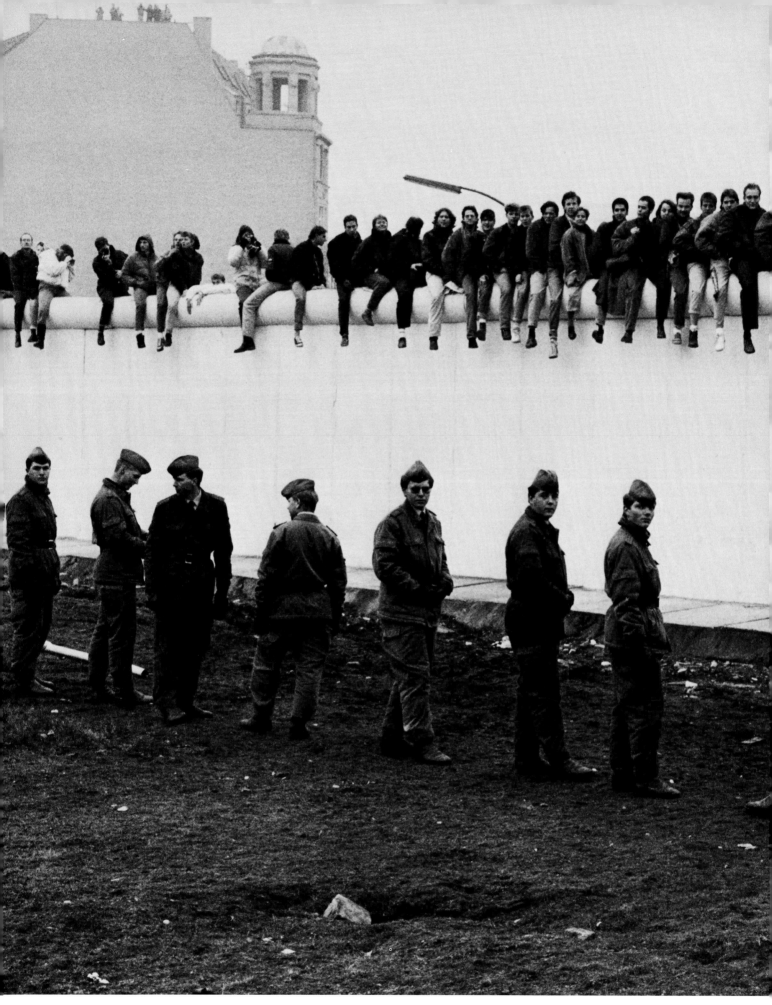

East German guards stand by passively as revelers perch on the Berlin Wall.
JAMES NACHTWEY FOR THE NEW YORK TIMES, 3RD PLACE

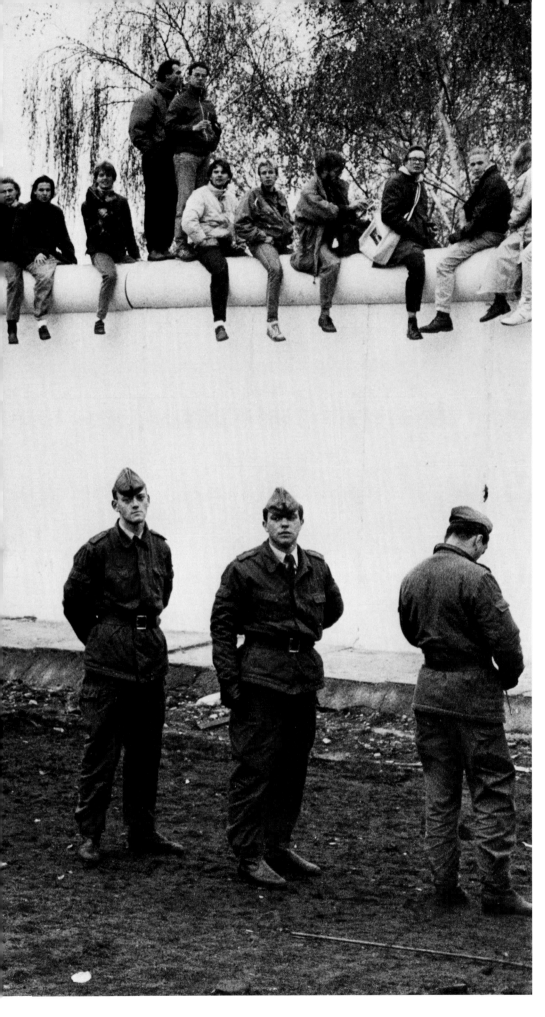

A new spirit at The Wall

For 28 years, the Berlin Wall had divided the East from the West, barring East Germans from freedom. Desperate people attempting to escape to the West would jump from windows at the wall's Bernauerstrasse passage. East German soldiers would shoot any citizens who tried to flee.

Eighty East Germans reportedly have been killed trying to escape over the wall since 1961. The last fatality occurred March 8, 1989.

In November, the border opened. Berliners celebrated at the site where people before had risked their lives for freedom. East German soldiers who previously were ordered to stop escapees with a bullet now helped East Berliners scale the fortification. After almost 30 years of separation, Berlin once again was whole.

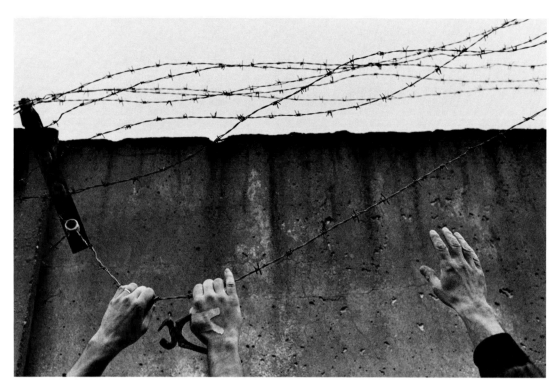

East Berliners clip pieces of the barbed wire to keep as souvenirs.

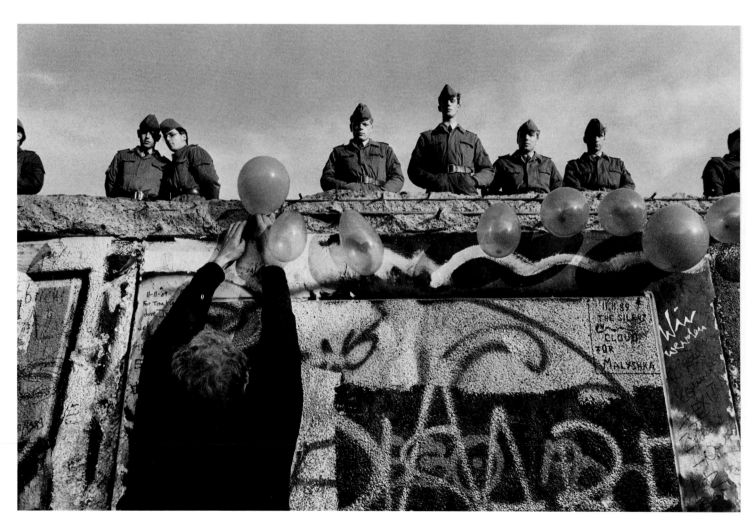

Once the symbol of oppression, the Berlin Wall becomes a place for celebration.

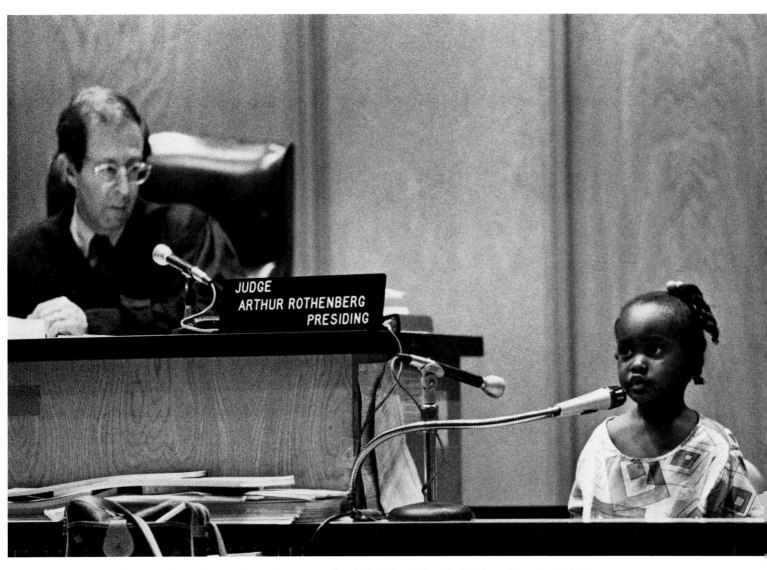

Five-year-old Jennifer Royal testifies against the man who killed her friend, Chelsea "Peaches" Wiley.
JAMES KAMP FOR LIFE, AWARD OF EXCELLENCE

The youngest witness

Jennifer Royal was only 4 years old when she became a victim of the violence that rules so many urban American neighborhoods. On a July day in 1988, Jennifer was playing in Liberty City, Fla., with her best friend, Chelsea "Peaches" Wiley, when they were caught in a drug-related shooting. Eight-year-old Chelsea was killed, and Jennifer was wounded.

The little girl, believed to be the youngest person to testify at a murder trial in the United States, recalled during the 1989 trial the day she was hurt.

"He shot me. It scared me. When the bullet got me it felt like a firecracker. . . . Peaches almost made it. Then I knew Peaches was dead."

Jennifer's assailant, Michael Ward, 25, was convicted, and the judge sentenced him to 80 years in prison, the maximum sentence allowable.

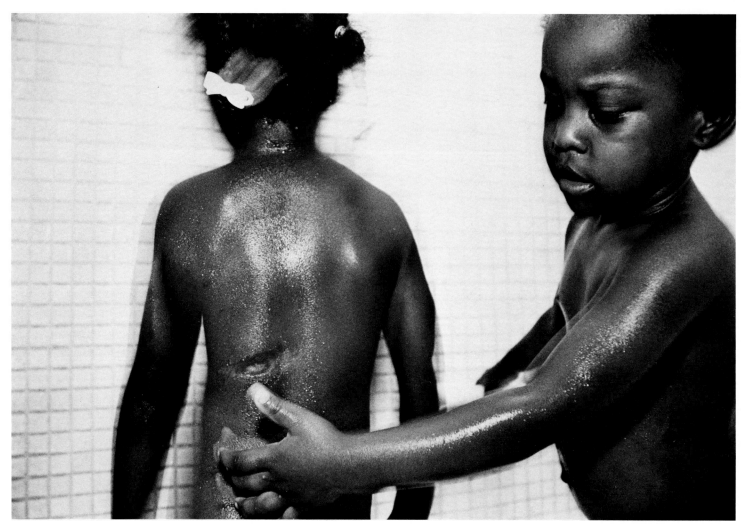

Jennifer's sister, Jaime, examines the scar left by the shooting. The bullet missed Jennifer's spine by inches.

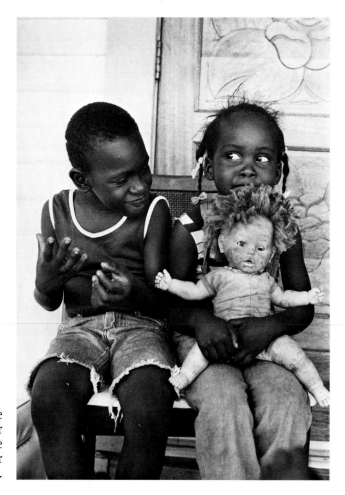

Jennifer sits on the porch of her grandmother's house holding one of her favorite toys.

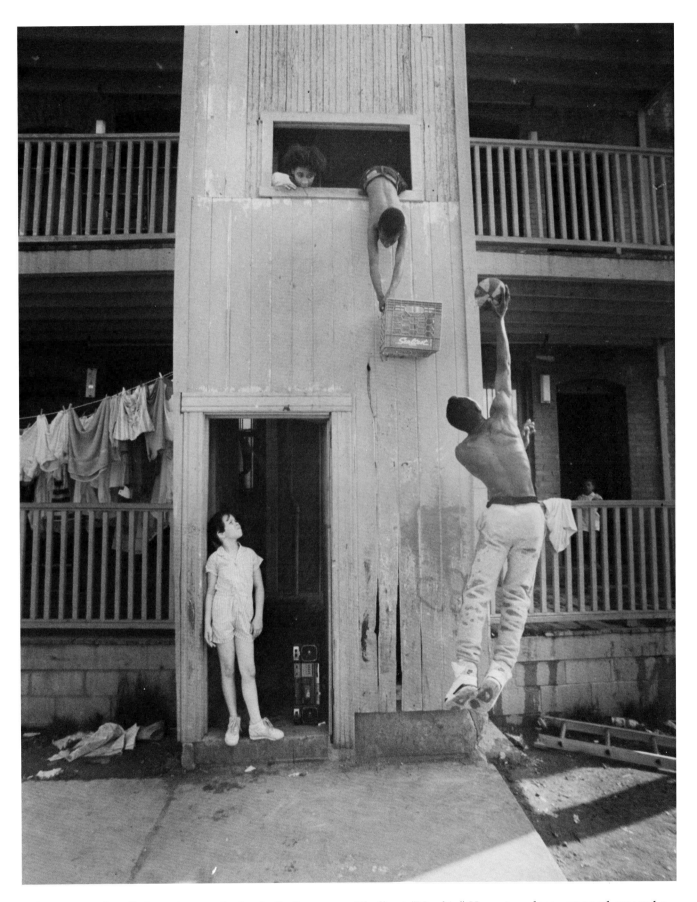

A flimsy wood wall doesn't stop the basketball game as Thelbert "Nookie" Hampton, legs wrapped around a stairwell handrail, holds the makeshift hoop for neighbor Joe Brown's hook shot.
BRADLEY E. CLIFT, THE HARTFORD (CONN.) COURANT, 2ND PLACE

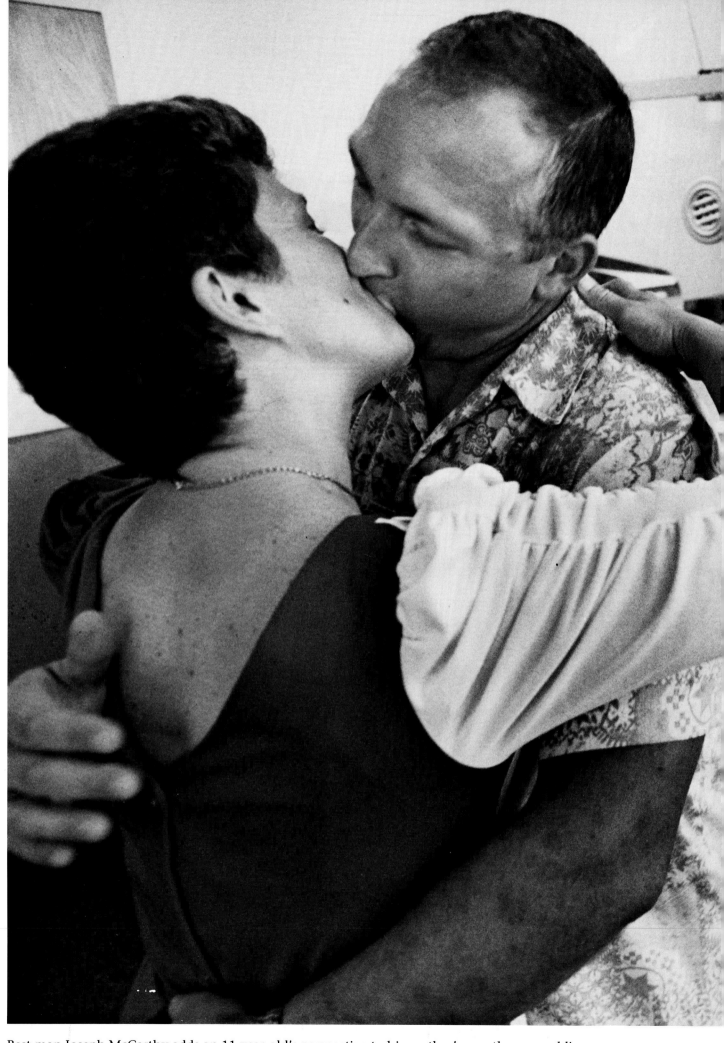

Best man Joseph McCarthy adds an 11-year-old's perspective to his mother's courthouse wedding.
CHRIS USHER, THE ORLANDO (FLA.) SENTINEL, 1ST PLACE

NEWSPAPER FEATURE PICTURE

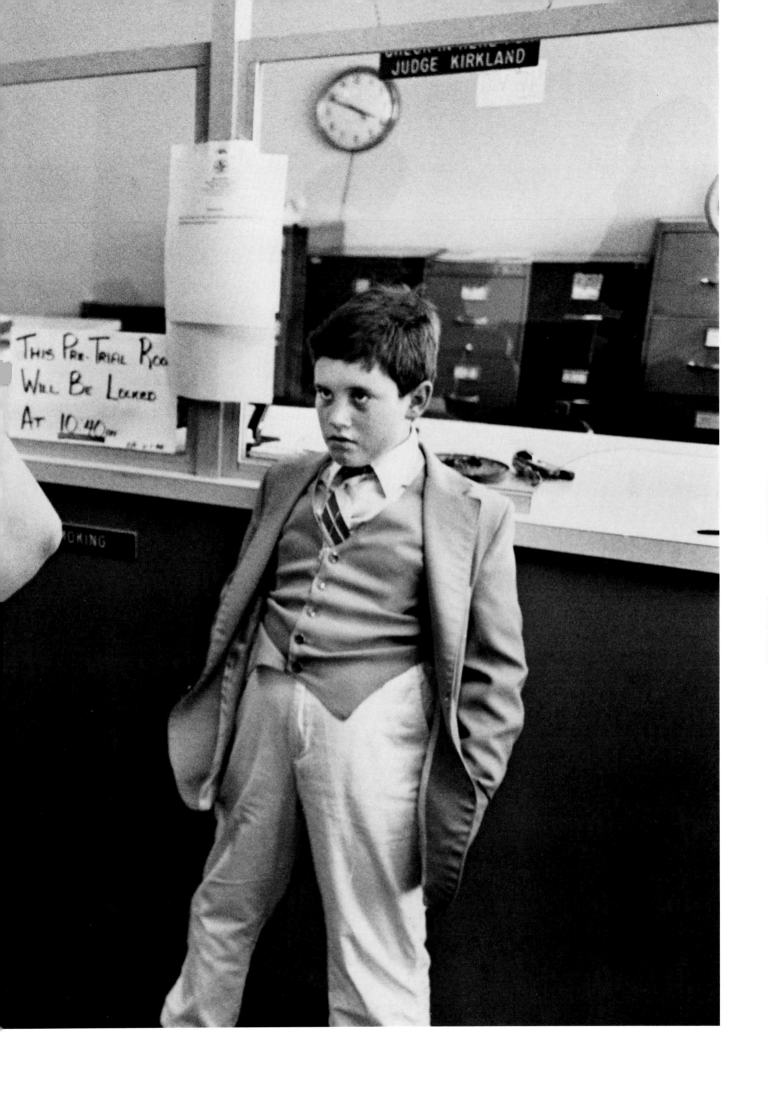

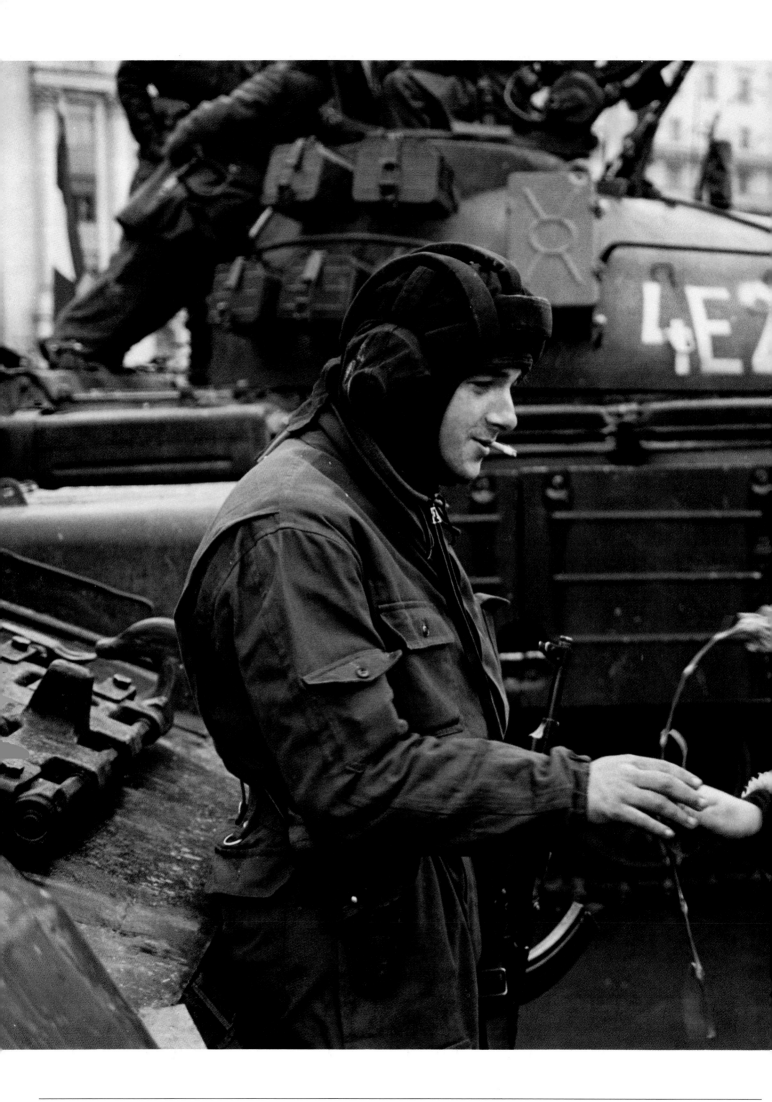

NEWSPAPER FEATURE PICTURE

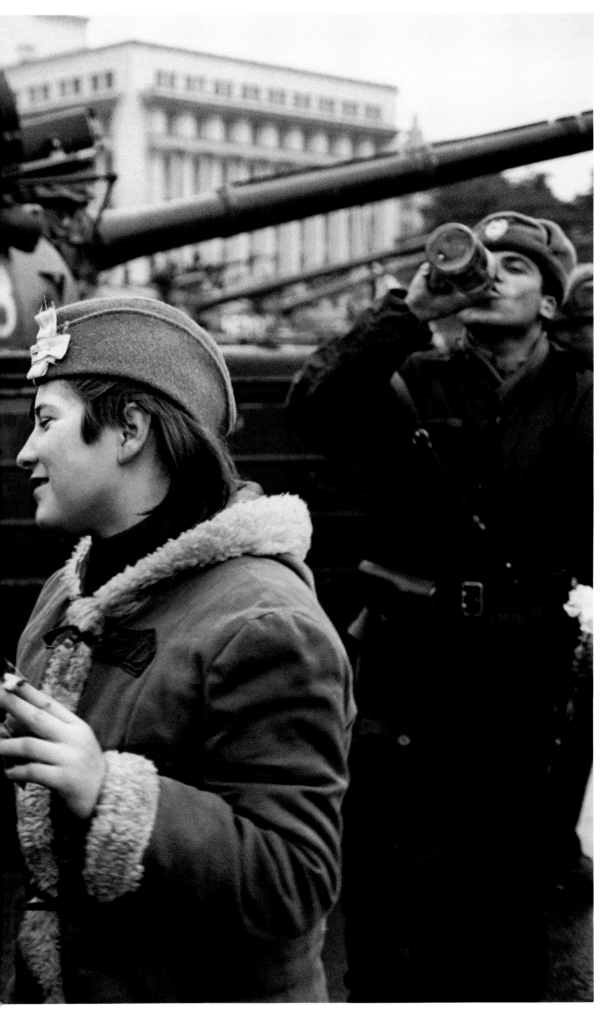

In December, the Romanian government of Nicolae Ceausescu was overthrown in a popular uprising supported by the army. After the fighting subsided, residents tried to resume normal lives. Here, a woman gives her soldier boyfriend a flower in Bucharest's Victory Square.
MICHAEL S. WIRTZ, THE PHILADELPHIA INQUIRER, 3RD PLACE

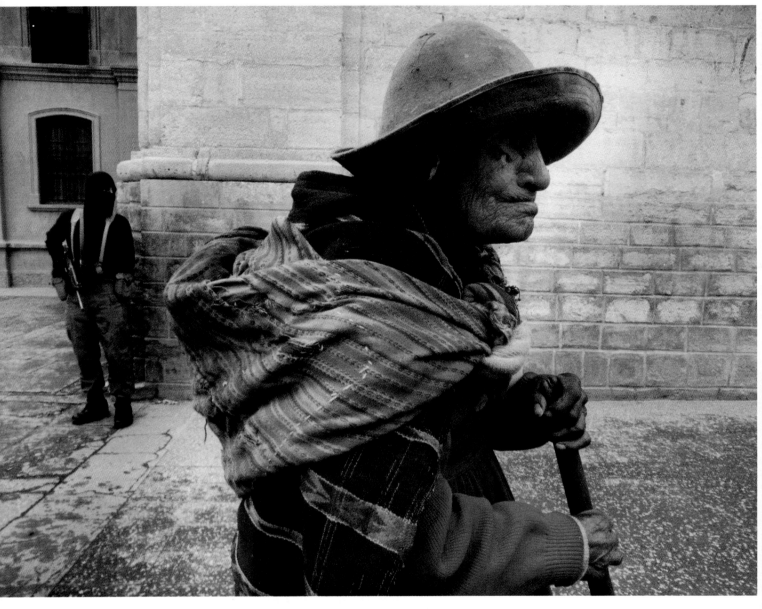

In Huancayo, Peru, an Indian woman walks past a government soldier, who wears a ski mask to hide his identity from Maoist rebels in the area.
DAVID LEESON, THE DALLAS MORNING NEWS, AWARD OF EXCELLENCE

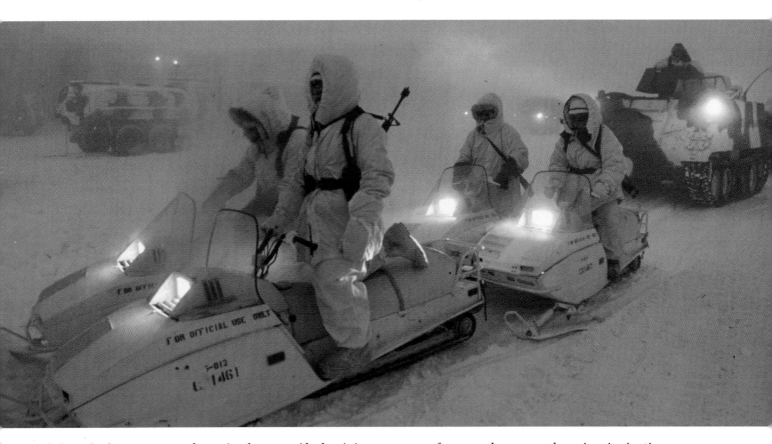

National Guard advance scouts from Anchorage, Alaska, join a convoy of armored personnel carriers in Arctic war exercises near Fairbanks.
JIM LAVRAKAS, ANCHORAGE DAILY NEWS, *AWARD OF EXCELLENCE*

A Buddhist nun performs one of her daily chores at her temple in Hacienda Heights, Calif.
ELAINE ISAACSON, THE ORANGE COUNTY REGISTER, *AWARD OF EXCELLENCE*

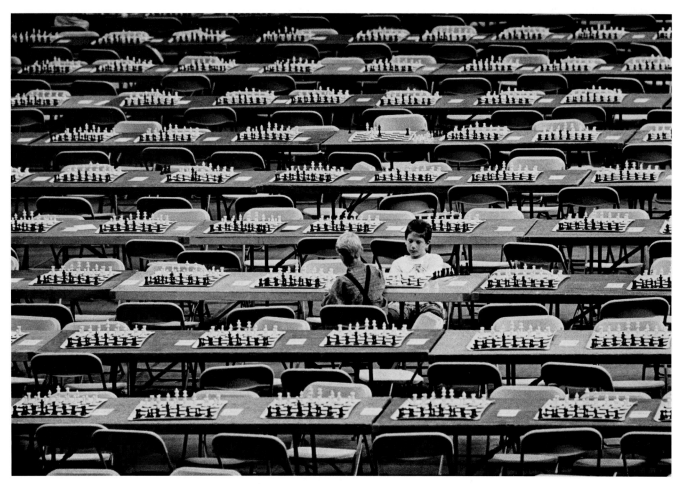

Two boys keep at their game long after others have finished during the National Elementary Chess Tournament in Tempe, Ariz.
JAMES GARCIA, THE PHOENIX (ARIZ.) GAZETTE, AWARD OF EXCELLENCE

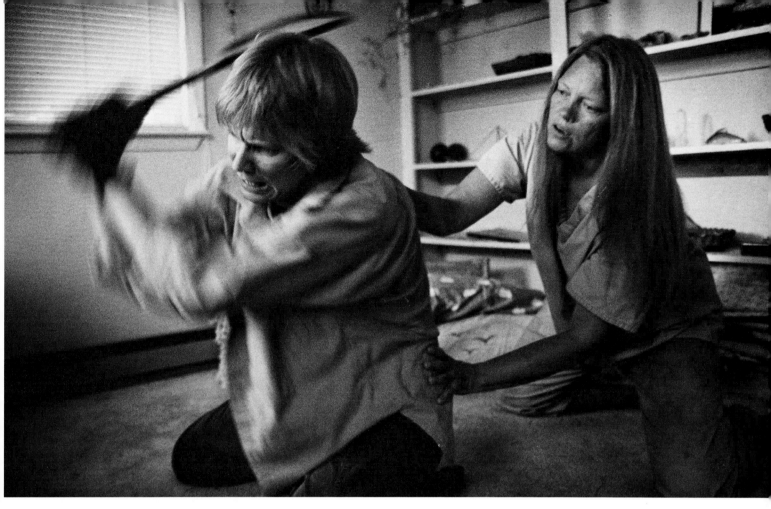

Barb Jackson, a victim of childhood incest, uses a tennis racquet to smash a couch as she fights back her childhood assailant during a session with her therapist.
JOANNE RATHE, THE BOSTON GLOBE,
AWARD OF EXCELLENCE

Mary Ann Crompton plays a soothing lullaby on her harp to help premature babies sleep peacefully in a hospital intensive-care unit.
GARY ALLEN, THE RALEIGH (N.C.) NEWS & OBSERVER,
AWARD OF EXCELLENCE

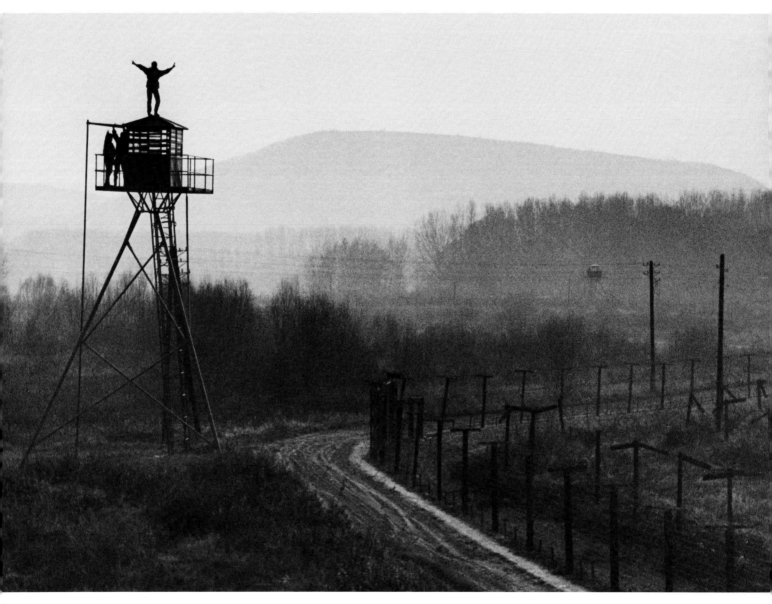

A Czech youngster plays on an abandoned guard tower near the village of Devin, where the Iron Curtain along the border of Austria was dismantled.
CAROL GUZY, THE WASHINGTON POST, AWARD OF EXCELLENCE

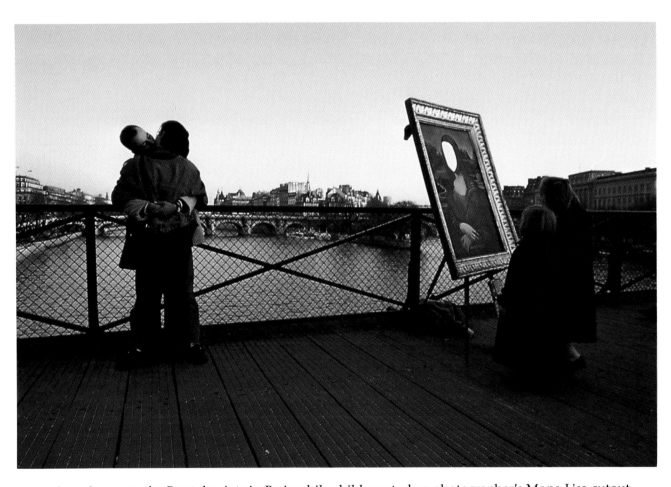

A couple embrace on the Pont des Arts in Paris while children study a photographer's Mona Lisa cutout.
JAMES L. STANFIELD, NATIONAL GEOGRAPHIC
AWARD OF EXCELLENCE

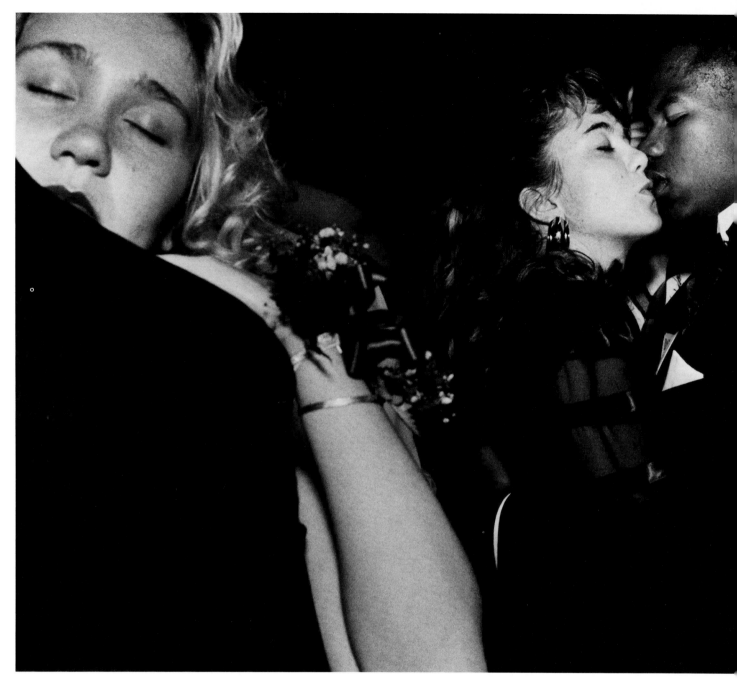

Couples dance at the Barkeley High School Prom. The mood was set by the prom's theme, "Let it last forever."
DONNA FERRATO, BLACK STAR FOR LIFE, 3RD PLACE

Tom, a beggar in New York City, crawls out of the subway shaft where he sleeps.
EUGENE RICHARDS, MAGNUM
AWARD OF EXCELLENCE

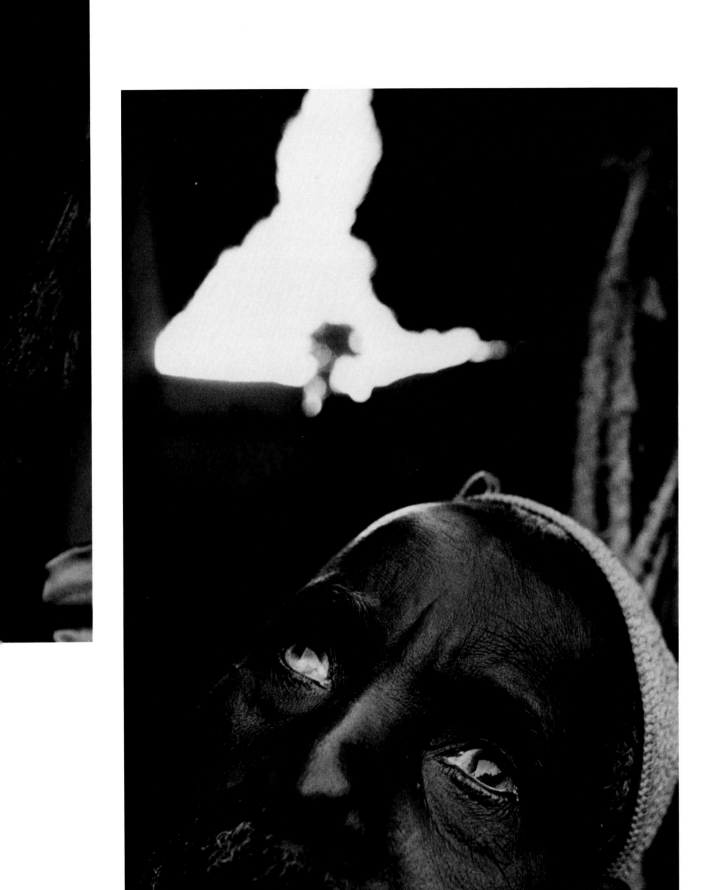

A grandfather of the Malinke tribe in Morigbedow, Guinea, sits in the shade between huts. His eyes show the scars of river blindness, a scourge that has affected 300,000 people.
EUGENE RICHARDS, MAGNUM, 2ND PLACE

An Indonesian worker hoists the symbol for Allah to the top of a new mosque.
CHUCK O'REAR FOR NATIONAL GEOGRAPHIC, 1ST PLACE

MAGAZINE FEATURE PICTURE

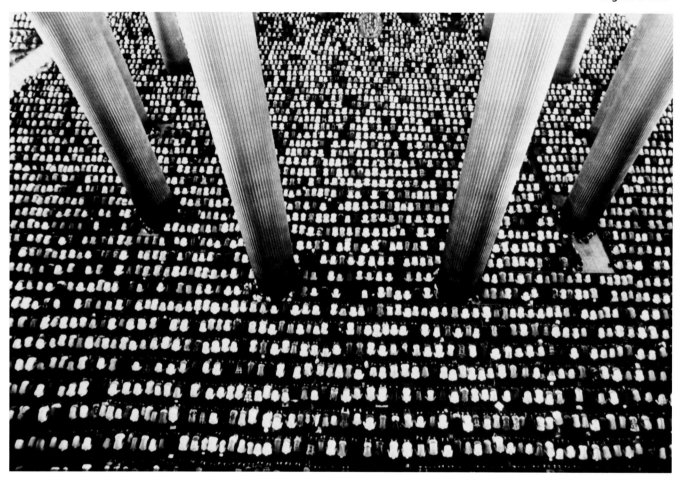

In Jakarta Mosque, the largest in Asia, 7,000 men bow toward Mecca during Friday afternoon prayers.
CHUCK O'REAR FOR NATIONAL GEOGRAPHIC, AWARD OF EXCELLENCE

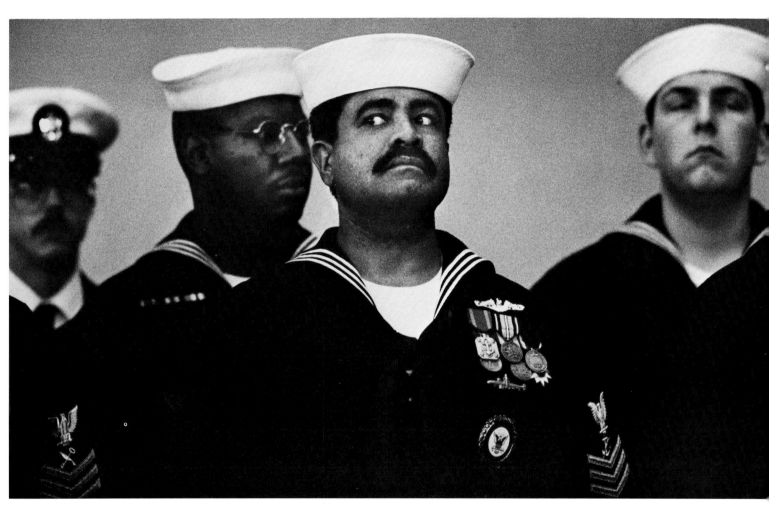

Ever watchful, a sailor stands at attention for full-dress inspection at a traditional Navy change-of-command ceremony.
MELISSA FARLOW, THE PITTSBURGH PRESS, 1ST PLACE

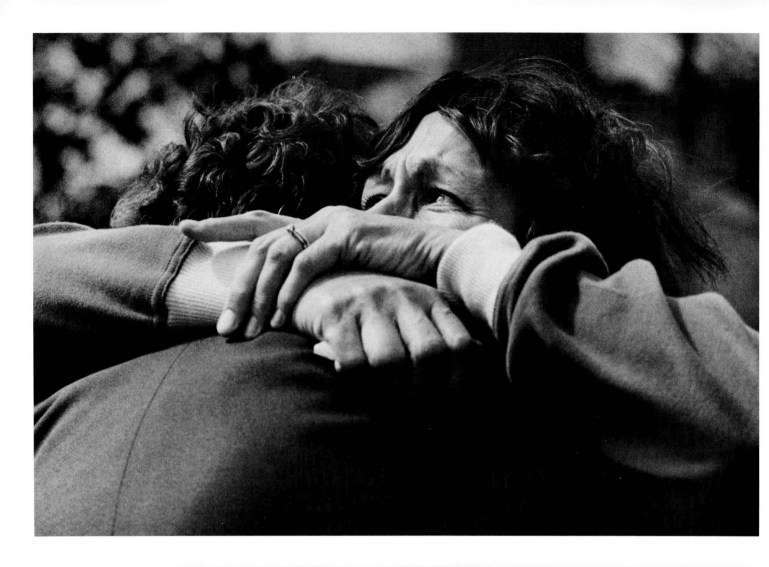

In April, families of those who died in the crash of Pan Am Flight 103 in December 1988 gathered for a memorial in Washington, D.C. They vowed to continue pressing legislators to find the terrorists who blew up the plane over Lockerbie, Scotland, killing all 259 people on board and 11 people on the ground.

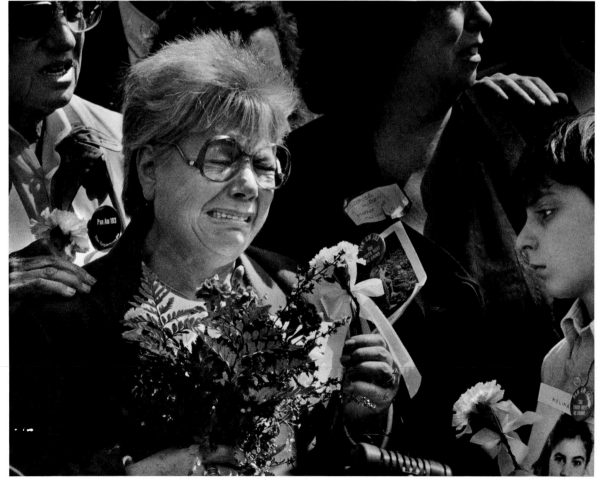

"Pineapple Upside Down Cake"

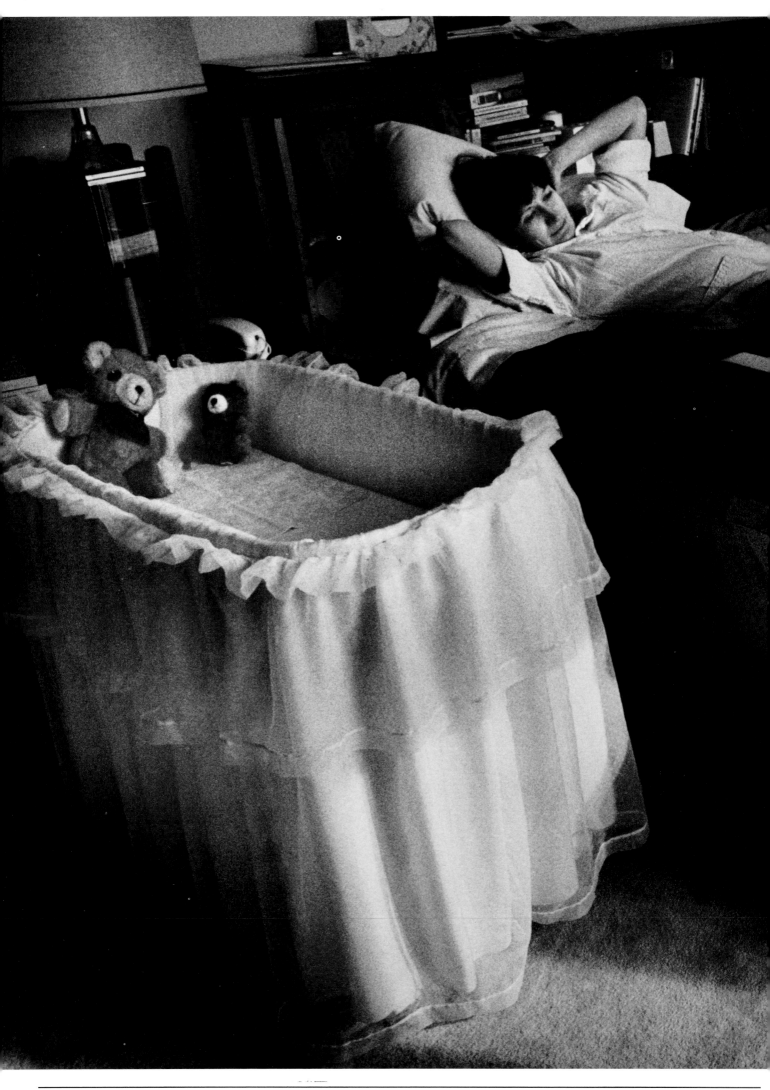

ONE WEEK'S WORK / *MELISSA FARLOW, 1ST PLACE*

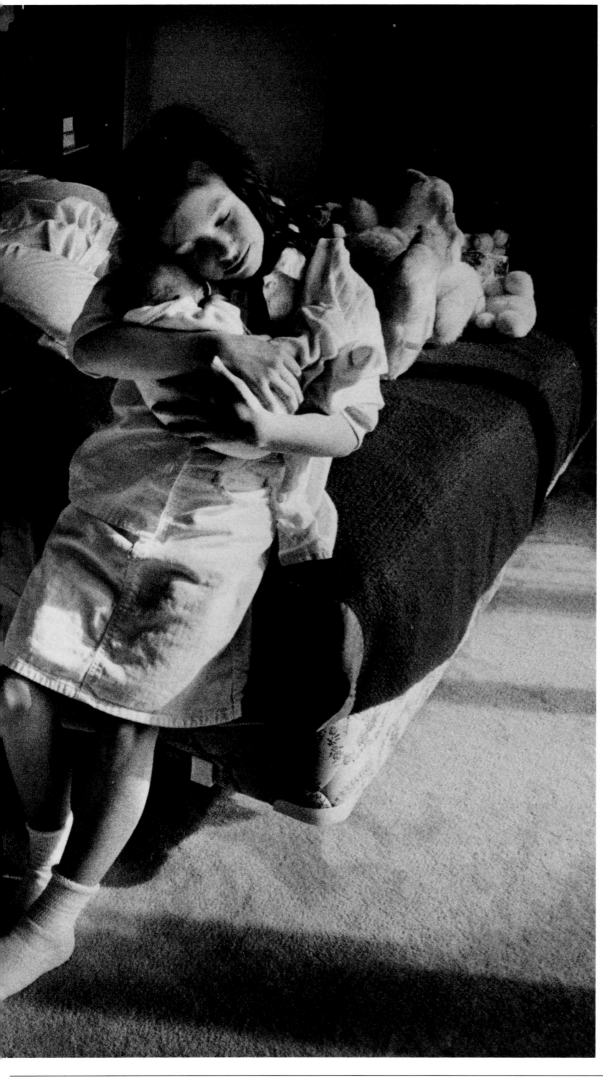

Kim Albright cuddles her new sibling as their mother relaxes. The photo was part of a series on bringing a baby into the family.

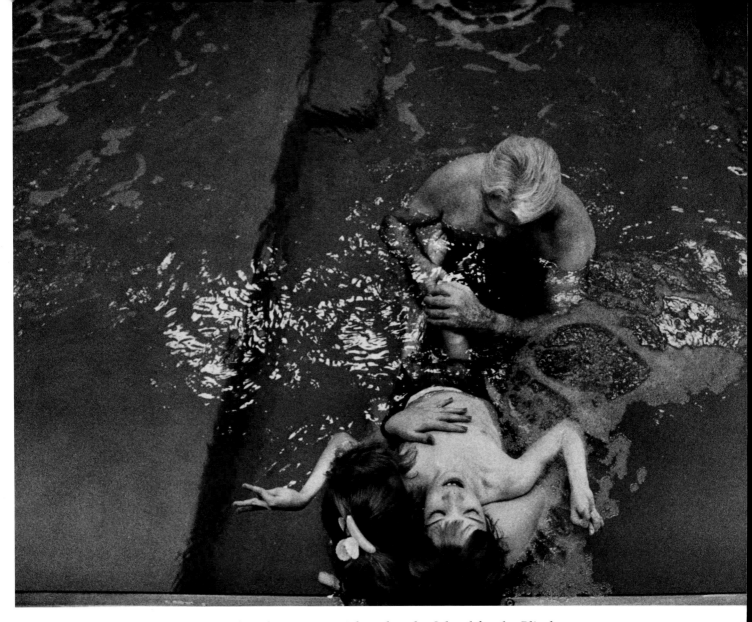

A therapist works with a handicapped student in a special pool at the School for the Blind.

Police use dogs to look for explosives after a telephone threat was made to the Port Authority Transit saying a bomb had been planted in a Pittsburgh trolley.

ONE WEEK'S WORK / *MELISSA FARLOW, 1ST PLACE*

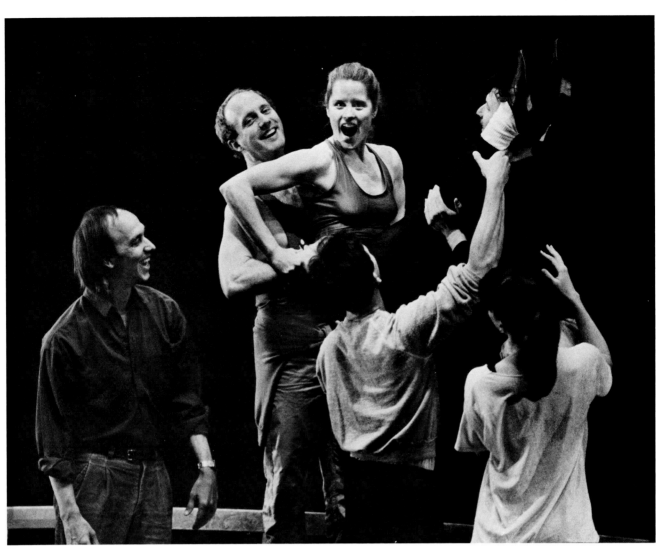

Members of the Dance Alloy Troupe nearly drop a dancer while hoisting her above their heads in rehearsal.

Dressed for the occasion, a little girl watches her father receive a special commendation from the mayor for saving a man's life by rescuing him from a burning building.

Newfound High School shortstop Randy Bucklin (left) and second baseman John Jenness play "who's got it" and both miss the ball on an infield pop-up in a game in Bristol, N.H.
DAN HABIB, CONCORD (N.H.) MONITOR, 2ND PLACE

ONE WEEK'S WORK

Joe Zanca (left) helps a firefighter in New Hampshire. Zanca was driving home when he saw the brush fire and stopped.

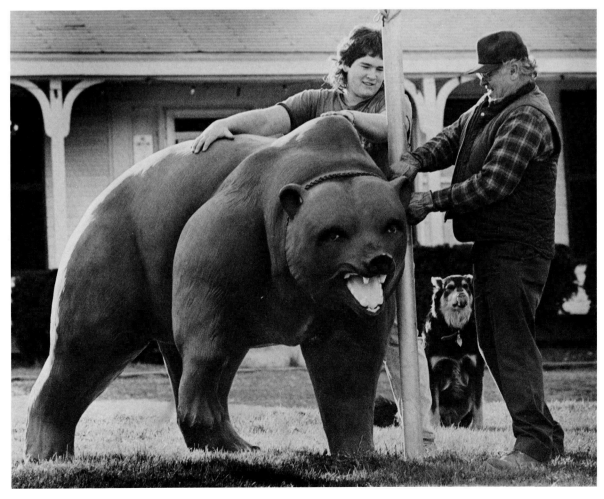

Erving Lane and his son, Jon, return a fiberglass bear to their front yard, where it has stood sentry duty for the past 15 summers. The bear hibernates in the barn every winter.

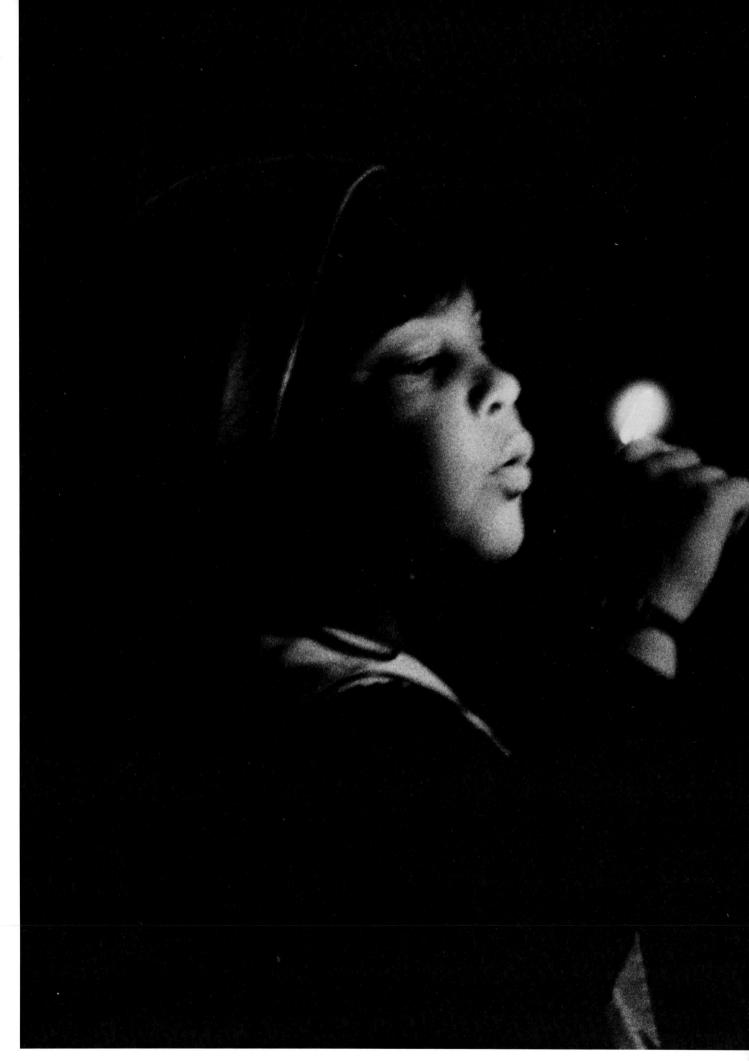

Rebekah Routos, 5, lights the candelabra for Mass at her Greek Orthodox church in Concord, N.H.

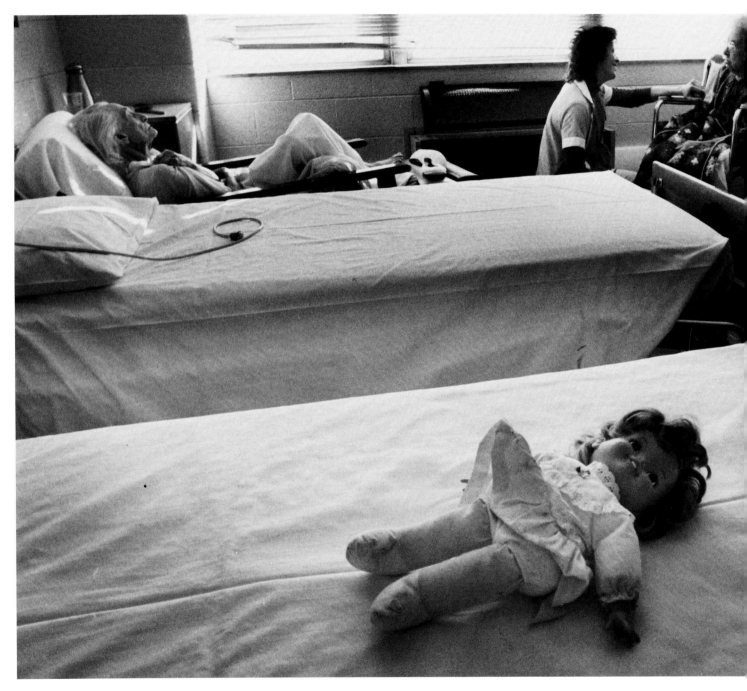

A child's baby doll rests on the bed of a 100-year-old patient at a home for the elderly.
MICHAEL FENDER, THE INDIANAPOLIS NEWS, 3RD PLACE

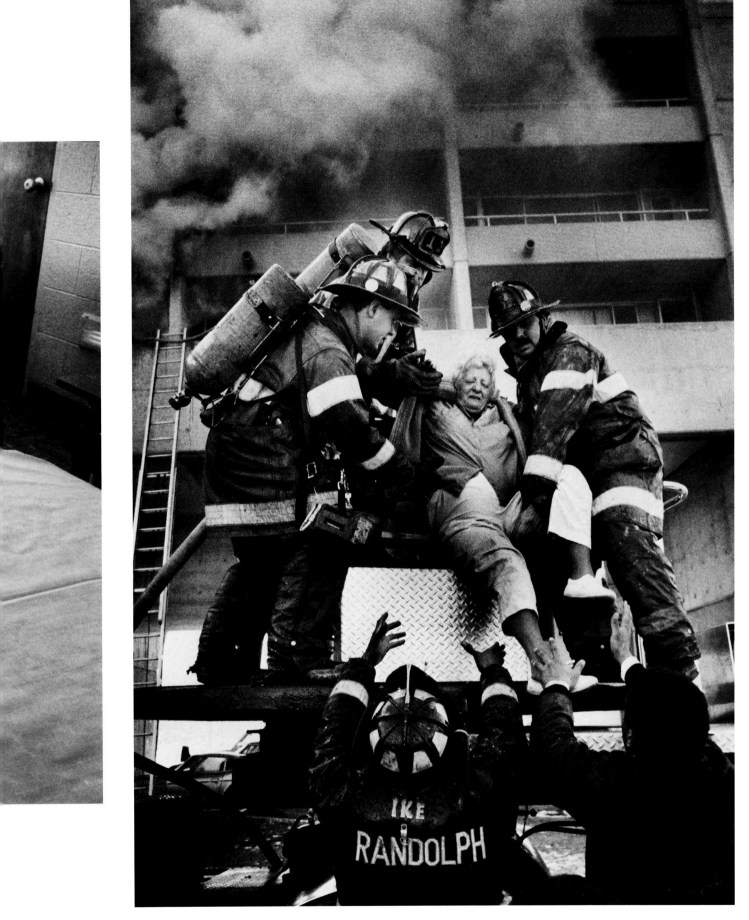

Firefighters rescue a 70-year-old woman from a burning apartment building in Indianapolis.

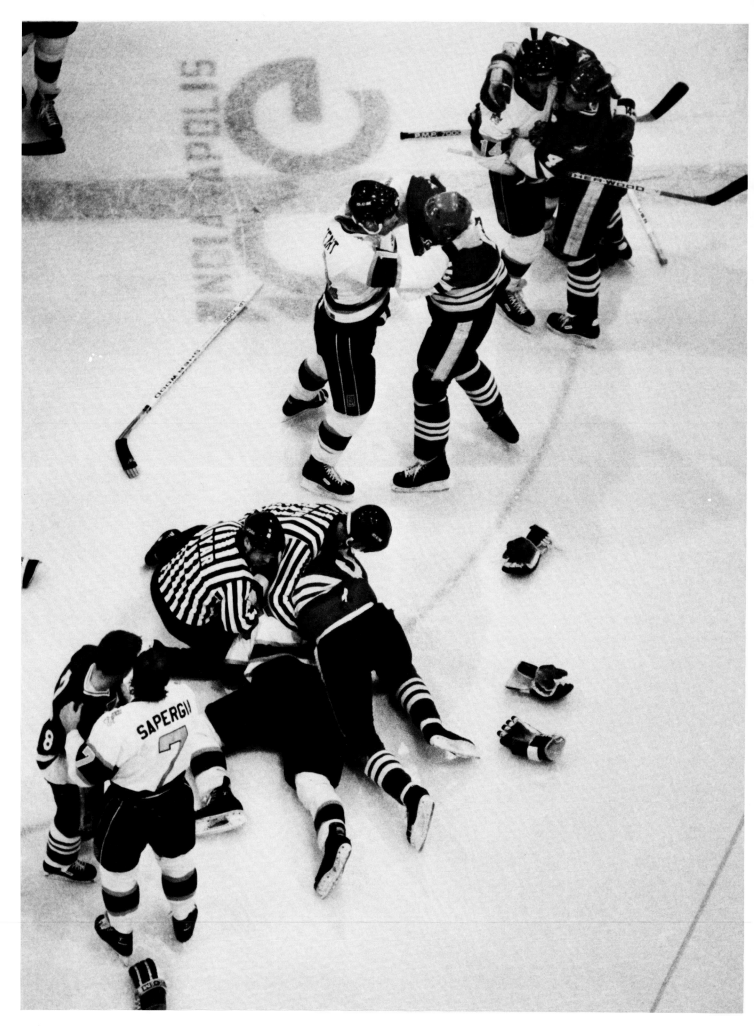

Referees try to break up a fight during an Indianapolis Ice minor league hockey game.

Original in color

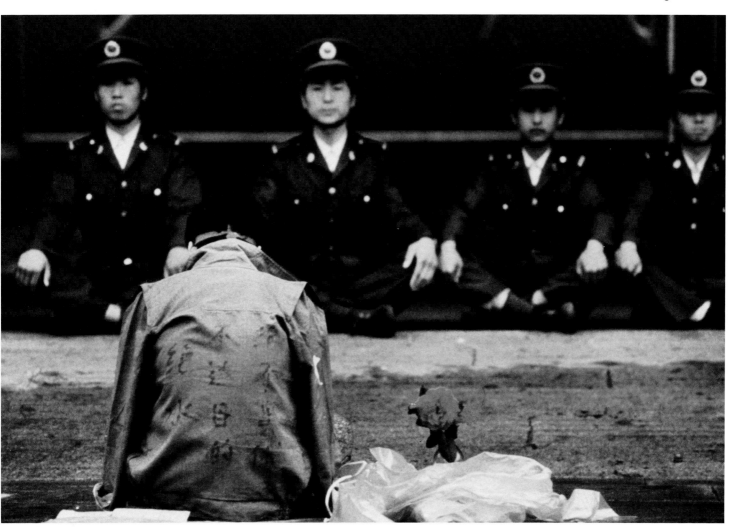

A lone striker matches wills against soldiers guarding Zhongnanhai, Beijing's seat of power.
KEN JARECKE, CONTACT PRESS IMAGES FOR TIME, 1ST PLACE

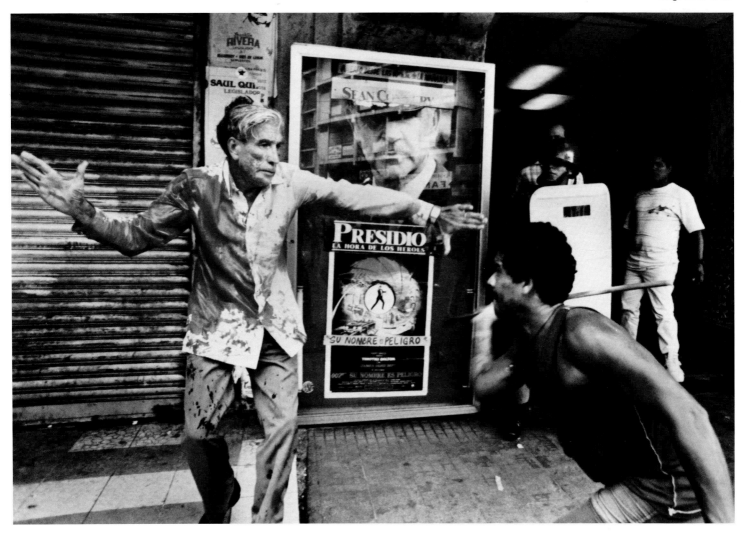

Panamanian vice-presidential candidate Guillermo Ford is beaten bloody by a member of Gen. Manuel Antonio
Noriega's "Dignity Batallion" after Noriega voided the results of May's elections.
RON HAVIV, AGENCE-FRANCE PRESS, 2ND PLACE

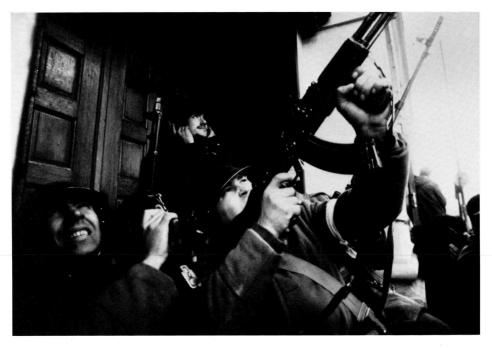

Members of the People's Guard return fire during a street battle with Nicolae
Ceausescu's secret police in Bucharest, Romania, in December.
GEORGES MERILLON, GAMMA LIAISON FOR TIME
AWARD OF EXCELLENCE

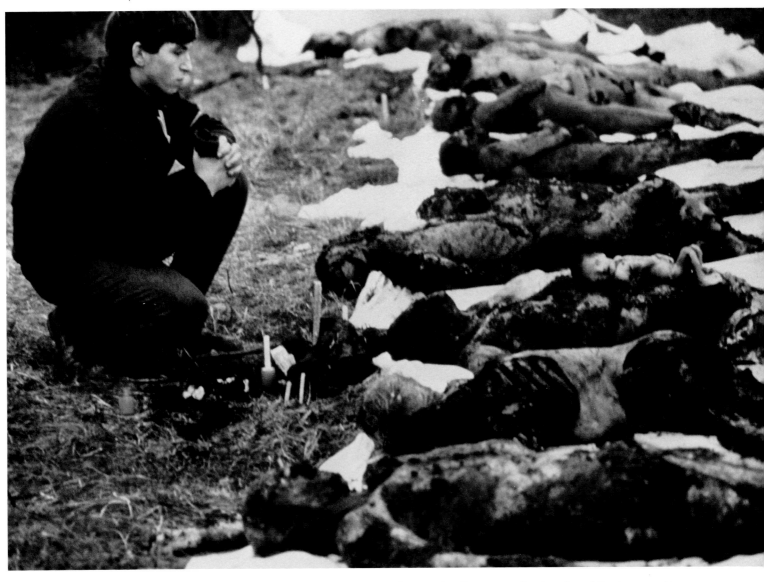

A man prays for Romanians found in a mass grave in Timisoara, Romania. Ceausescu had ordered their executions.
GILLES SAUSSIER, GAMMA LIAISON FOR TIME, 3RD PLACE

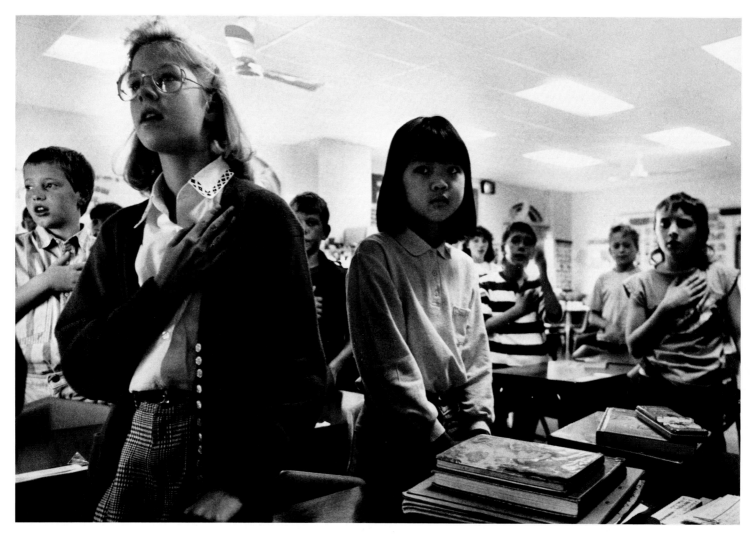

Mychiko Fujito, 10, a newcomer to the United States, stands silent as her classmates recite the Pledge of Allegiance.
CHIEN-CHI CHANG, INDIANA UNIVERSITY, AWARD OF EXCELLENCE

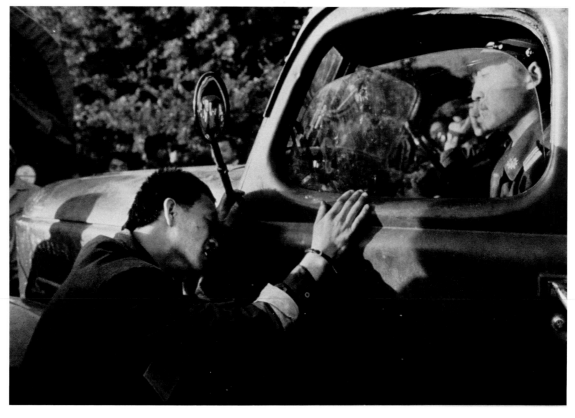

A Chinese dissident begs Communist soldiers to join pro-democracy demonstrations.
PETER TURNLEY, BLACK STAR, AWARD OF EXCELLENCE

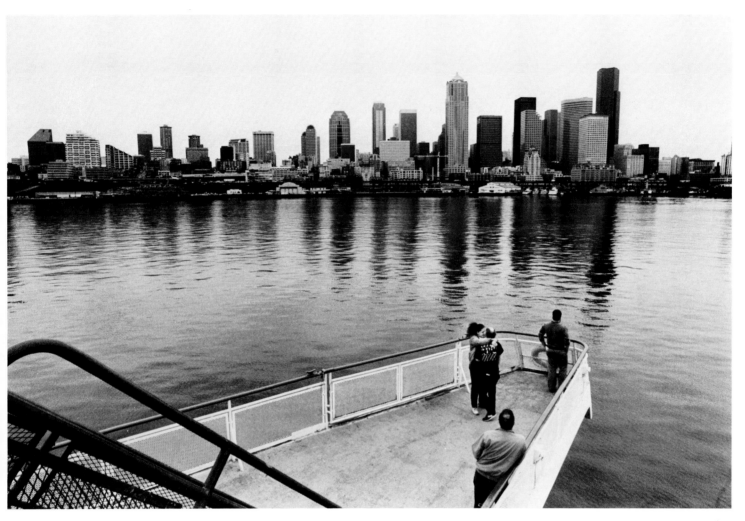

The Seattle skyline becomes more cluttered every year, yet the city continues to top many "most livable cities" lists.
ALAN BERNER, THE SEATTLE TIMES, 2ND PLACE

Seattle's growing pains

In November, *The Seattle Times* published "The Peirce Report," a seven-part series examining growth in the Puget Sound region of Washington. The newspaper hired Neal Peirce, an author and columnist who specializes in state and local issues, to assess the area's problems and suggest directions for positive growth.

In their report, Peirce and two other urban-affairs experts concluded that the Puget Sound area was beginning to succumb to the worst problems of growth: congestion, sprawl, divisive government, poverty and declining social-service and education systems.

The Seattle Times presented the team's conclusions and recommendations in a series that could prompt readers to understand and discuss the problems. The series ran with Alan Berner's photos, which captured the essence of the area's growing pains.

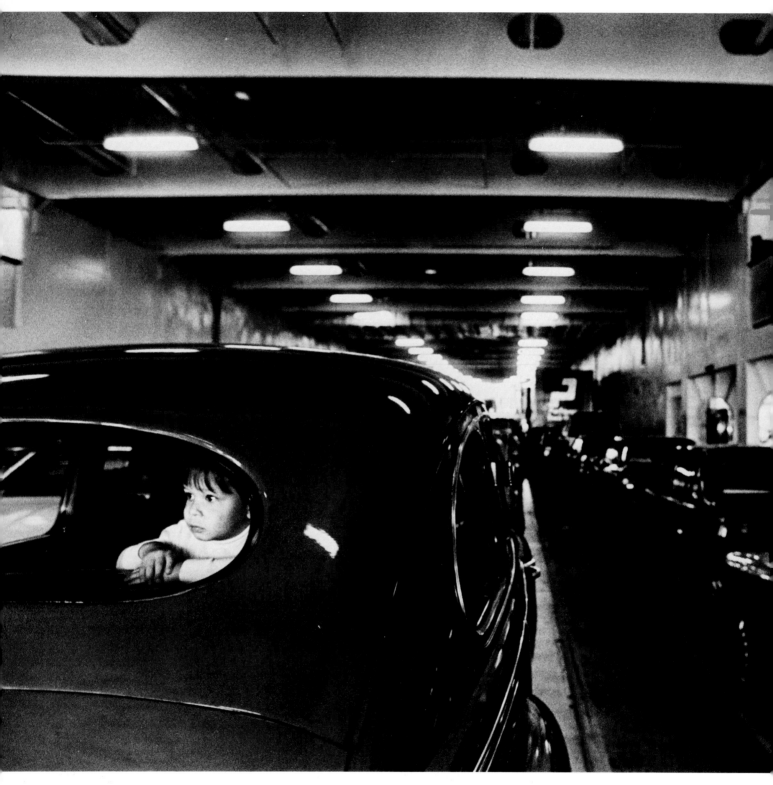

People traveling from their suburban homes to Seattle have turned the state's ferries into floating parking lots.

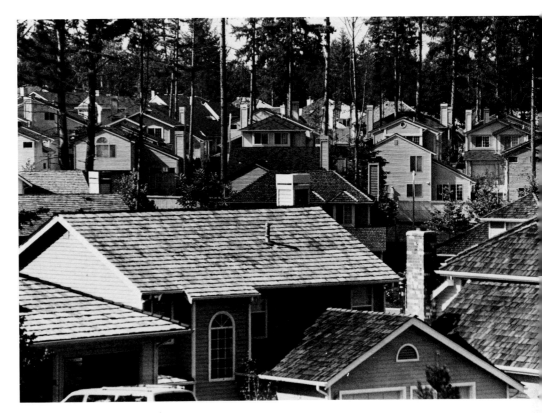

A new development of more than 1,000 homes exemplifies the area's growth.

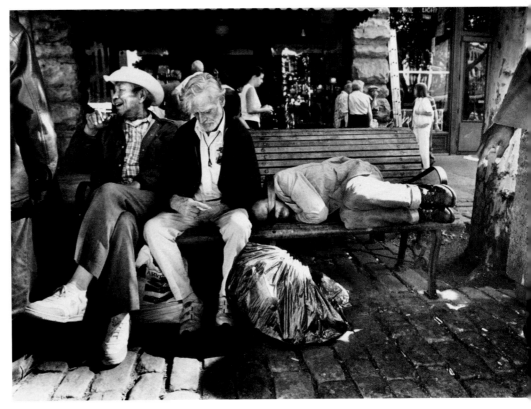

Edgar Saluskin (left) and his friend, Howard, usually sleep in Seattle's shelters and spend their days in the city's Pioneer Square.

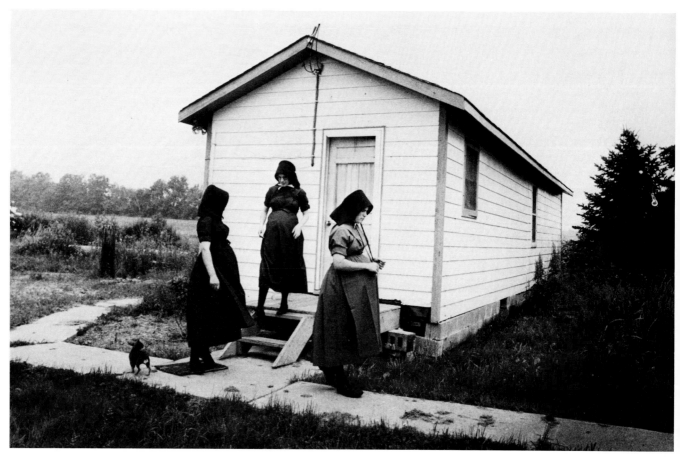

Amish women arrive at Lucille Sykes' clinic for their checkups.

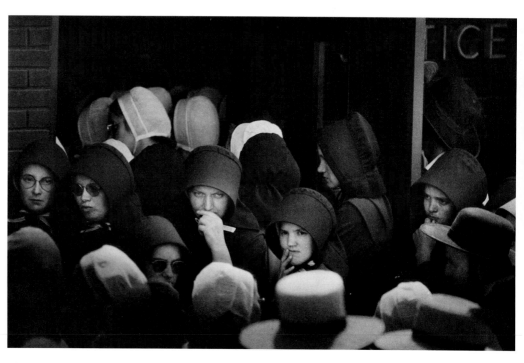

The normally shy Amish tolerate the media's presence during Lucille's trial.

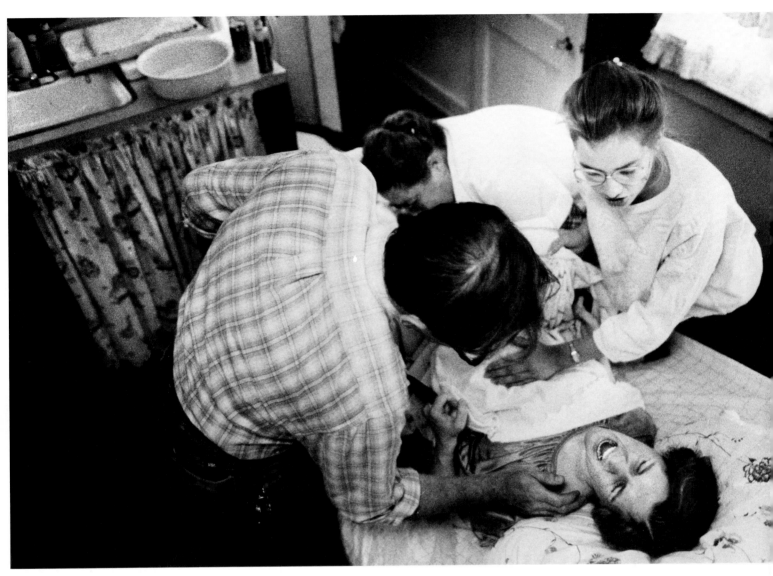

Lucille's trial hasn't kept her from her practice. Here, her daughter (right) assists in a delivery.
RANDY OLSON, THE PITTSBURGH PRESS, 3RD PLACE

Tradition on trial

Thirteen years ago, an Amish community in rural Pennsylvania moved a birth clinic onto Lucille Sykes' property and asked the lay midwife to deliver babies.

More than 600 deliveries later, Lucille's quiet practice was thrown into the limelight when a birth developed complications.

The child died en route to a hospital, and a criminal investigation was begun. The state brought charges against Lucille for operating as an unlicensed midwife.

The Amish rallied behind Lucille. More than 200 people gathered at the courthouse to protest the proceedings. They brought their children – the children Lucille had delivered – with them.

Lucille emerged victorious. The judge could not determine whether a state act that governed the licensing of medical professionals applied to midwives, so he threw out the case.

Despite warnings that more charges may be filed against her, Lucille continues her practice.

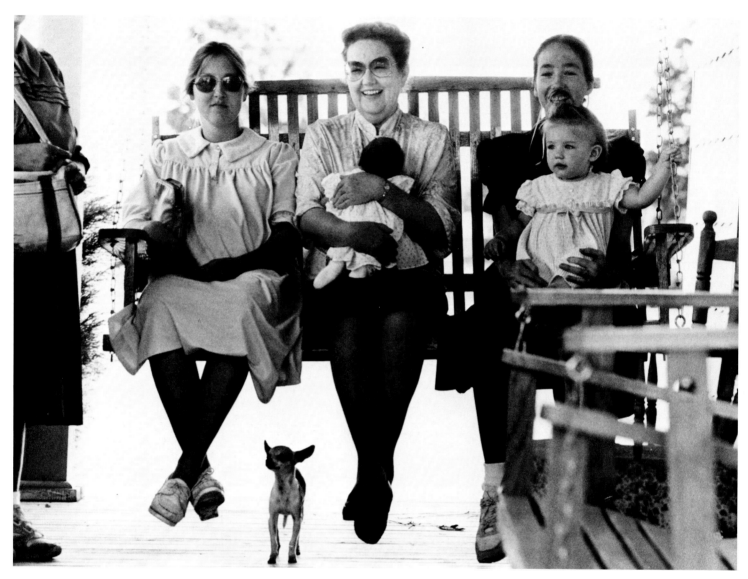

Lucille (center), relaxing on her porch, embraces one of the many babies she has delivered.

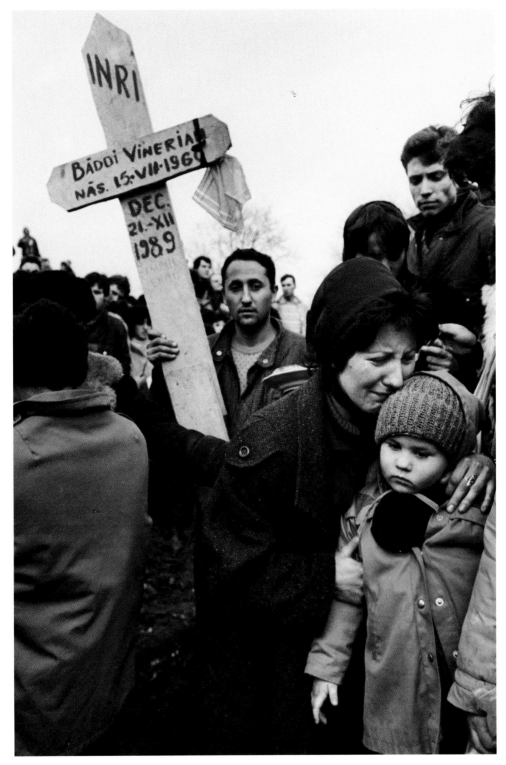

A child and her family mourn her father, who was killed by Ceausescu's forces.
DAVID C. TURNLEY, DETROIT FREE PRESS, 1ST PLACE

Revolution in Romania

In 1989, pro-democracy uprisings swept through Communist countries. The most violent revolution occurred in Romania, where the people united to oust dictator Nicolae Ceausescu.

On Dec. 21, after being jeered by a crowd during a speech in Bucharest, Ceausescu reportedly ordered his Securitate forces to fire on the citizens.

The next day, Ceausescu was chased from power. Army troops joined civilians in the revolution, fighting fiercely against Securitate forces.

Ceausescu and his wife, Elena, were convicted of genocide and "particularly grave crimes" against Romania.

The two were executed on Christmas.

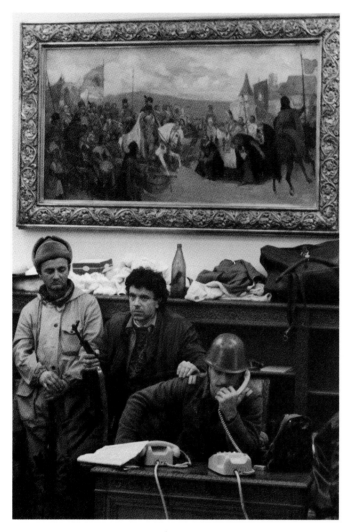

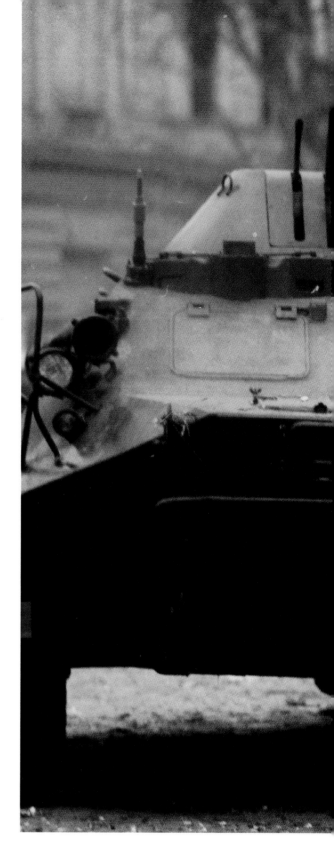

After Ceausescu's fall, militiamen set up business in his opulent office in Bucharest.

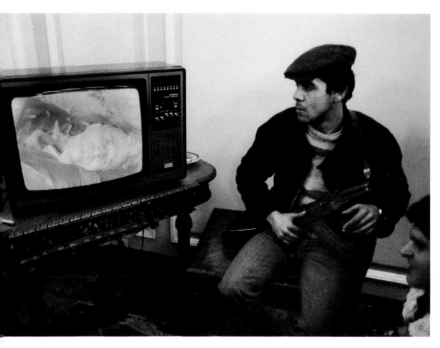

A Romanian militiaman watches Ceausescu's execution on the former leader's television.

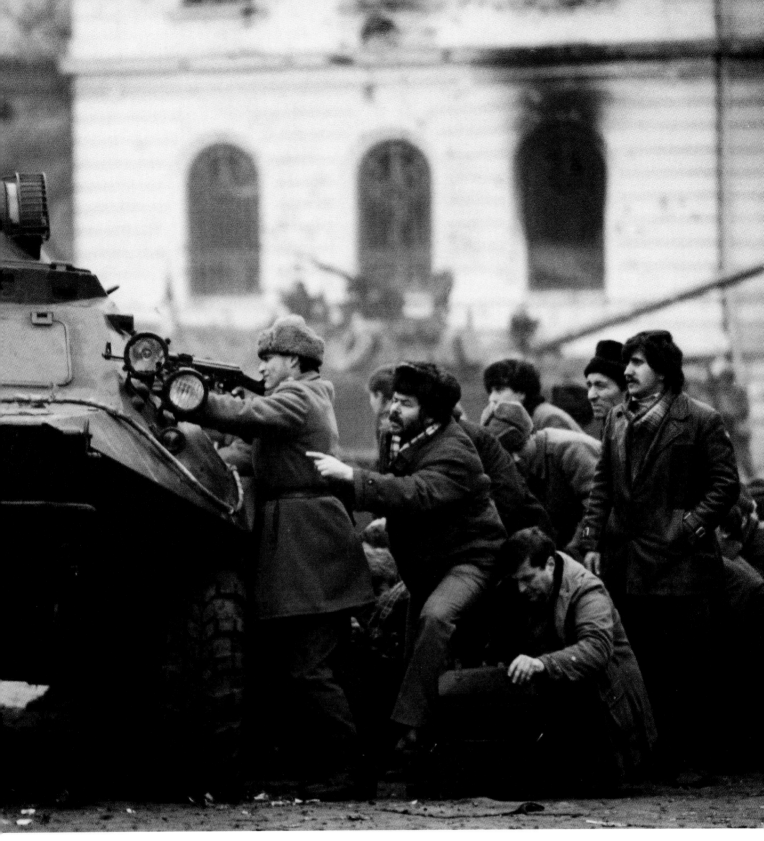

After the collapse of Ceausescu's regime, army soldiers band with citizens to continue fighting members of Ceausescu's dreaded Securitate in Bucharest. The anti-revolutionary forces were told to surrender or face trial.

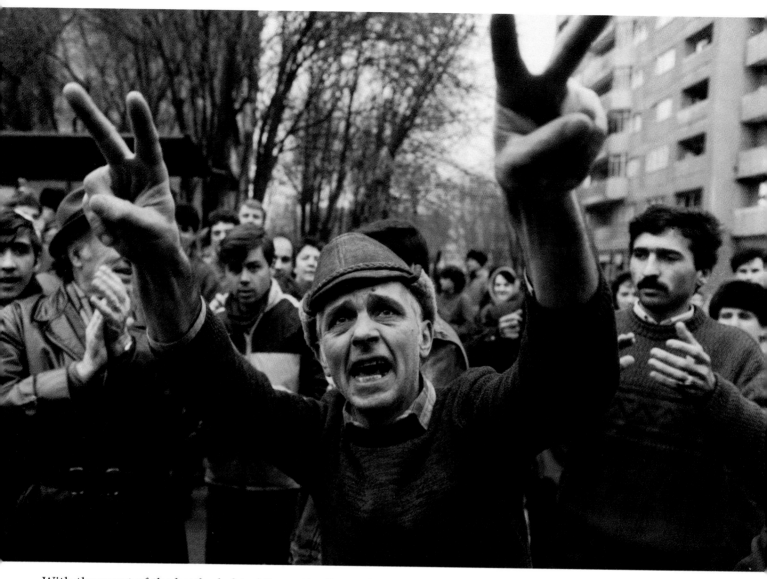

With the worst of the battles behind them, the Romanian people savor their victory.

NEWSPAPER NEWS PICTURE STORY / *DAVID C. TURNLEY, 1ST PLACE*

Alon Reininger, Contact Press Images

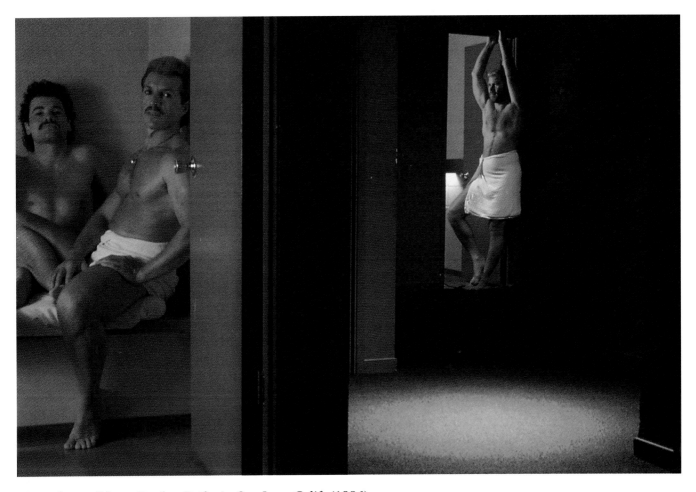

Men relax at Water Garden Baths in San Jose, Calif. (1986)

AIDS: America's epidemic

Alon Reininger is the winner of the 1989 **Kodak Crystal Eagle Award for Impact in Photojournalism** for his study of the spread of AIDS in America. Reininger first began photographing victims of acquired immune deficiency syndrome in 1982, when the disease was barely known outside medical circles. Since that time, his work has appeared in magazines in the United States, Japan, Italy, France, Germany and Great Britain.

Because of its association with gay men and intravenous drug users, AIDS long remained an uncomfortable topic. President Reagan had been in office since the virus first was diagnosed in 1981, yet he did not make a policy statement about AIDS until May 1987.

It was in 1987 that many of Reininger's photographs began to appear widely in the American press. His images dig deeply into the world inhabited by AIDS victims, often confronting viewers with the tragedy of imminent death. AIDS, as depicted in his photographs, has touched all ages, sexes, classes and ethnic groups.

Americans could no longer pretend it was an isolated disease affecting small segments of our population.

The National Centers for Disease Control reports that as of Dec. 31, 1989, AIDS has been diagnosed in 117,781 Americans. Of those, 70,313 have died since 1981.

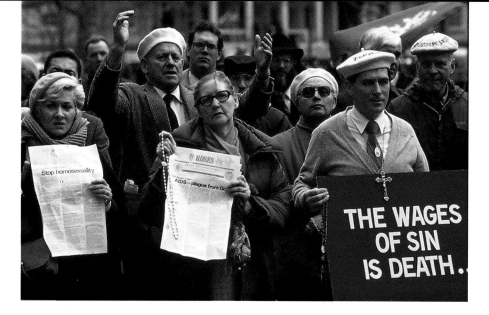

New York residents protest against a proposed Gay Rights Bill. (1986)

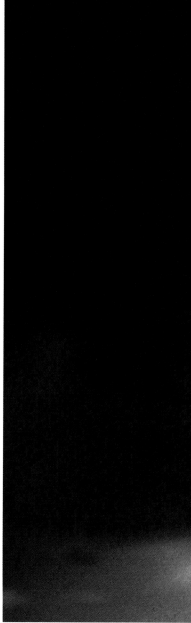

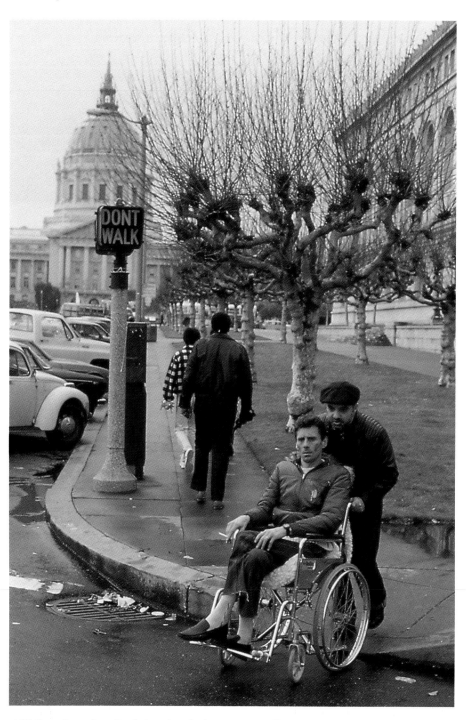

AIDS patient Ian Beck is wheeled to City Hall in San Francisco. (1986)

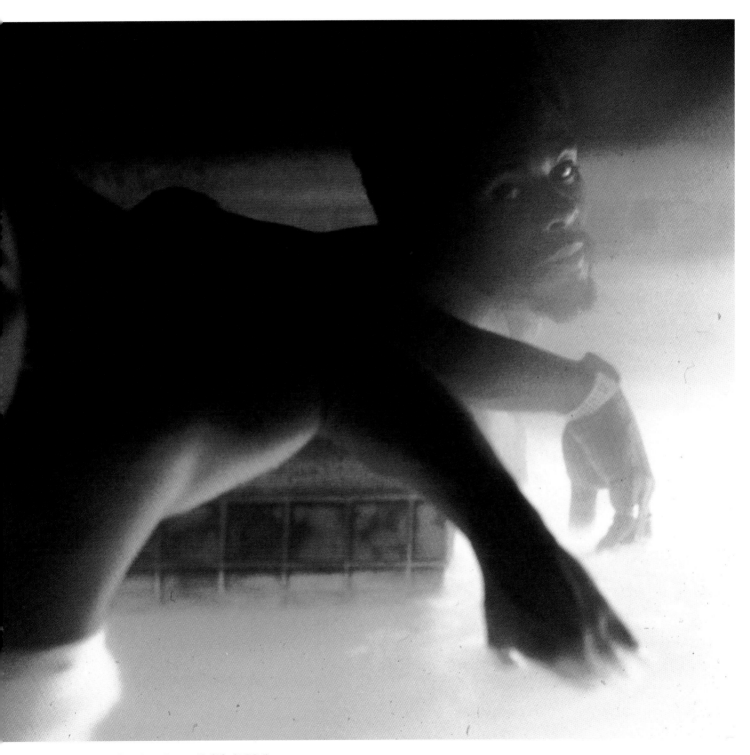

Water Garden Baths, San Jose, Calif. (1986)

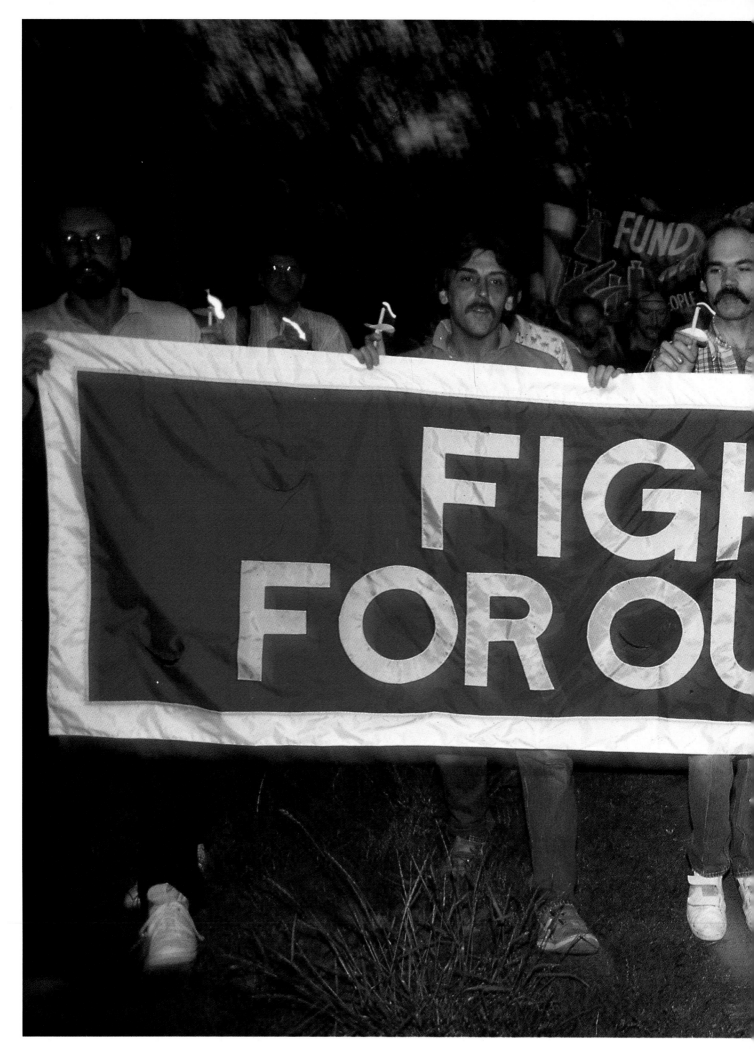

Marchers at the Third International Conference on AIDS. (1987)

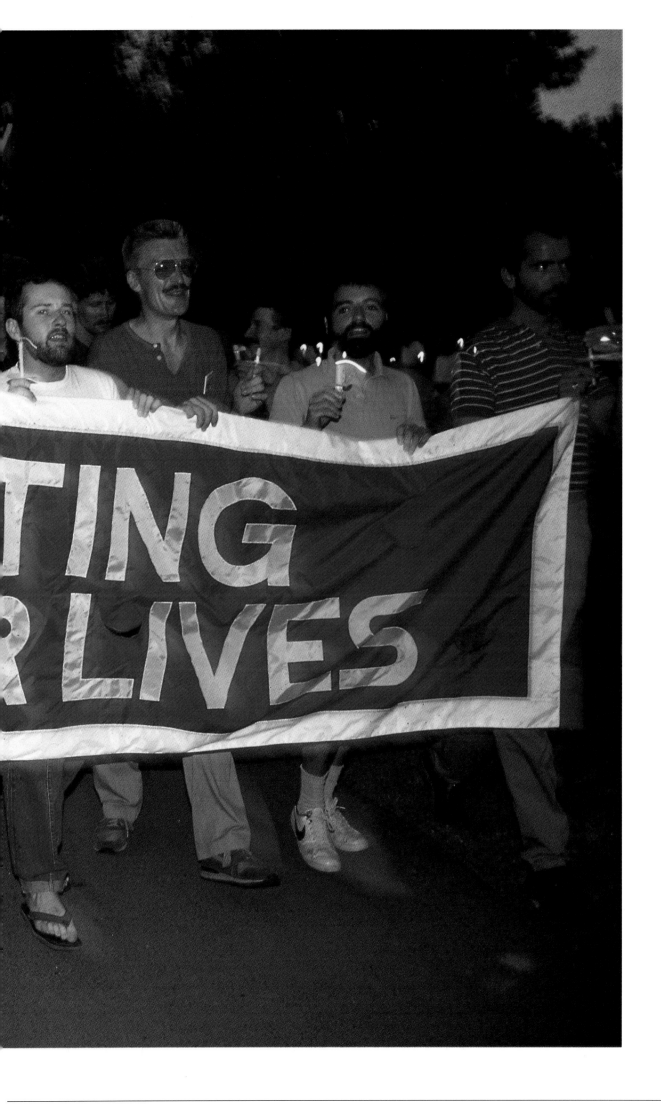

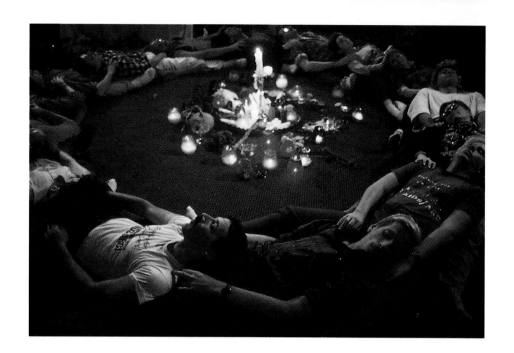

The Aliveness Project
(above) helps AIDS
victims deal with
their illness in a
spiritual manner.
(1987)
AIDS patient David
Hefner is comforted
by his wife, Maria
Ribeiro, in New York.
(1983)

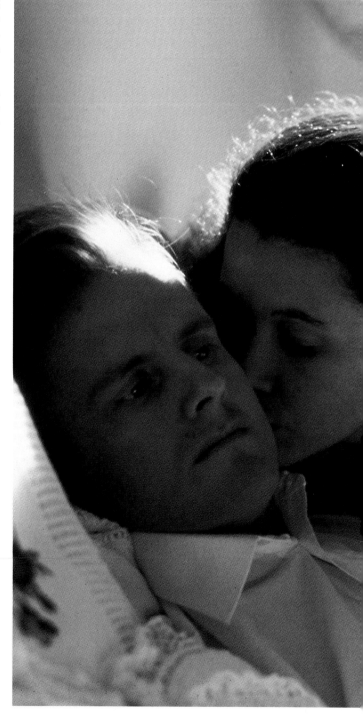

The AIDS quilt (next page), measuring 150,000 square feet, is displayed at the base of the Washington Monument. All 50 states and a dozen foreign countries are represented in the quilt's 8,288 panels. (1987)

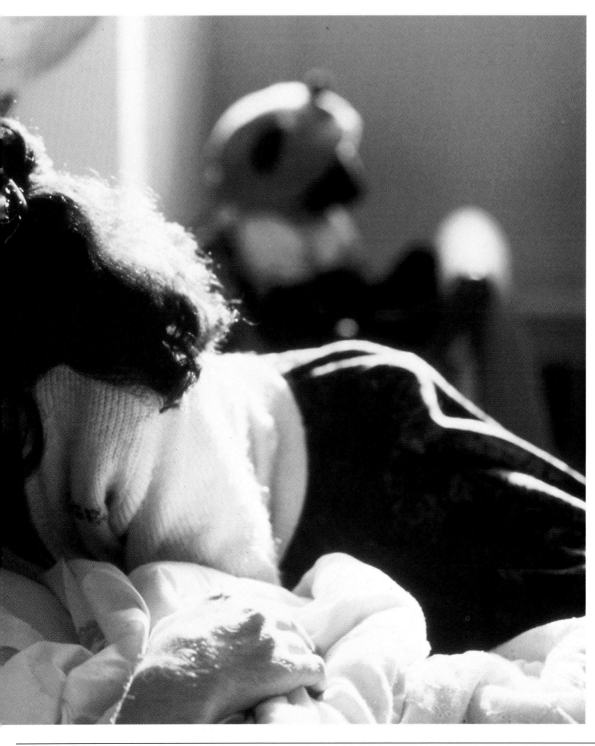

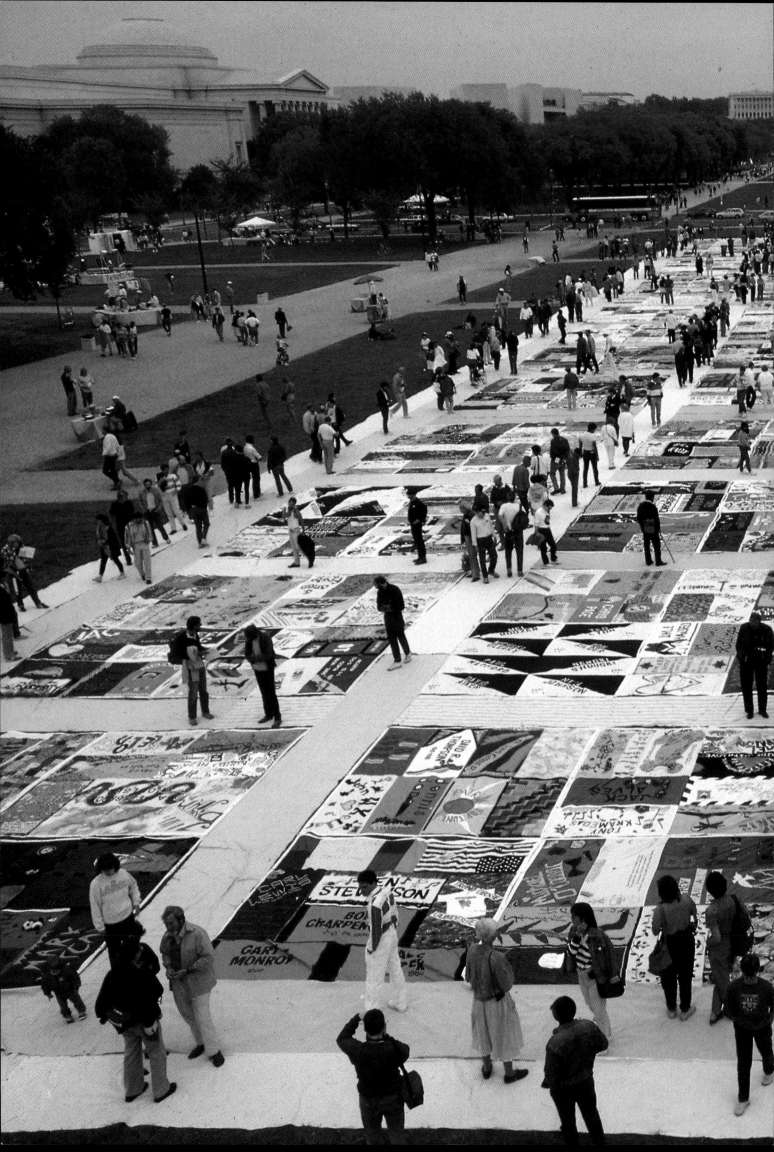

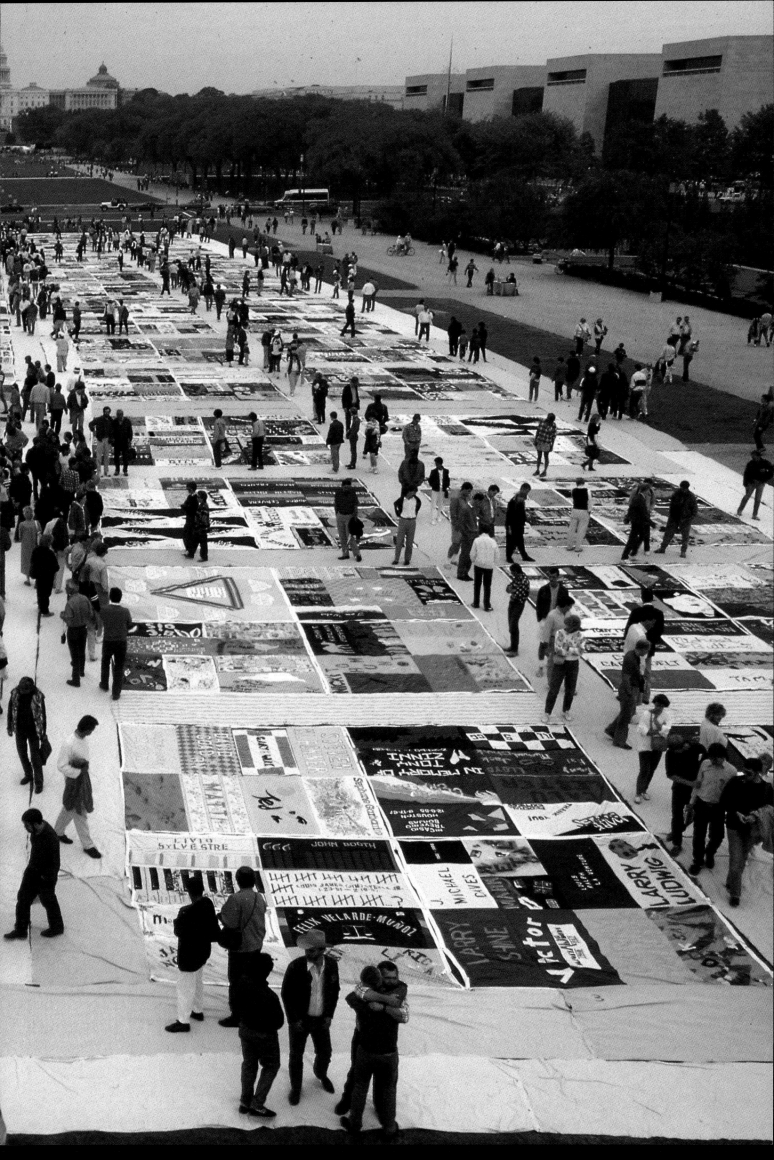

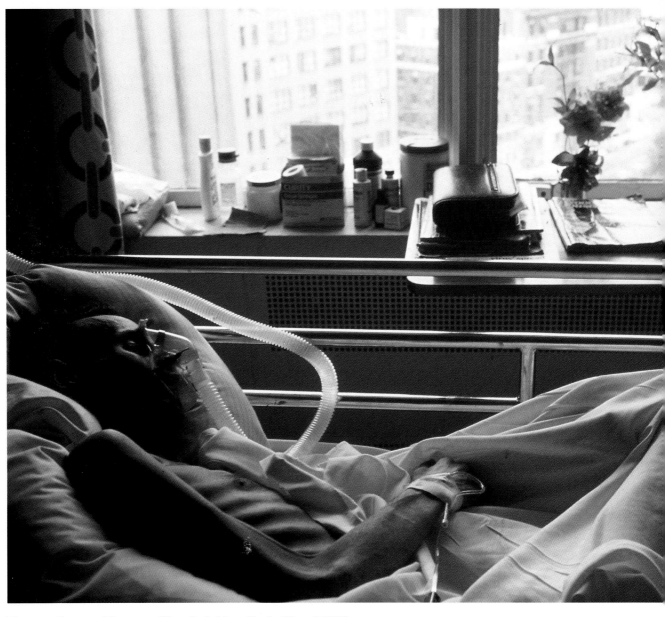

Thomas Ramos, Veterans Hospital, New York City. (1987)

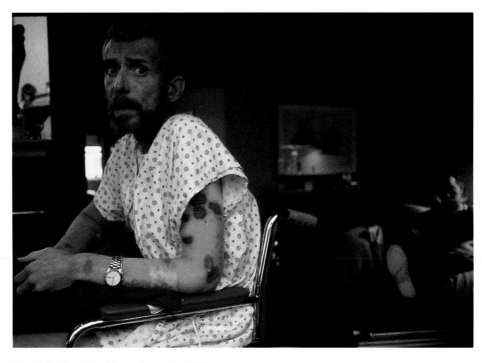

Ken Meeks, San Francisco. (1988)

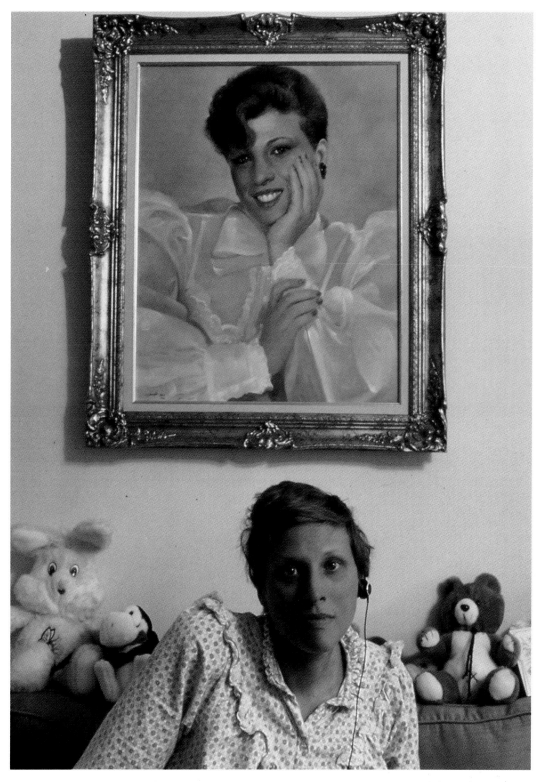

Sunnye Sherman, Silver Spring, Md. (1989)

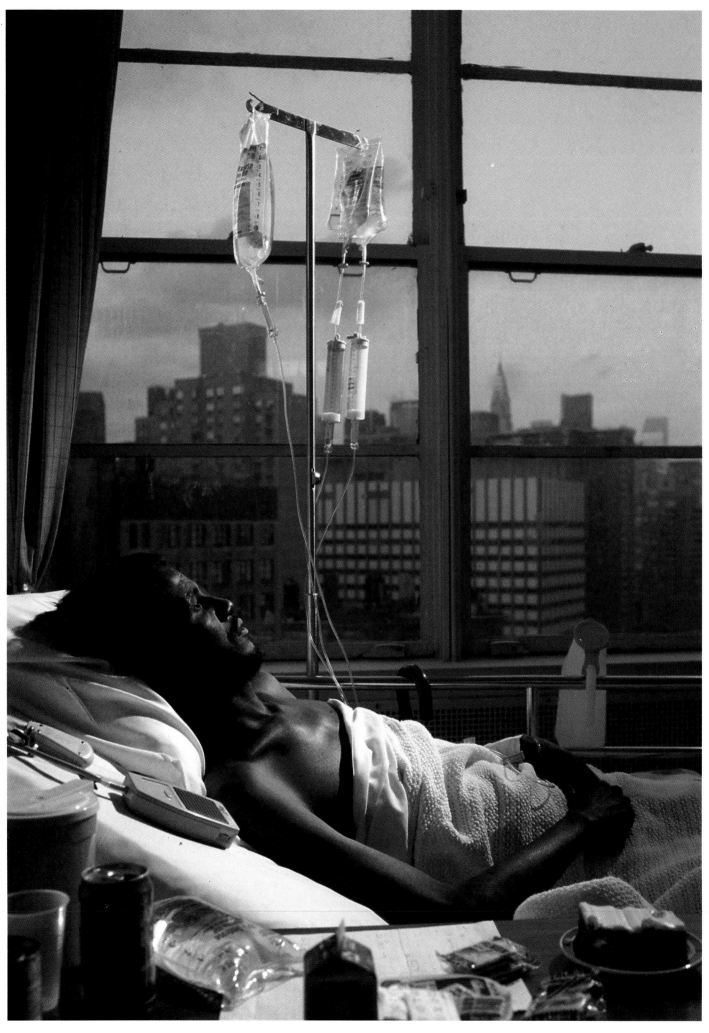

Howard Bagby, New York City. (1987)

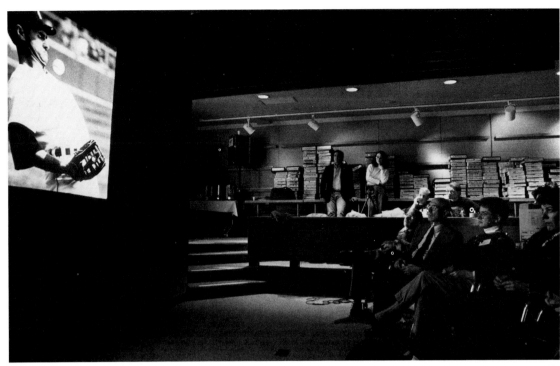

Judges Angus McDougall, Cheryl Magazine and Natalie Fobes look for the top photograph in the sports action category. Contest director Bill Kuykendall observes the process.

Photo by George Kelly

47th POY judging comments

By Bill Kuykendall

Though the 47th Pictures of the Year contest included many powerful and diverse portfolios, a large number of strong picture stories and essays and a broad sampling of work from the year's top national and international news events, total submissions and numbers of entrants were down significantly from last year. Entrants decreased from 1,931 to 1,666; total slides and tearsheets decreased from approximately 35,000 to about 30,000. These numbers are, more or less, the same as those of POY 44, the year POY changed from print to slide entries. Elimination of the additional submission option (during the previous three years, entrants could submit more than the allowed 21 entries by paying $5 per additional entry) led to a decrease of approximately 1,000 entries.

It isn't clear whether this drop reflects lack of time to prepare entries because of the unusually busy year or other factors. More than half of the 1,053 who entered POY 46 didn't enter POY 47. On the other hand, nearly half of the 796 entrants of POY 47 had not entered POY 46. This suggests that, though not everyone participates every year, over time, the contest involves many more people.

Questions to ask

Do photographers sit out a year or two between contests? Are new people coming into NPPA and POY? Was there confusion about the rules or problems in the delivery of calls for entries? We will be surveying previous and new entrants to explore these and other questions so that we can better understand the role POY plays in the lives of NPPA members.

Many winners

Though there were fewer total entries than the previous year, the judges gave out virtually the same number of awards: 241 in POY 46, 240 in POY 47. (This comparison omits 11 *Campaign '88* awards selected from 1,300 submissions given last year in categories that are offered only during national election years.) This suggests that the drop in numbers reflects a decrease in weaker entries; perhaps photographers are simply doing a better job of editing submissions.

Most of the decline occurred in the newspaper photography division. Here, entrants decreased in every category except in *One Week's Work*, which grew from 37 to 46 portfolios. *Newspaper Photographer of the Year* portfolios decreased from 120 last year to 107, the smallest number of portfolios entered in the past five years. Still, the judges gave a total of five awards in this category, up from three in POY 46, among them Carol Guzy, the first woman *Newspaper Photographer of the Year*.

Magazine sports decline

Participation in the magazine division fell off also. The greatest decline occurred in the *Magazine Sports Picture* category, down from 185 to 69. Eight *Magazine Sports Portfolios* were entered. There were 10 last year, five the year before and eight in POY 44, the year the category was created. Magazine sports photographers are clearly under-represented in POY. Each year judges have suggested that we actively recruit more entrants or drop the category altogether.

Perhaps the first *Kodak Crystal Eagle Award* winner, Charles Moore, set impossibly high standards with his 1960s Civil Rights entry last year; or perhaps many photographers were too modest to claim that their work had had an impact on society

(most entrants have been nominated by others). Whatever, only four portfolios were submitted in this category (compared with 15 in POY 46). Alon Reininger's winning AIDS portfolio continues the high standard established by Moore yet broadens the definition of what can win in this category.

Nominating panel

To maintain a selection of deserving entries in the future, a panel of distinguished photographers, editors and scholars will be invited to nominate photographers for the *Kodak Crystal Eagle Award*. Nominations still may be made from the membership at large.

Canon Essayist entries exhibited very strong growth: 59 were entered last year, 72 this year. Indeed, many felt that the climax of POY 47 judging was the projection of the six Canon Essay finalists. In addition to the 3 winners (that dealt with child abuse, AIDS and a homeless couple's trip to a presidential inaugural ball), the judges considered essays on adolescent sexuality by Donna Ferrato; the nation of Malawi by Eli Reed and elderly families that are rearing infant grandchildren by Jean Shifrin.

Judges added

To ensure adequate time to screen and discuss entrants, we increased the number of judges this year. Consequently, on average, one-half hour of additional time was spent discussing each category. During the first week of the competition, six judges spent five days choosing winners in the newspaper division. Following a day off, five of the judges were joined by another five; these 10 then were assigned to separate panels for the magazine and editing divisions. This was the first time editing entries had

Continued on the next page

The Judges

Richard J. Murphy began his newspaper career in high school as the summer replacement photographer for the Holyoke Transcript-Telegram in western Massachusetts. Some years after graduating from Allegheny College, he became chief photographer of the Jackson Hole News in western Wyoming, a position he held for 11 years. Currently, Murphy is photo editor of the Anchorage Daily News.

Jocelyn Benzakin is founder and President of JB Pictures Ltd., a New York-based photo agency since 1985. She is winner of the "Works of Special Distinction" award at the Tokyo Video Festival. The prize was won for the first video the agency produced using still photos. Prior experience in the field of photography was with Time magazine and as a correspondent for French photo agencies and magazines.

Michel duCille is picture editor of The Washington Post. In 1985 duCille shared a Pulitzer Prize as a Miami Herald photographer with Carol Guzy, then also with the Herald, in the Spot News category for coverage of the eruption of Colombia's Nevado Del Ruiz Volcano. In April 1988 he won a second Pulitzer Prize in Feature Photography for a photo essay on crack-cocaine addicts in a Miami housing project. In July 1988 he was named Journalist of the Year by the National Association of Black Journalists.

Larry Nighswander is illustrations editor for National Geographic's WORLD Magazine. Prior to joining the National Geographic Society, he was Assistant Managing Editor/Graphics at The Cincinnati Post, picture editor of The Columbus Dispatch, and director of photography at The Washington Times and The Cleveland Press. In 1983-84 he was an assistant professor in the School of Visual Communication at Ohio University.

Angus McDougall is a professor emeritus at the University of Missouri School of Journalism. Prior to his retirement in 1983, he was head of the photojournalism sequence and director of the Pictures of the Year competition. In earlier competitions he was chosen Magazine Photographer of the Year and Picture Editor of the Year. The National Press Photographers Association gave him the Sprague Memorial Award.

William Luster has been a staff photographer for The Courier-Journal in Louisville, Ky., for 20 years. In 1976, he shared the Pulitzer Prize for Feature Photography with other members of the Courier-Journal photographic staff, and was a member of the news team that won the Pulitzer Prize for Local Reporting in 1989. He has won numerous awards in the annual Pictures of the Year competition, and in 1982 was runner-up for Newspaper Photographer of the Year.

Don Doll, S.J. has been a professor of Fine Arts in Photography at Creighton University for the past 20 years. He has photographed for such major publications as A Day in the Life of America, National Geographic and Geo. He has won numerous awards for his photography in the Pictures of the Year contest and other competitions. He was given the Robin F. Garland Award for his outstanding contributions to the education of photojournalists.

Gene Foreman is managing editor of The Philadelphia Inquirer. He began his journalism career as a reporter at the Arkansas Gazette in 1957; he later was promoted to assistant city editor and state editor there. In 1962, he took a position as a copy editor at The New York Times. He later became managing editor at the Pine Bluff (Ark.) Commercial and the Arkansas Democrat in Little Rock. From 1971-73, he was executive news editor at Newsday in Long Island, N.Y. He began work at the Inquirer in 1973.

Cheryl Magazine became senior photo editor at U.S. News & World Report in 1989 after working as a full-time parent at home with two children for almost seven years. Prior to that, she served as special projects editor at The Louisville Times, picture editor at The Courier-Journal, assistant picture editor at The Milwaukee Journal and photographer/reporter at the Herald-Telephone in Bloomington, Ind., and Suburban Week, a tabloid supplement to the Chicago Sun-Times.

Dieter Steiner is the bureau chief of Stern magazine in New York, where he has worked for 18 years. He is a member of the international advisory committees for the W. Eugene Smith Memorial Fund; World Press Photo, Amsterdam; and World Press Photo, U.S.A. Before joining Stern, he was with United Press International for eight years.

Lois Bernstein placed third in the portfolio division of POY in 1988. She was the 1987 Virginia News Photographer of the Year and the 1984 Ohio News Photographer of the Year. Bernstein was a staff photographer for three years at The Virginian-Pilot in Norfolk. She has been a photographer at The Sacramento Bee for two years.

Natalie Fobes became a freelance photographer two years ago after leaving a staff photography position at The Seattle Times. Prior to that, she was a staff photographer for The Cincinnati Enquirer. In the past two years, she has worked almost exclusively for National Geographic magazine. Fobes has won numerous awards and honors for her photography.

47th POY judging comments

Continued from previous page

their own panel. This attention by POY to editors and publications that strive to create a stimulating environment for photojournalism will only increase in the future.

Participation in the picture editing portfolio categories was up slightly from last year: 18 newspaper teams (22 last year); 37 newspaper individuals (29 last year); seven magazine (six last year). Series and special section submissions more than doubled to 83 entries (38 last year). Categories recognizing the best use of photos in newspapers showed healthy growth: under 25,000 circulation had 18 entries (nine last year); 25,000-150,000 had 18 entries (16 last year); over 150,000 had 15 entries (12 last year). Discussion of these categories was particularly rigorous. Judges considered the use of photos on inside pages as well as on section fronts; the incidence of local versus wire photos; the comparison of news-enterprise photos

that accompanied text to lines-only, stand-alone photos; whether active, documentary photos appeared more often than photo illustrations and environmental portraits; the completeness of captions and the compatibility of headlines; economy of editing (lots of big photos could work against an entry); logical sequencing, grouping and sizing of multiple photo packages; and the appropriate use of color.

Documentary importance

Following many discussions with NPPA members that suggested growing apprehension within the profession about the practice by newspapers and many magazines of choosing photo illustration over in-depth photo reporting, we decided to drop the *Editorial Illustration* category from POY. *Food* and *Fashion* were retained but the rules were rewritten to encourage entrants to submit work that employed a documentary approach.

Indeed, this year POY has been redefined as a totally documentary photo contest. This is a continuation of the move begun by NPPA and the University of Missouri four years ago to encourage those who best exploit the still camera as a reporting tool. As we wrote last year in *The Best of Photojournalism/14*, "It is hoped that, by discontinuing awards for contrived images, Pictures of the Year can emphasize its commitment to the documentary photograph.... In the future we hope that POY will become, even more than it is today, a forum for celebrating reportorial photography.... We hope that every serious photographer — journalist, artist, anthropologist or sociologist — who uses still cameras to explore and comment upon contemporary culture will participate. Thus, perhaps, the collective weight of the year's great, unposed photographs may better inspire the dedicated professionals who make them and influence others to follow their example."

The Winners List

Judged Feb. 19 through Feb. 28, 1990, at the University of Missouri-Columbia and sponsored by the **National Press Photographers Association** and the **University of Missouri School of Journalism** with grants from **Canon USA, Inc.,** and the **Professional Photography Division, Eastman Kodak Co.**

NEWSPAPER PHOTOGRAPHER OF THE YEAR

1st Place **Carol Guzy**, The Washington Post
2nd Place **Randy Olson**, The Pittsburgh Press
3rd Place **David C. Turnley**, Detroit Free Press/Black Star

Awards of Excellence
Bill Greene, The Boston Globe
April Saul, The Philadelphia Inquirer

MAGAZINE PHOTOGRAPHER OF THE YEAR

1st Place **Eugene Richards**, Magnum
2nd Place **Peter Turnley**, Black Star for Newsweek
3rd Place **Anthony Suau**, Black Star

CANON PHOTO ESSAY AWARD

Stormi Greener, "Cycle of Abuse," Star Tribune: Newspaper of the Twin Cities (Minneapolis, MN)

Judges Special Recognition
Carol Guzy, "Cinderella Story," The Washington Post
Michael Schwarz, "When AIDS Comes Home," Atlanta Journal and Constitution

KODAK CRYSTAL EAGLE AWARD

Alon Reininger, "AIDS," Contact Press Images

Individual Awards: Newspaper Division

NEWSPAPER SPOT NEWS

1st Place **Les Stone**, "Panama Election," Reuters/Sygma
2nd Place **Liu Heung Shing**, "Love Under Fear," The Associated Press
3rd Place **Stuart Franklin**, "Wang Weilin Stops a Convoy," Magnum

Awards of Excellence
Nancy Andrews, "Breaking Free," The Free Lance-Star (Fredericksburg, VA)
Anonymous, "Crushed to Death," The Associated Press
Carol Guzy, "The Wall Comes Down," The Washington Post
Durell Hall Jr., "Printing Plant Massacre," The Courier-Journal (Louisville, KY)
Michael Macor, "Cypress Rescue," The Tribune (Oakland, CA)
Robert A. Martin, "Yanked Free," The Free Lance-Star (Fredericksburg, VA)
Pat McDonogh, "Drug Bust," The Courier-Journal (Louisville, KY)
Mel Nathanson, "Shooting," Ohio University
Jack Smith, "Oil Covered," The Associated Press
Greg Sorber, "Shocking Experience," Albuquerque Journal (NM)
Steven Spak, "Impaled on Fence," Freelance (Elmhurst, NY)
Chris Young, "Interstate Rescue," Omaha World-Herald

NEWSPAPER GENERAL NEWS

1st Place (Tie) **Michael Schwarz**, "When AIDS Comes Home," Atlanta Journal and Constitution
1st Place (Tie) **Angela C. Pancrazio**, "A Community Mourns Earthquake Dead," The Tribune (Oakland, CA)
2nd Place **David C. Turnley**, "A Chinese Woman Pleads," Detroit Free Press/Black Star
No 3rd Place was awarded

Awards of Excellence
Louis DeLuca, "The Long Ride Home," Dallas Times Herald
John Gaps III, "Oily Swim," The Associated Press
Bill Greene, "Migrant Child," The Boston Globe
David McNew, "Stampede," Freelance (San Diego, CA)
Michael A. Schwarz, "Lighting the Flames of Freedom," Atlanta Journal and Constitution
Scott Wiseman, "Rained Out," The Palm Beach Post
Alan Youngblood, "Private Conference," Ocala Star-Banner (Ocala, FL)

NEWSPAPER FEATURE PICTURE

1st Place **Chris Usher**, "Courthouse Wedding," The Orlando Sentinel
2nd Place **Bradley E. Clift**, "Tenement Testament," The Hartford Courant
3rd Place **Michael S. Wirtz**, "Freedom," The Philadelphia Inquirer

Awards of Excellence
Gary Allen, "Nursery Harpist," The News & Observer (Raleigh, N.C.)
James Garcia, "Chess Battles," The Phoenix Gazette (AZ)
Carol Guzy, "Victory," The Washington Post
Elaine Isaacson, "A Monk's Life," The Orange County Register
Jim Lavrakas, "War in Winter - Brim Frost 1989," Anchorage Daily News
David Leeson, "Hidden Wars," The Dallas Morning News
Joanne Rathe, "Fighting Back," The Boston Globe

NEWSPAPER SPORTS ACTION

1st Place **Stephan Savoia**, "Javelin," State-Times & Morning Advocate (Baton Rouge, LA)
2nd Place **Jason M. Grow**, "Picked Off," for the San Francisco Chronicle
3rd Place **John Gastaldo**, "All Out," The Jersey Journal (Jersey City, NJ)

Awards of Excellence
Benjamin Benschneider, "Final Sprint," The Seattle Times
Gary Higgins, "Suicide Squeeze," The Patriot Ledger (Quincy, MA)
Paul Rodriguez, "Rubber Arm," The Orange County Register

NEWSPAPER SPORTS FEATURE

1st Place **Rollin Banderob**, "Close Decision," Clovis Independent / Record Searchlight (Redding, CA)
2nd Place **Sean Dougherty**, "Dismount," Fort Lauderdale News/Sun-Sentinel
3rd Place **Denis Finley**, "Wrestling Hold," The Virginian-Pilot/Ledger-Star (Norfolk, VA)

Award of Excellence
Drew Perine, "Kareem Imposters," The Herald (Everett, WA)

NEWSPAPER PORTRAIT/PERSONALITY

1st Place **Pat Greenhouse**, "At the Ballet," The Tribune (Oakland, CA)
2nd Place **Lloyd Fox**, "Ballet Dancer," for The Philadelphia Inquirer
3rd Place **Richard Chapman**, "Pride of the Polish," Daily Herald/Chicago Sun-Times (Arlington Heights, IL)

Continued on the next page

Judges Michel duCille, Cheryl Magazine and Don Doll, S.J. preview the newspaper feature picture story category.

Photo by Tom Murray

Continued from previous page

Awards of Excellence
Scott Eklund, "Old Man of the Sea," Journal-American (Bellevue, WA)
David R. Jennings, "Mother Teresa," Sentinel Newspapers (Denver)
Bruce Johnson, "Medellin Roses," The Tampa Tribune (FL)
Yunghi Kim, "Urban Family: Holding On," The Boston Globe
Kevin J. Larkin, "The New Speaker," Freelance for Photopress International
Eric J. Olig, "Miss Prissy," The Augusta Chronicle (GA)
David James Rogowski, "Camera Collector," The Fairfax Journal (VA)
Susan Tripp-Pollard, "News Man," California Delta Newspapers
Jennifer Werner Jones, "The Chinese Patriarch," Seattle Post-Intelligencer

NEWSPAPER PICTORIAL

1st Place Nadia Borowski, "Kremlin Gate," The Orange County Register
2nd Place Bradley E. Clift, "Morning Mist," The Hartford Courant
3rd Place Jeff Wheeler, "Gear Down," Star Tribune: Newspaper of the Twin Cities (Minneapolis, MN)

Awards of Excellence
Gerry Broome, "Ice," Greensboro News & Record (NC)
Michael Chow, "Power House," The Phoenix Gazette (AZ)
Christopher Fitzgerald, "Gone With the Wind," The Middlesex News (Framingham, MA)
Jennifer Werner Jones, "Marching to a Different Drummer," Seattle Post-Intelligencer
Robert A. Martin, "Riding the Rapids," The Free Lance-Star (Fredericksburg, VA)
David McNew, "Surfing Dolphin," Freelance (San Diego, CA)
David McNew, "Deer & Lightning in South Dakota," Freelance (San Diego, CA)
Joe Tabacca, "Boats," The Hartford Courant
Bob Thayer, "Picture Within a Picture," The Journal-Bulletin (Providence, R.I.)

NEWSPAPER FOOD ILLUSTRATION

1st Place Kevin Clark, "Peppers," Journal-American (Bellevue, WA)
2nd Place Ellen M. Banner, "Springtime Asparagus," Freelance (Tacoma, WA)
3rd Place John Trotter, "Honey," The Sacramento Bee

Award of Excellence
Paul Rodriguez, "Say Pears," The Orange County Register

NEWSPAPER FASHION ILLUSTRATION

1st Place Michael Bryant, "Training Bra," The Philadelphia Inquirer
2nd Place Smiley N. Pool, "Prom Wear," Austin American-Statesman (TX)
3rd Place Pat Davison, "Ties Have It," The Albuquerque Tribune (NM)

Awards of Excellence
Michael Bryant, "Accessories After the Fact," The Philadelphia Inquirer
Michael Kiernan, "Red Barn Fashion," New Haven Register (CT)

NEWSPAPER NEWS PICTURE STORY

1st Place David C. Turnley, "Romanian Revolution," Detroit Free Press/ Black Star
2nd Place Alan Berner, "Grappling With Growth," The Seattle Times
3rd Place Randy Olson, "Amish Midwife on Trial," The Pittsburgh Press

Awards of Excellence
Bill Greene, "A Meager Existence: Migrant Farm Workers in America," The Boston Globe
Genaro Molina, "Nature's Beauty, Man's Shame," The Sacramento Bee
Les Stone, "Panama Election," Reuters/ Sygma
David C. Turnley, "Beijing Spring," Detroit Free Press/Black Star
Brant Ward, "Earthquake in the Marina," San Francisco Chronicle
John H. White, "Fireball," Sun-Times (Chicago)

NEWSPAPER FEATURE PICTURE STORY

1st Place April Saul, "Remarried . . . with Children," The Philadelphia Inquirer
2nd Place Bruce Chambers, "Return to the Killing Fields," Press-Telegram (Long Beach, CA)
3rd Place Jim Gensheimer, "Building From Scratch," San Jose Mercury News (CA)

Awards of Excellence
Wende Alexander, "Fighting Crack With Faith," The Grand Rapids Press (MI)
Bradley E. Clift, "The State Veterans Home: Where Dreams and Vets Die," The Hartford Courant
Bill Greene, "Punchin' Doggies," The

Boston Globe
Stormi Greener, "Cycle of Abuse," Star Tribune: Newspaper of the Twin Cities (Minneapolis, MN)
Carol Guzy, "The Wall Comes Down," The Washington Post
Carol Guzy, "Tearing It Down," The Washington Post
Michael Kimble, "Working Girl," Freelance (Naples, FL)
Eric Mencher, "West Belfast Diary," The Philadelphia Inquirer
Michael A. Schwarz, "When AIDS Comes Home," Atlanta Journal and Constitution
Betty Udesen, "Neighborhood," The Seattle Times
Bill Wood, "Senior Citizen Prom," The Montgomery Journal (MD)

NEWSPAPER SPORTS PORTFOLIO
1st Place **Vince Musi**, The Pittsburgh Press
2nd Place **David Peterson**, The Des Moines Register (IA)
3rd Place **Rob Goebel**, The Indianapolis Star

Awards of Excellence
Brant Ward, San Francisco Chronicle
Lui Kit Wong, The Virginian-Pilot/Ledger-Star (Norfolk, VA) and The News Tribune (Tacoma, WA)

NEWSPAPER: ONE WEEK'S WORK
1st Place **Melissa Farlow**, The Pittsburgh Press
2nd Place **Dan Habib**, The Concord Monitor (NH)
3rd Place **Michael Fender**, The Indianapolis News

Individual Awards: Magazine Division

MAGAZINE NEWS OR DOCUMENTARY
1st Place **Ken Jarecke**, "Battle of Wills," Contact Press Images for Time
2nd Place **Ron Haviv**, "Bloody Democracy," Agence-France Press
3rd Place **Gilles Saussier**, "Vigil," Gamma Liaison for Time

Awards of Excellence
Wesley Bocxe, "Fleeing Combat Zone," Sipa Press
Chien-chi Chang, "Struggle for Assimilation," Indiana University
Linda L. Creighton, "Changing of the Guards," U.S. News & World Report
Stuart Franklin, "Defiance," Magnum for Time

Georges Merillon, "Unfinished Revolution," Gamma Liaison for Time
Michael Quan, "Peering Through the Berlin Wall," Freelance (Somerville, MA)
Peter Turnley, "Beijing Spring," Black Star for Newsweek

MAGAZINE FEATURE PICTURE
1st Place **Chuck O'Rear**, "Mosque Shrine," for National Geographic
2nd Place **Eugene Richards**, "River Blindness," Magnum for The New York Times Magazine
3rd Place **Donna Ferrato**, "Let It Last Forever," Black Star

Awards of Excellence
Chuck O'Rear, "Friday Prayers," for National Geographic
Eugene Richards, "Up from the Subway," Magnum
Phil Schofield, "Curiosity Feeds the Cat," Freelance for National Geographic
James L. Stanfield, "Pont des Arts," National Geographic

MAGAZINE SPORTS PICTURE
1st Place **Robert Beck**, "Simon Law," Surfer Magazine/Allsport USA
2nd Place **Dorothy Littell**, "Glistening Cap," for Bostonia Magazine
3rd Place **Mark Reis**, "Cloud of Dust," Colorado Springs Gazette Telegraph

MAGAZINE PORTRAIT/ PERSONALITY
1st Place **Dilip Mehta**, "The Workaholic," Contact Press Images for Fortune Magazine
2nd Place **Karen Kasmauski**, "Sailors' First Swim," for National Geographic
3rd Place **Joanna Pinneo**, "AIDS Victim," Black Star/The Commission Magazine

Awards of Excellence
Joanna Pinneo, "AIDS Orphans," Black Star/The Commission Magazine
Steven L. Raymer, "Nentsy Boy," National Geographic

MAGAZINE PICTORIAL
1st Place **Annie Griffiths Belt**, "Forest Fog," National Geographic
2nd Place **Frans Lanting**, "King Penguin Colony," National Geographic
3rd Place **Pete Souza**, "Independence Day," Freelance (Arlington, VA)

Awards of Excellence
Annie Griffiths Belt, "Colorado River Delta Meets Sea of Cortes," National Geographic

Phil Schofield, "Evening Roundup," for National Geographic
Michael S. Yamashita, "Daichiji Garden," National Geographic

MAGAZINE ILLUSTRATION
1st Place **Donna Terek**, "Rush of Silk," Michigan Magazine (The Detroit News/Free Press)
2nd Place **Jose Azel**, "Nose Job," Contact Press Images
3rd Place **Gary S. Chapman**, "Shadow Fashion," Sunday Magazine (The Courier-Journal, Louisville, KY)

Awards of Excellence
Donna Terek, "In the Swim," Michigan Magazine (The Detroit News/Free Press)

MAGAZINE SCIENCE/ NATURAL HISTORY
1st Place **David Doubilet**, "Fiordland Dolphins," National Geographic
2nd Place **Annie Griffiths Belt**, "White Pelicans," National Geographic
3rd Place **James Balog**, "Chimpanzee," Black Star

Awards of Excellence
James Balog, "Florida Panther," Black Star
James Balog, "Grizzly Bear," Black Star
Craig Chapman, "Kit Fox Yawns," The Orange County Register
Frans Lanting, "Petrel in Snow," National Geographic
Frans Lanting, "Albatross and Young," National Geographic

MAGAZINE PICTURE STORY
1st Place **Phil Schofield**, "Sage Brush Country," for National Geographic
2nd Place **Eugene Richards**, "River Blindness," Magnum for The New York Times Magazine
3rd Place **James Nachtwey**, "East Berlin Diary," Magnum for The New York Times Magazine

Awards of Excellence
James Kamp, "Jennifer, The Littlest Witness," Black Star for Life
Maggie Steber, "Cleansing Waters," J.B. Pictures for Independent Magazine (London)
Peter Turnley, "Beijing Spring," Black Star for Newsweek

MAGAZINE SPORTS PORTFOLIO
1st Place **Bill Frakes**, The Miami Herald/Freelance for Sports Illustrated
2nd Place **Andrew Hayt**, Sports Illustrated
3rd Place **Robert Beck**, Surfer Magazine/Allsport USA

Continued on the next page

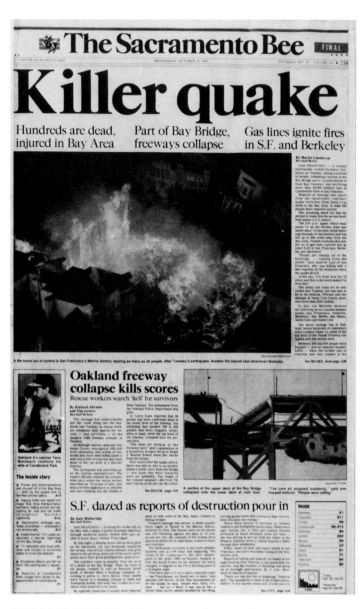

THE SACRAMENTO BEE, 1ST PLACE, NEWSPAPER PICTURE EDITING, TEAM

MIKE DAVIS, THE ALBUQUERQUE TRIBUNE, 1ST PLACE, NEWSPAPER PICTURE EDITING, INDIVIDUAL

Continued from previous page

Editing Division

NEWSPAPER PICTURE EDITING/ TEAM

1st Place **The Sacramento Bee (CA)**
2nd Place **The Hartford Courant (CT)**
3rd Place **The Virginian-Pilot/Ledger-Star (Norfolk)**

NEWSPAPER PICTURE EDITING/ INDIVIDUAL

1st Place **Mike Davis**, The Albuquerque Tribune (NM)
2nd Place **Tim Cochran**, The Virginian-Pilot/ Ledger-Star (Norfolk)
3rd Place **Rick Shaw**, The Sacramento Bee (CA)

Awards of Excellence
Alex Burrows, The Virginian-Pilot/Ledger-Star (Norfolk)
Randy Cox, The Hartford Courant (CT)
Pam Lettie, The Montgomery Journal (MD)
Geri Migielicz, San Jose Mercury News (CA)
Lisa Roberts, The Sacramento Bee (CA)

THE HARTFORD COURANT, 2ND PLACE, NEWSPAPER PICTURE EDITING, TEAM

TIM COCHRAN, THE VIRGINIAN-PILOT/LEDGER STAR, 2ND PLACE, NEWSPAPER PICTURE EDITING, INDIVIDUAL

TIM COCHRAN, "VIRGINIA BEACH RIOT," THE VIRGINIAN-PILOT/LEDGER STAR, 1ST PLACE, NEWS STORY — NEWSPAPER/MAGAZINE

MIKE DAVIS, "THE GRAND VOYAGE," THE ALBUQUERQUE TRIBUNE, 1ST PLACE, FEATURE STORY — NEWSPAPER

NEWS STORY — NEWSPAPER/ MAGAZINE

1st Place **Tim Cochran**, "Virginia Beach Riot," The Virginian-Pilot/Ledger-Star (Norfolk)

2nd Place **Team Entry**, "Blast on Iowa Kills 47," The Virginian-Pilot/ Ledger-Star (Norfolk)

3rd Place **Guy Cooper**, "After the Shock," Newsweek

Awards of Excellence

Guy Cooper, "People of the Year," Newsweek

Alex Burrows, "Nursing Home Fire Kills Nine," The Virginian-Pilot/Ledger-Star (Norfolk)

Rick Shaw, "Chinese Troops Crush Protest," The Sacramento Bee (CA)

Brian Stallcop, "Soccer Tragedy," The Indianapolis News

Team Entry, "Romania: Revolution," The Detroit News/Free Press

Team Entry, "Massive Quake," San Jose Mercury News (CA)

FEATURE STORY — NEWSPAPER

1st Place **Mike Davis**, "The Grand Voyage," The Albuquerque Tribune

2nd Place **Mike Healy**, "Fatal Neglect," Star Tribune: Newspaper of the Twin Cities (Minneapolis, MN)

3rd Place **Alex Burrows**, "History in the Making: A Look Back at Doug Wilder's Campaign," The Virginian-Pilot/Ledger-Star (Norfolk)

Awards of Excellence

J. Bruce Baumann, "Little Mother," The Pittsburgh Press

Fred Barnes, "Surviving the Grind at Capitol," The Hartford Courant (CT)

Murray Koodish, "The Killing Season," San Jose Mercury News (CA)

Rick Shaw, "The Dying River," The Sacramento Bee (CA)

Continued on the next page

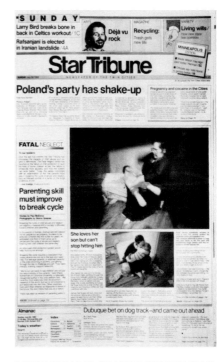

MIKE HEALY, "FATAL NEGLECT," STAR TRIBUNE: NEWSPAPER OF THE TWIN CITIES, 2ND PLACE, FEATURE STORY — NEWSPAPER

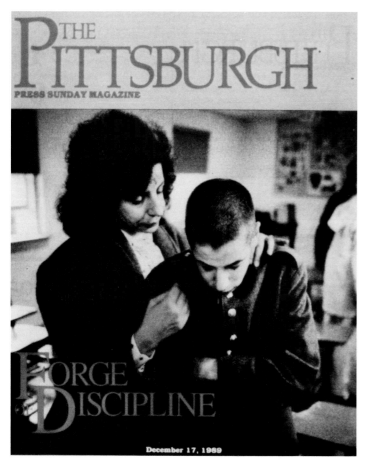

J. BRUCE BAUMANN, "FORGE OF DISCIPLINE," THE PITTSBURGH PRESS, 1ST PLACE, FEATURE STORY — MAGAZINE

KATHY RYAN, "CLIFF HANGER," THE NEW YORK TIMES MAGAZINE, 1ST PLACE, SPORTS STORY — NEWSPAPER/ MAGAZINE

Continued from previous page

FEATURE STORY — MAGAZINE

1st Place **J. Bruce Baumann**, "Forge of Discipline," The Pittsburgh Press
2nd Place **Kathy Ryan**, "River Blindness," The New York Times Magazine
3rd Place **Bert Fox**, **Tom Gralish**, **Gerard Sealy**, "The Rape of the Rain Forest," The Philadelphia Inquirer

Awards of Excellence
J. Bruce Baumann, "Eye of the Times: TV at 50," The Pittsburgh Press
Bill Douthitt, "Living with Radiation," National Geographic
Sandra Eisert, "Building from Scratch," West Magazine (San Jose Mercury News)
Bert Fox, "Remarried ...with Children," The Philadelphia Inquirer
Bert Fox, "Killing Fields," The Philadelphia Inquirer
Peter Howe, "A Seared Land," Life
Wolfgang Behnken, "Der Tod ist ihr Leben," Stern magazine

KATHY RYAN, "RIVER BLINDNESS," THE NEW YORK TIMES MAGAZINE, 2ND PLACE, FEATURE STORY — MAGAZINE

SPORTS STORY — NEWSPAPER/MAGAZINE

1st Place **Kathy Ryan**, "Cliff Hanger," The New York Times Magazine
2nd Place **J. Bruce Baumann**, "Poke,"

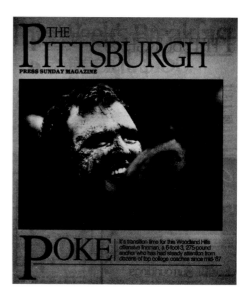

J. BRUCE BAUMANN, "POKE," THE PITTSBURGH PRESS, 2ND PLACE, SPORTS STORY — NEWSPAPER/ MAGAZINE

The Pittsburgh Press
3rd Place **Timothy A. Broekema**, "Sox bring it Home Against Indians," The Journal-Bulletin (Providence, RI)

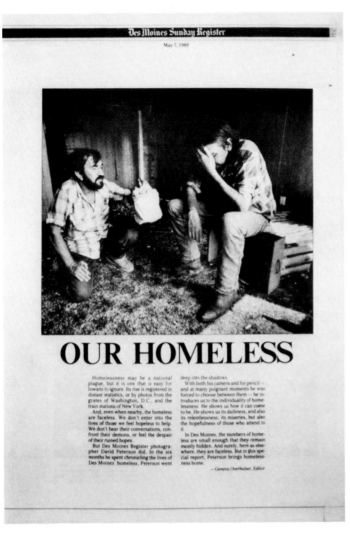

DAVID PETERSON, "OUR HOMELESS," THE DES MOINES
REGISTER, 1ST PLACE, NEWSPAPER EDITING — SERIES OR
SPECIAL SECTION

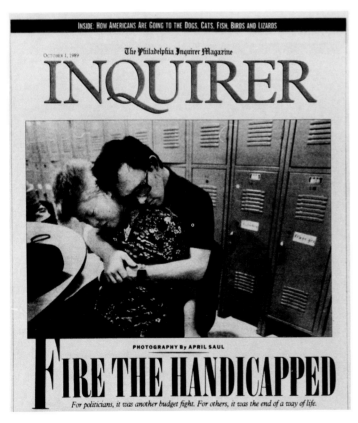

BERT FOX, TOM GRALISH AND GERARD SEALY, THE
PHILADELPHIA INQUIRER, 1ST PLACE, NEWSPAPER-
PRODUCED MAGAZINE PICTURE EDITING AWARD

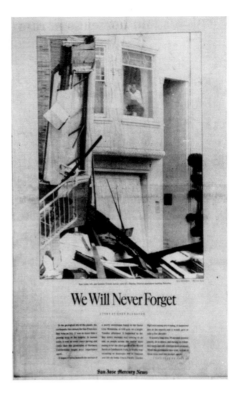

SANDRA EISERT,
"WE WILL NEVER
FORGET," SAN JOSE
MERCURY NEWS,
2ND PLACE,
NEWSPAPER
EDITING — SERIES OR
SPECIAL SECTION

NEWSPAPER EDITING — SERIES OR SPECIAL SECTION

1st Place **David Peterson**, "Our Homeless," The Des Moines
Register (IA)
2nd Place **Sandra Eisert**, "We Will Never Forget," San Jose
Mercury News (CA)
3rd Place **Mike Davis**, "A Price on their Heads" The
Albuquerque Tribune (NM)

Awards of Excellence
John Davidson & Ed Kohorst, "Famine as a Weapon," The
Dallas Morning News
Charlie Leight, "Beyond a Miracle," The Arizona Daily Star
(Tucson, AZ)

NEWSPAPER-PRODUCED MAGAZINE PICTURE EDITING

1st Place **Bert Fox, Tom Gralish, Gerard Sealy**, The
Philadelphia Inquirer
2nd Place **J. Bruce Baumann**, The Pittsburgh Press
3rd Place **Kathy Ryan**, The New York Times Magazine
Continued on the next page

J. BRUCE BAUMANN,
THE PITTSBURGH
PRESS, 2ND PLACE,
NEWSPAPER-
PRODUCED
MAGAZINE PICTURE
EDITING AWARD

JOURNAL TRIBUNE (YORK COUNTY, ME), 1ST PLACE, BEST USE OF PHOTOS BY A NEWSPAPER W/CIRC. UNDER 25,000

THE ALBUQUERQUE TRIBUNE, 1ST PLACE, BEST USE OF PHOTOS BY A NEWSPAPER W/CIRC. OF 25,000 TO 150,000

Continued from previous page

BEST USE OF PHOTOS BY NEWSPAPER, CIRCULATION UNDER 25,000

1st Place **Journal Tribune**, (York County, ME)
2nd Place **The Herald**, (Jasper, IN)
3rd Place **Daily Ledger/Pittsburg Post Dispatch** (CA)

Awards of Excellence
The Medina County Gazette (OH)
The Daily News (Longview, WA)

BEST USE OF PHOTOS BY NEWSPAPER, CIRCULATION 25,000 TO 150,000

1st Place **The Albuquerque Tribune** (NM)
2nd Place **The Register-Guard**, (Eugene, OR)
3rd Place **Lexington Herald-Leader** (KY)

Awards of Excellence
The Montgomery Journal, (MD)
The Spokesman-Review/Spokane Chronicle (WA)

THE HERALD (JASPER, IN), 2ND PLACE, BEST USE OF PHOTOS BY A NEWSPAPER W/CIRC. UNDER 25,000

THE REGISTER-GUARD (EUGENE, OR), 2ND PLACE, BEST USE OF PHOTOS BY A NEWSPAPER W/CIRC. OF 25,000 TO 150,000

THE VIRGINIAN-PILOT/LEDGER-STAR (NORFOLK), 1ST PLACE, BEST USE OF PHOTOS BY A NEWSPAPER W/CIRC. OVER 150,000

COMMUNITY NEWS (THE ORANGE COUNTY REGISTER), 1ST PLACE, BEST USE OF PHOTOS BY A NEWSPAPER — ZONED EDITIONS

BEST USE OF PHOTOS BY NEWSPAPER, CIRCULATION OVER 150,000

1st Place **The Virginian-Pilot/Ledger-Star** (Norfolk)
2nd Place **San Jose Mercury News** (CA)
3rd Place **The Seattle Times**

BEST USE OF PHOTOS BY NEWSPAPER — ZONED EDITIONS

1st Place **Community News** (The Orange County Register, CA)
2nd Place **Today** (The Seattle Times)
3rd Place **Neighborhoods** (The Courier-Journal, Louisville, KY)

Continued on the next page

SAN JOSE MERCURY NEWS, 2ND PLACE, BEST USE OF PHOTOS BY A NEWSPAPER W/CIRC. OVER 150,000

TODAY (THE SEATTLE TIMES), 2ND PLACE, BEST USE OF PHOTOS BY A NEWSPAPER — ZONED EDITIONS

NATIONAL GEOGRAPHIC, 1ST PLACE, BEST USE OF PHOTOS BY A MAGAZINE

Continued from previous page

BEST USE OF PHOTOS BY MAGAZINE
1st Place **National Geographic**
2nd Place **International Wildlife**
3rd Place **The Commission** (Foreign Mission Board)

Awards of Excellence
National Wildlife
The Philadelphia Inquirer

INTERNATIONAL WILDLIFE, 2ND PLACE, BEST USE OF PHOTOS BY A MAGAZINE

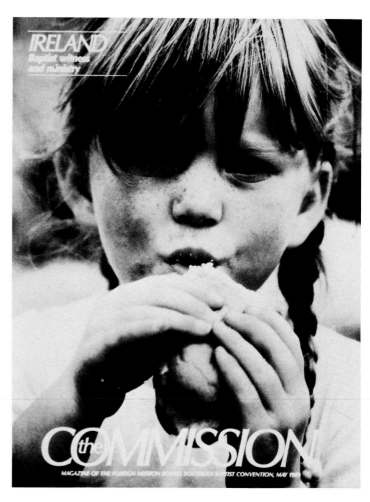

THE COMMISSION (FOREIGN MISSION BOARD), 3RD PLACE, BEST USE OF PHOTOS BY A MAGAZINE

Index

Continued on the next page

Continued from previous page

This book was produced using Apple Macintosh computers, a Varityper VT-600 printer, and AmperPage, Microsoft Word and Aldus PageMaker software. Final output was done on a Linotronic typesetter. All of the book's type is of the Stone typeface family.